To Ron

These were the good old days...
So now what?
only time will tell

Be Well
Peter G.

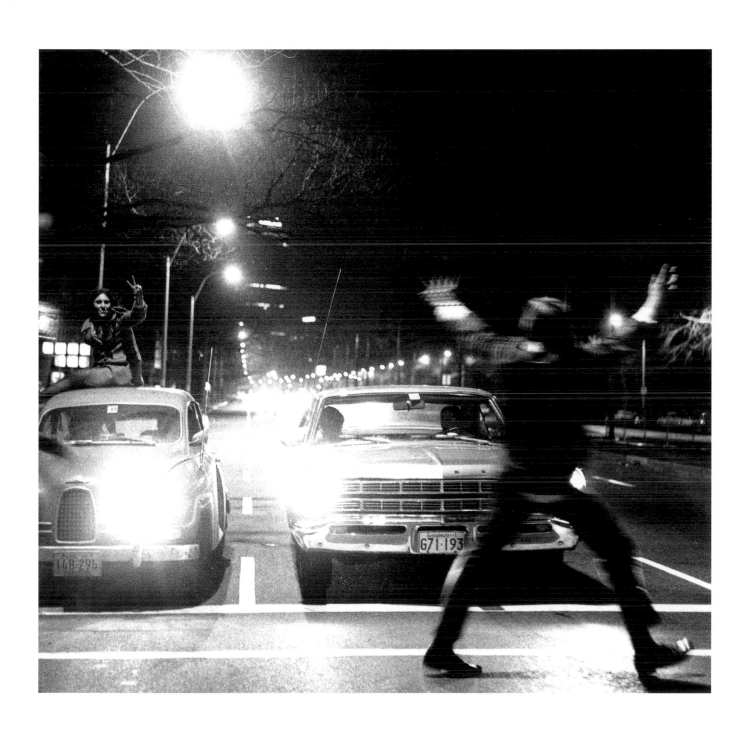

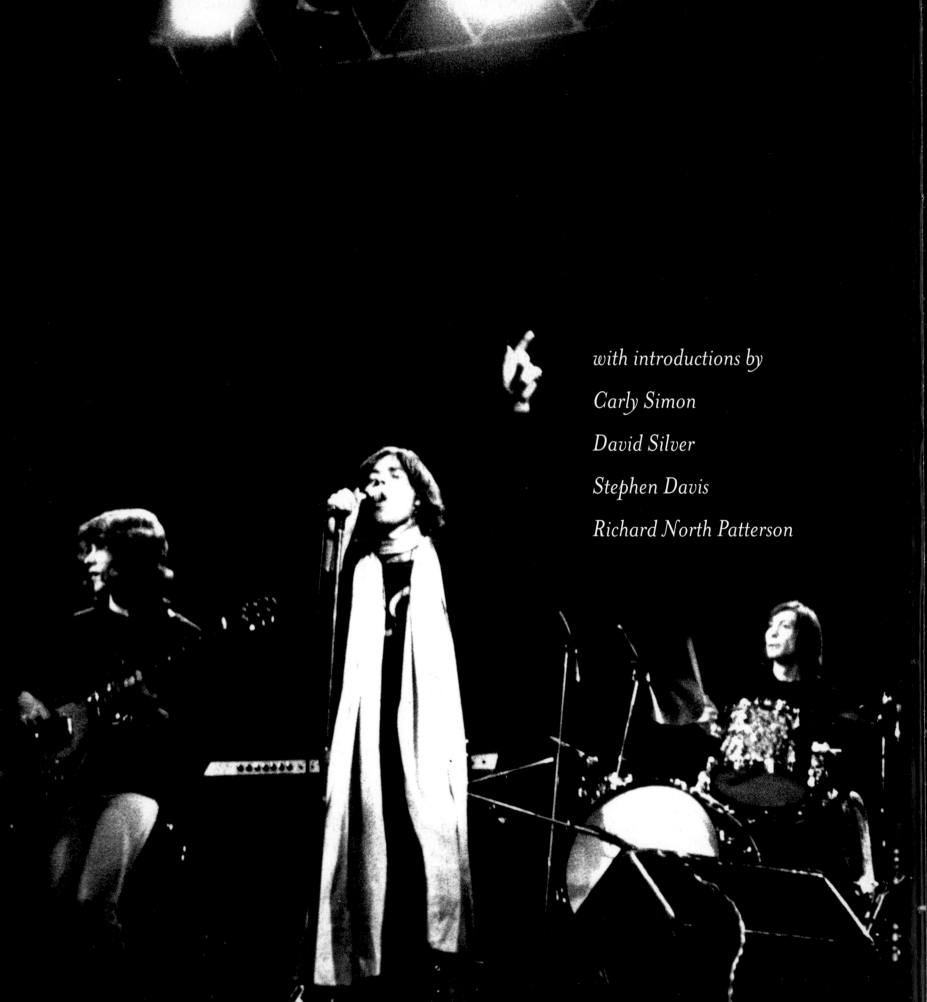

with introductions by

Carly Simon

David Silver

Stephen Davis

Richard North Patterson

I and EYE

Pictures of My Generation

by PETER SIMON

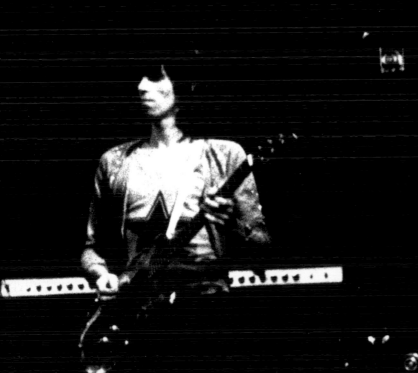

A Bulfinch Press Book

Little, Brown and Company BOSTON NEW YORK LONDON

PAGE I: HEY, HEY, HIP-HOORAY, LBJ DROPPED OUT TODAY!
BOSTON, SPRING 1968.

PAGES II–III: THE ROLLING STONES AT THE BOSTON GARDEN, 1969.

PAGES VI–VII: ANTIWAR SENTIMENT AND MEDIA, DURING THE
SPRING MOBILIZATION AT THE UNITED NATIONS HEADQUARTERS,
NEW YORK CITY, 1967.

All photographs are by Peter Simon with the exception of
those on pages: xviii, 2, 3 (left and center), 175 by Richard
Leo Simon; 3 (right) © Philippe Halsman, courtesy Halsman
Estate; 4, 5 (photographers unknown); 6 by Andrea Simon;
60 (right) by Sondra Sunseri; 107 by Rameshwar Dass; 111
(left) by Peter Barry Chowka and (right) by Bruce Davidson.

FIRST EDITION

Library of Congress Cataloging-in-Publication Data
Simon, Peter.
I and Eye: pictures of my generation / by Peter Simon; with
contributions by Carly Simon . . . [et al.]—1st ed.
p. cm.
ISBN 0-8212-2645-2
1. Simon, Peter, 1947– 2. News photographers—United
States—Biography. 3. Photojournalism—United States—
History—20th century. I. Title.
TR140.S365 A3 2001
070.4'9'092—dc21
[B] 00-066420

Bulfinch Press is an imprint and trademark
of Little, Brown and Company (Inc.)

PRINTED IN SINGAPORE

To my mother, Andrea, who guided me thoughtfully through
the turbulent sixties with her wisdom and faith.
Until her death in 1994, Andy put up with and even appreciated my idiosyncratic ways.

And to my wife, Ronni, who has loved me with loyalty and grace,
and has allowed me the space and given me the support I needed to follow my dreams.

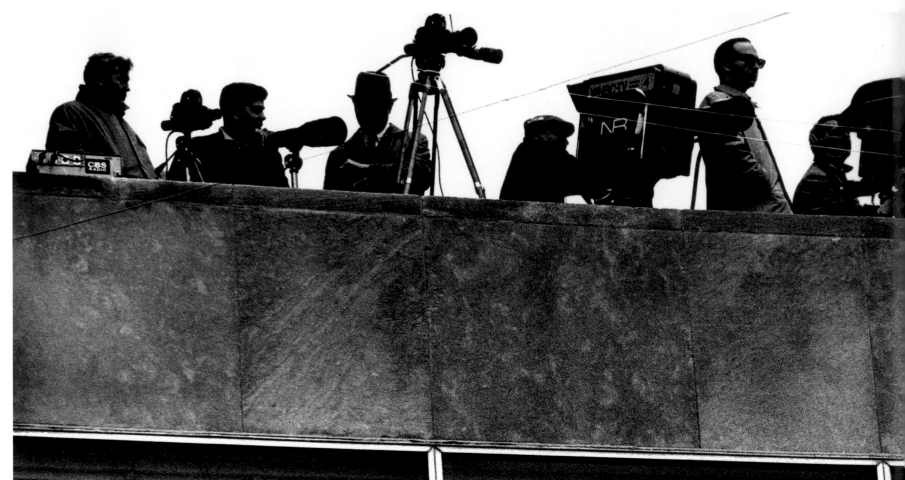
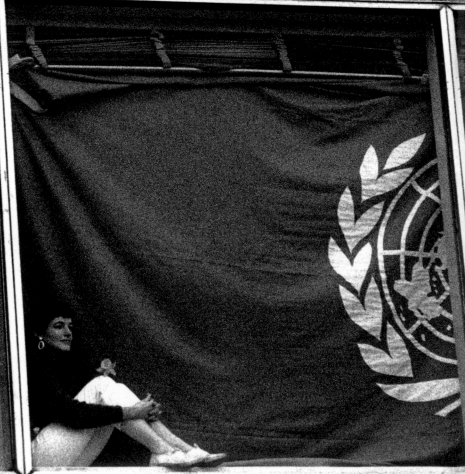

Contents

Introductions

Carly Simon

My brother, Peter, in his early years, with enormous gusto, was interested in only a few topics, but *boy* was he interested — photography, waves, highways, baseball, and putting out our family newspaper. I'm talking about when he was eleven, twelve, and thirteen. This was before music changed all our lives in the mid-sixties.

The newspaper was called *The Quaker Muffet Press.* He would ask all members of our extended family to submit articles, mostly of a personal nature, about our home and family life. We were encouraged to write character sketches or make up crossword puzzles. Almost anything, in fact everything, was appreciated initially by Peter, and most often by his friends and family. Because of Peter's imposed deadline, he was avoided and feared. Nobody loves a deadline demanded, fairly randomly, by a twelve year old behaving as if he were William Randolph Hearst. But, once the tall order was accomplished and then delivered, Peter would assemble the articles and type them out with one finger. He polished off the process with an original photograph on the cover and a binding consisting of one large staple. Inside, there was a table of contents, an editor's comment, the articles, games, and puzzles. The focal point was a photographic essay — the cover story — including Polaroids and full-page eight by tens, processed by the publisher in black and white. The feature article usually would focus upon one member of the household as she or he wished to be viewed, that is if she or he would consent to a proper interview. If we did not agree to such an audience with our demanding boy publisher, he would simply write it himself, unauthorized and scandalous. "Carly was seen in the attic trying on Joey's pale yellow prom dress. Chocolate pudding stain. Too bad." Yes, there would be flailing of the hands and wrists. Retribution consisted of not watching *The Twilight Zone* with Peter for a week. That being said, it was still a great time sitting around the kitchen table communally reading the finished edition out loud. I felt proud to be part of such a daffy and intelligent crew, one that might make the Round Table look square.

In addition to immediate family members, some contributors to *The Quake* whom you may meet as characters who people Peter's engrossing life story, include my boyfriend of many years, Nick Delbanco, who wrote poetry from Greece, and Joey's boyfriend, Bob Morton. Bob was one of the chief supporting players for *The Quaker Muffet Press.* He was erudite. He drew *New Yorker*–like cartoons with hilarious Thurber-esque captions. Some of his stories involved the personification of my dog, Laurie Brown, who took on many identities but was most often seen as a Moorish slave transplanted to

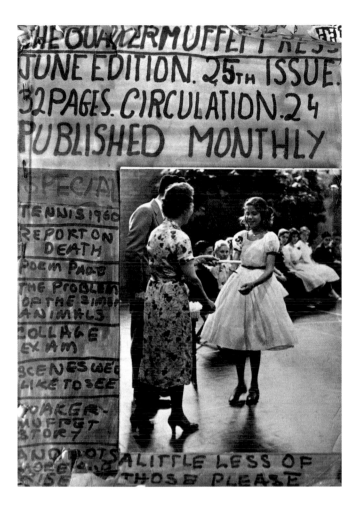

ARCHIVAL EDITION OF "THE QUAKER MUFFET PRESS,"
FEATURING A COVER PHOTO OF CARLY GRADUATING FROM
MIDDLE SCHOOL, JUNE 1960.

England. Her shadow was the very catalyst of a plot to overthrow Arthurian knights in whatever capacity they needed overthrowing. The rest of us, in a less elaborate way, would prattle on about any old subject, eventually wearing thin all the material of our household affairs: "Andrea Simon nearly severs a finger in a garlic press mishap." A headline I wrote toward the end of the second year, "Cheerios all used up — need to go grocery shopping," was an indicator that the writing staff clearly needed a vacation. We were grasping at straws. But Peter was

game; as long as the article was turned in he gave you credit and he published you. I don't remember if he was quite the impresario any earlier than this, but if he wasn't, he was then! This skill at getting the reluctant contributor to "cough it up" would propel him all the way into the next millennium. Peter is relentless. Knowing deep down inside that the squeaky wheel gets the grease, he squeaks well into the night.

Another project in which I was more of a hub was the "operas" that Peter, a childhood friend, and I would write and record on the Simon family tape recorder. Peter operated the machinery as well as improvising many of the arias. We were dauntingly adventurous, and I was probably at the height of my talent as a fifteen year old with nothing to lose. The productions were spontaneous, startlingly musical, and redolent of hyper-hormone humor and scatalogical bad taste — naughty kid stuff. Characters sang from toilet seats everywhere: Rome, Turin, Pittsburgh. An early hippie-borne principle was given voice in another aria, "I Have a Problem," which went: "I have a problem, yes I have a problem. I like to look at kaleidoscopes, but they don't like to look back at me."

Listening to the tapes recently, I was absolutely positive nothing had ever been so much fun. Again, Peter was the chief organizer. He had the idea to do it "NOW," and so we did. The same was true of card games, softball games, and watching *Alfred Hitchcock Presents.* It's always important to have a motivator in every group. Certainly it wasn't me. I was morosely trying to get through adolescence by lighting up cigarettes behind my locked bedroom door and watching out the window for Bobby Elliott to walk by on his way home from some preppy girl's cool embrace. He would be looking down and smoking as he passed under my window.

CARLY AT THE TREE FROG FARM COMMUNE, 1970.

I could still be sitting there had it not been for Peter's insatiable quest for my participating in his next big scheme.

As Peter got older and wiser, he went to Boston University and then moved to a commune: Tree Frog Farm. As a great-looking, curly-haired, roach-smoking, privileged kid with a Nikon, he heralded the no-nonsense approach to bring it all back home to the earth, but with the best that modern technology could afford: a Sony tape recorder and a color TV. He was dropping out, but he was hooked up. Some of the best chapters in this book describe those years. What a time it was, too. Peter has told the tale with more honest insight than I could have imagined. He is without defensiveness and he laughs at himself when criticized, just as he also enjoys a big fat compliment. Peter has always been such an exuberant lover that at times he has made the beloved feel uneasy. He is good natured

about receiving a "no," but it doesn't mean he doesn't continue to try.

So, as a young photographer, a lover of women, the weed, and "the way," he took his pleas, his beliefs, and his yearnings and gave them direction and energy. He took them to the street, backstage, the farm, the field, and the foyer. Also to the bedroom, and to the bedrooms of his fellow men and women. He wanted and he expected a response. The story of his life is a great way to focus on what it was like to be utterly preoccupied with counterculture in the late sixties/early seventies.

Peter's life at Tree Frog Farm, though a bit over the top at times, mostly made a great deal of sense to me. I visited him there during the early winter of 1970, just as I was making my first solo album. It was there that Peter took pictures of me with his Leica and Hasselblad. I posed sitting on his threadbare, doggy-stained couch, which he made look inviting with shawls and pillows. It might have been our first professional session together. I think he got paid about $200 from Elektra Records. Peter had inherited our father's cameras and he was learning their scope and range. He regularly drove the four hours to Riverdale, where he had learned the basics of how to make his own prints in the darkroom that Daddy had built, to process his own film. If ever there were a son who took after a father he hardly knew, it was Peter after Richard. The context of their minimal relationship *was* the darkroom. I remember Peter would sit and measure out chemicals with Daddy. There was magic to watching forms materialize, and Peter, without question, developed not only a love of the process, but also an ease with it. When Peter took pictures of me, I was comfortable. I felt the naturalness of having been photographed so many times before by someone who looked and moved a lot like him.

I loved going to Riverdale with Peter to develop the prints and watch him try new techniques that would have bothered the purist (our father) and others of an earlier generation. Peter liked to blur edges (as if the marijuana wasn't blurring enough of them). This was called the "Norman Seef effect," as we had heard of Norman's techniques and had laughs trying to imitate them. One trick was putting Vaseline on the lens to make haze of the actual image, thereby reducing unflattering lines. Fog does much the same thing, but you can't bring fog with you, and you can buy Vaseline quite inexpensively. (Now I need Vaseline all over — not only for photos but my face itself. I slather it on every morning before anyone sees me. Some people think it is their eyes, but no. It is my Vaseline.) I have tried to interest Peter in using special lighting effects in his portraits. But he is more interested in showing the real person. It was only in those early Tree Frog years that there was experimentation with lubricants on lenses.

Which reminds me — at Tree Frog Farm there was free love in its many manifestations, which my brother took the opportunity to photograph: muddy children in the shower, long-haired, acid-tripping boys and girls dancing Rockette-style on the lawn, and bisexual farmers reading Rimbaud to their cows. Peter Simon was an industry at the center of this group of characters and made a madly inventive book about it, *Decent Exposures.*

Although he had moved out of the house in Riverdale, as we all had, he was a good son to our mother and, what is more impressive, a loving one.

He came back, prodigally or not, to see our mum, who was always crazy to see him. Years before he met and married Ronni he brought home many girls. Some had Indian names bestowed upon them by traveling gurus and visionaries. These girl-friends adored him; he fell in love quite easily. Hearts were not meant to be broken in this atmosphere of free love. You were supposed to be generous and lend your girlfriend out for the night. But I believe that hearts and egos got far more injured than people could cop to. It wasn't "cool" to be possessive, and pot dimmed the immediate, primal urge to strike the welcomed interloper with a big frying pan. I witnessed Peter being heartsick as a direct result of his expansive instinct: sharing his lady loves with his best friends. I so often wanted to tell him something — to give him the advice of an older sister, a sage of love. But no, I knew and know nothing. We're supposed to know things, if only to be role models, but at least it's better to know you don't know. It's good to watch. I still think the Vaseline trick holds promise as a philosophy of life: throw some haze around the shore, and then continue to proceed as a newcomer.

· · ·

I should leave off at this stage in the Peter Simon story for others to take over. He has many admirers, and here they should have the floor. It is hard to pick out the various and rich ways our lives have intersected. But this is his book. Even as we, his nearest and dearest, add our two cents' worth, it is for him to tell his distinctive and exotic story.
— C.S.

David Silver

Peter always carried his camera — he documented your every gene. Its Leica eye massaged you and captured you. And this is only allowable from an intruder with a widely open heart, like Peter's.

Peter is preternaturally natural. His inhibition quotient is close to zero. It has always been that way. Startling and endearing behavior comes from his fem side, his freer right brain, his observational enthusiasm. Thus Peter's unpretentious photographic receptivity. Any minimal macho was eradicated from the lad seemingly incarnations ago. In the Elysian hippiedom of a third of a century ago, when I first bumped into him, he was already the living, breathing objective correlative of sixties sexy sway and winsome words. He adored most of the women on the planet — but sidled up to them via a new, soft charm rather than conventional, neanderthal mating action. During those lysergic libertine days, Peter wove in and out of women, his only constancy to his camera — like B.B. King and "Lucille." Rock and Rolleiflex.

Remember, Peter's pacific gait and gab came out of constant cohabitation with a most obviously wonderful set of females, no hyperbole. He spent every day of his young life with Andrea, Joanna, Lucy, and Carly . . . an entrancing aggregation of muses and mothers and musicians. Andrea, Mum, my pal — how totally daunting to encapsulate any-

thing about her without a whole biography to do it in: brilliant, beauteous, sarcastic, witheringly critical, shockingly accepting — a friend to the poor, a force to the rich. Andrea, a maven of fiery contradictions, a real snob one minute, a real Samaritan the next. Her ability to love you to death when she wanted to was insuperable and irresistible. Her cutting critiques of everything in the universe gave this magnetism its fearsome edge and kept you nervously on your toes in the sincerity and integrity departments.

If Chekhov had known *these* three sisters, he would have written a musical. Featuring the massed talents of La Scala Joanna, Lucidity Lucy, and Cosmical Carly. Serious pulchritude along with harmonies from heaven plus totally individuated artistic attack. I hear their voices resounding throughout Peter's lucky life. These are his ridiculously formidable formative females. And *all* of them very witty women. So this family trait combo of funny, smart, and gentle made much of Peter possible.

The next big woman event for the seeking Simon was Hilda. Hilda Charlton was an incandescent spiritual teacher whom Peter learned from and loved, as did I. She effortlessly transmitted a treasure of knowledge about great avatars and gurus. Truthfully, Peter's participation in Hilda's

DAVID SILVER WITH RONNI SIMON, NEW YORK, 1979.

rigorous *satsang* was less than totally committed. It is a measure of his being a worshipper of every good goddess that he persisted in seeing Hilda even though there were too many rules for him. Hilda's heart was always emblematically right there in front of you. She could open up the heart chakra. Peter was pure in his appreciation of this. He just didn't care for the discipline. But the heart aspect is the key — this ancient soul Divine Mother with the strict rules of conduct manifested such vatic love that Peter was as bowled over as with one of his country cuties. His fourth chakra persona is his most authentic and valuable, personally and professionally. People are themselves in front of his lens because he is *him*self. So he may not be monk material, but he certainly knows a prophet when he sees one, whether it's St. Hilda or Mr. Marley.

It's always folly to try and sum up anyone's life — there are too many trillions of hidden variables to be so bold — but the girl world has always impacted strategically upon Peter's outlook and style. No earthly being has impacted him as much as Ronni, his wife. Pragmatism emanating from a seductive soulmate is powerful indeed, and Peter couldn't resist her approximately one nanosecond after they met. No doubt over the years her left eyebrow has arched even higher on most days, but her wry way with Peter has grounded his whole life. Robert Louis Stevenson said, "To know what you like is the beginning of old age. Youth is wholly experimental." Ronni eased Peter through that passage, and we became super-close friends — I was the best man at the wedding and have been dazzled ever since by her charms and talents in her own right. Sure, Ronni has enhanced Peter's skills, but she has also donated to all of us her radiant soul as well as a bright, challenging clarity of mind.

My own friendship and laughing camaraderie with Peter has survived for decades. We are a frequent reminding mutual support system, rekindling the same nurturing sentiments and concepts from our youth — most crucially the worship of Gaia and remembering relentlessly that all you need is love is still true, despite twenty-five years of societal movement toward Mammon. Thank goodness that Peter's heart and mind are still receptacles of the loving sensibility we all found so easy to embrace not so long ago. — D.S.

Stephen Davis

Bob Marley frowned when Peter Simon asked him to take off his cap, and my heart did the Jamaican one-drop. It was in March 1976, and I had just finished a somewhat contentious dialogue on faith with Bob in the yard of his house on Hope Road in Kingston. Peter and I had been waiting weeks to meet with the reggae superstar while we were working on a book about Jamaican music, and getting good quotes and evocative photographs of the elusive Marley was crucial to our project. I had wondered how Marley, dreadlocked Rastafarian musician from the slums of Trench Town, would react to Peter Simon, shaggy trustafarian photographer from suburban Riverdale. When Bob screwed up his face after Peter politely suggested he lose the hat and flash his locks, I thought it was all over for us. Peter had gone too far this time. *No one* asked the Black Prince of Reggae to take off his hat.

But then Marley looked carefully at Peter, really checked him out, and something cool happened. A flicker of a smile animated his taciturn mouth. I think Bob intuited a psychic connection from Peter's earnest enthusiasm and innocent request. After all, they were both about the same age and liked the same things: music, women, herbs, independence, and freedom. Peter started rapping to Bob about how much he loved his music, and slowly Bob Marley let it go. He kept his

cap on but leaned back on his silver BMW and lit a ganja cigar. Bob, I realized, was posing now, using the spliff as a prop. Peter kept up the gentle patter, shooting while Bob Marley puffed away, getting him to move this way and that. I realized that what made Peter so good at taking acute portraits of people — rock stars, politicians, athletes, gurus, anyone — was his ability to use his eyes to assure his subjects he intended no harm and had their best interests at heart. Eventually Bob Marley even took off his cap, and we had what we came for. As it developed, Peter's pictures of Bob Marley are among the most revealing ever taken of one of the great heroes of our time.

· · ·

Reggae Bloodlines, our book about Jamaica, was published in 1977 and has been in print ever since. We're both proud of this collaboration, which was the culmination of a partnership that began ten years earlier at Boston University. We started in 1967 as a writer-photographer team at the *BU News,* one of the biggest college papers in America. Together Peter and I covered the turmoil and upheavals of Boston in the sixties: antiwar protests, civil rights demonstrations, hippie love-ins, race riots, building occupations, sexual revolution, drugs, rock and roll. We shared an old house in Cambridge, bonding for life in an atmosphere of

music, friends, and weird trips. After college we kept working together. Our first professional gig was covering Jack Kerouac's funeral in October 1969 for *Rolling Stone.* When Peter moved to his communal farm in the hills of Vermont, I stayed in the city to write. But I visited Tree Frog Farm whenever I could, bringing the latest records from town for Peter's insatiable music addiction. Vermont was much more isolated then, an idyllic green prison, and I would hassle Peter about his dubious decision to retire at twenty-four to a country seraglio of semiclad hippie girls and gentleman farming. He tried to get me to join the commune, but I wasn't into brown rice and milking goats.

But we stayed in constant touch, meeting up for magazine and newspaper assignments, enjoying many aimless and irresponsible summers in ramshackle fishing camps up-island on Martha's Vineyard. (Harper Barnes, my editor at the *Phoenix,* Boston's alternative weekly, got annoyed that I spent so much time away from the paper. He complained I was always flitting down to the Vineyard to hang out with Peter Simon. Once he asked me, "What do you guys actually *do* down there?" After I explained that we spent all day on remote private beaches swimming with naked girls, Harper never raised the subject again.)

By the mid-1970s, Peter and I were doing music features for the Sunday edition of the *New York Times* and hanging out with rock groups like Led Zeppelin for other publications. Peter's Zeppelin pictures were eventually printed in my book *Hammer of the Gods.* Our piece on reggae brought us a book contract that resulted in *Reggae Bloodlines.* I still think the work Peter did on the run in Jamaica was the best of his career, so I used to give him a hard time about retiring to the Vineyard to raise his family instead of staying with me in the trenches of jour-

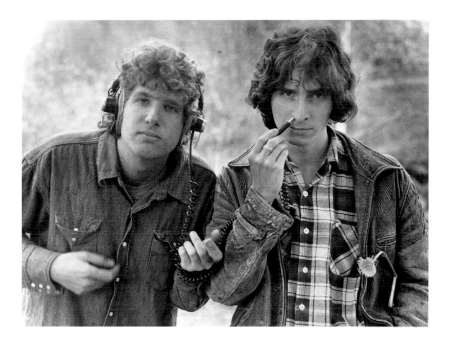

PETER SIMON WITH FRIEND AND COLLABORATOR STEPHEN DAVIS, RIFFING AT TREE FROG FARM, 1973.

nalism. But this book, and his three volumes of prose and portraits of the Vineyard, are the best evidence that he made the right decision for himself. Peter's ongoing chronicle of that beautiful island and its people has become a life work of personal journalism and an invaluable social history of one of America's most interesting microsocieties.

· · ·

Peter Simon and I have been friends for thirty-five years at this writing, so retracing his adventures through this book has been a flashback journey for me as well. I feel fully qualified and entitled to tell you that Peter remains an irrepressible, flamboyant personality and the (sometimes-maddening) sum of his interests and obsessions. He's a generous friend, a good husband and father, a masterful stickball player, a way-cool DJ and radio host, and a frustrated, unresolved weatherman. He's an eccentric tennis player, an innovative record producer, an independent publisher, an unrepentant Deadhead, and (in the words of his lawyer friend Alan Dershowitz), a walking sexual

Richard North Patterson

harassment case who tends to fondly caress any attractive or sympathetic human in his immediate orbit. Please don't take it amiss — as Jackie Onassis once did — if Peter starts hugging *you* someday. His (not always unwanted) attentions to a slender waist or an inviting bottom are inspired more by a naturally warm affection for people in general than by vulgar desire. So hats off to Peter Richard Simon — my soul brother, inspired partner, and true mate, who helped shift my young life into gear and who has saved my own sorry bottom more than once.

The photographs and autobiographical texts in this book portray both the most wonderful and the most problematic aspects of a privileged American life in the second half of the twentieth century. Peter's story is emblematic of the conflicted, double-edged reality of the postwar baby boomers: a wealthy, empowered, optimistic generation that thought it could change the world; a narcissistic, delusional, self-absorbed generation out of touch with the world it wanted to change. When our era is history, I think Peter's pictures will endure because they vibrate to the ring of truth. He has always worked from the inside, living the life he photographed rather than recording or capturing someone else's. This book is a journey many of us have taken, and I bet that many of his readers will enjoy it as much as we have. — s.d.

One of the many pleasures of this stunning collection of words and photographs — the life's work of a deeply talented, perpetually curious man — is to reflect on the role Martha's Vineyard has played in nurturing both the talent and the life.

In his treatment of Martha's Vineyard, Peter records his first impression of the island. It is both lovely and poignant. The loveliness derives from the deep impression the island made on the senses of an eight-year-old child, with a child's openness combined with the precocious eye of the photographer he was to become. The poignancy reflects the complexity of Peter's family life: a precious day with his often distant father, interrupted by his dad's sudden illness; a sense of closeness to his sisters that too often eluded him. And now, forty-five years later, Peter remains attuned to the way the beauty of the Vineyard affects a slowing down, an ability to savor a time and place, which almost by chance allows parents to remember why they chose each other, and chose to have a family.

For Peter, the Vineyard is part of that choice. This unique personal history reflects the various stages of his life: as a member of the counterculture, savoring nude swimming, dope smoking, and a serious absence of rules; as a subsistence liver who cared more for the pleasure of his craft than the pleasures of money; as a newlywed, contemplating

his future with a new sense of seriousness; as a father, weighing choices that, inevitably, diminished his freedom while enriching his life — one of which, happily for the island, was to make Martha's Vineyard his home. The thoughts of a child about the Vineyard and family have, in the father, come full circle.

These metamorphoses have left Peter profoundly changed and yet, in the best ways, not. He still goes barefoot. He remains openhearted and open-minded. He has as great an appreciation of people as ever, and is as generous in his enjoyment of having people he likes meet other people he likes. Anyone who knows Peter and Ronni as a result knows other great people — perhaps through an evening during which Peter shares his enthusiasm for a new CD from a talented singer he has discovered and encouraged. As for Peter's passion for music, it is now expressed in a Sunday-night radio show in which he passes on his knowledge of, and enthusiasm for, the rhythms of our times. Peter remains a resource — and a whole lot of fun.

Now, in middle age, Peter tries to care about money. But it will never come naturally. And he seldom undertakes a commercial project related to the Vineyard — like his wonderful "On the Vineyard" series of photographs and essays — without

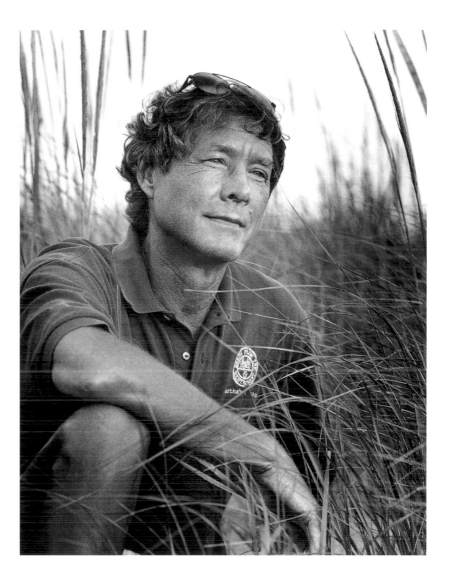

RICHARD NORTH PATTERSON ON THE VINEYARD, 2000.

cutting in a Vineyard charity. In this, as in other ways, the best of Peter abides.

As for Peter's photographs, I merely note what is obvious: they are sharp, eclectic, vital, and, when beauty is the point, quite beautiful. And his diverse images of the Vineyard reflect both what it is and who Peter is: a gifted photographer who is more than a visitor, or even a devotee. Peter Simon, like his photographs, is part of the warp and woof of Martha's Vineyard. — R.N.P.

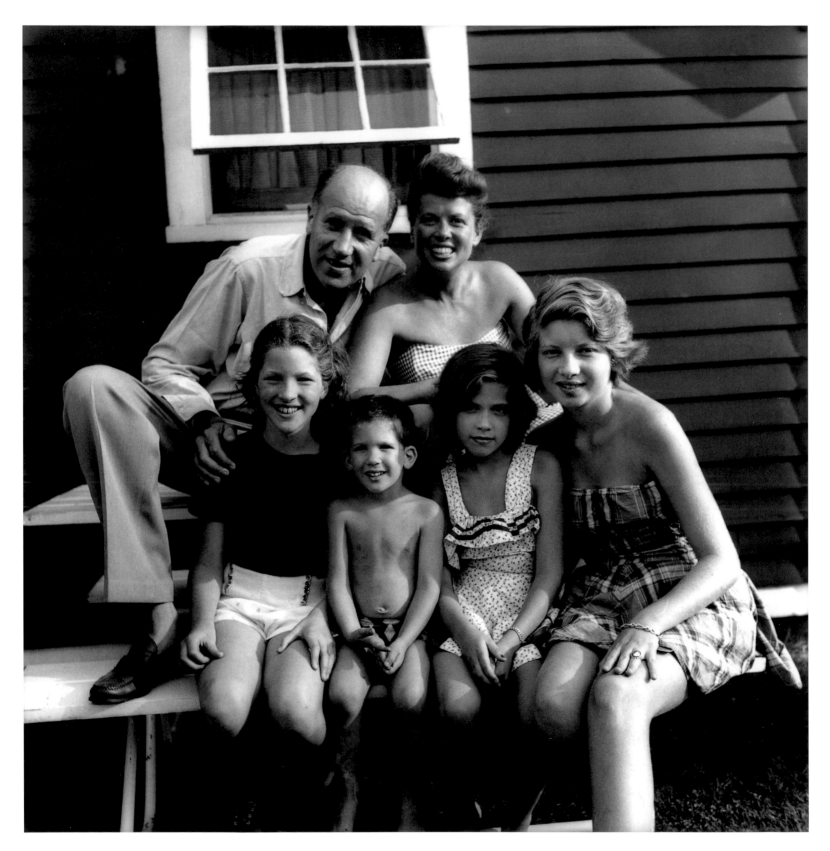

THE SIMON FAMILY, CIRCA 1952. MY FATHER PUT HIS CAMERA ON A TRIPOD AND USED A DELAYED SHUTTER RELEASE.

Growing Up Is Hard to Do

1947–1965

I entered this world on the morning of January 26, 1947. Since my birth certificate doesn't show an exact time and my mother did not remember, I have never been able to obtain an accurate astrological reading. But there must be *something* in my chart about the water, the weather, music, baseball, documenting the passage of time, women, and family. These are the major constants and passions of my life.

Of course, being the only son of a father (Richard) who founded a publishing company, loved the piano, and was an avid amateur photographer must have been an influence as well. Having three older sisters (Joanna, Lucy, and Carly) and a strong-willed, charismatic mother (Andrea) provided a somewhat overwhelming female environment in which to define and establish a reasonable facsimile of a male identity. But at least I was coddled and nurtured lovingly throughout my early childhood.

My first visual memory is that of my sister Carly and me eating vanilla pudding on a window seat in our Greenwich Village apartment, bathed in sunlight. I was about three at the time. I also vaguely remember thundering around the apartment in one of those toddler walkers, and being deathly afraid of an odd-looking pipe that protruded from the ceiling in my room and ran along the wall.

Every night to allay my fears before I went to sleep, I would make my mother kiss the pipe good-night after she kissed me.

By the time I was four, my father decided he had had enough of city life. He awoke one morning to discover a parking ticket on his windshield. He was parked on the street in front of the brownstone apartment building that he owned on West Eleventh Street. The building housed not only us, but his mother-in-law, sister, brother, and their young families as well. So incensed was he about the ticket that he abruptly sold the building, and we all moved to a fashionable suburb within city limits but outside Manhattan called Riverdale. Our home was an elegant brick colonial on a tree-lined street with a nice hilly front yard, beautiful gardens, and ample parking. We also bought a summer home in Stamford, Connecticut, which was estatelike, with a tennis court, a swimming pool, a windmill, three guest cottages for friends, relatives, and caretakers, an enormous copper beech tree, an apple orchard, a vegetable garden, and a huge barn converted into a family performance center. It was a glorious compound.

My lifelong interest in music surfaced at an early age. Surrounded by three singing sisters, a father who played Tchaikovsky's Symphony no. 9 brilliantly on the piano, and a family that had

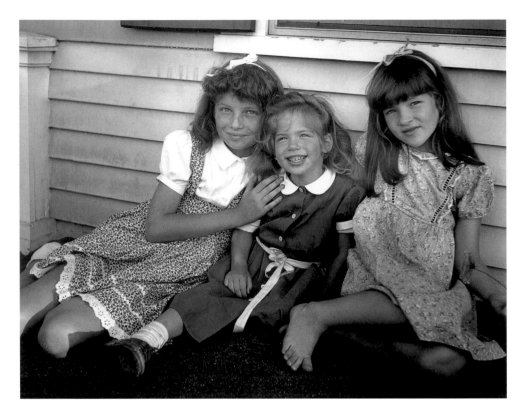

MY THREE SISTERS, JOANNA, CARLY, AND LUCY, MUG FOR MY DAD, 1948.

> MY MOTHER, ANDREA, AND ME (AGE THREE) IN A COZY MOMENT.

CARLY AND ME DRESSED TO KILL.

AN "OFFICIAL" PORTRAIT OF MY FATHER, RICHARD LEO SIMON, TAKEN BY NOTED PORTRAIT PHOTOGRAPHER PHILIPPE HALSMAN, 1954.

sing-alongs at any time of day or night, I absorbed the notes and they resonated deep within. At an early age I had a turntable and a radio beside my bed. I collected music, mostly classical albums, which I propped up neatly on a shelf. The Moonlight Sonata and Beethoven's Fifth were among my favorites. In the mid-fifties there was the Frank Sinatra phase. And when Buddy Holly and the Crickets rocked the nation in 1957, I was all ears.

By 1959 I had developed a fanatical interest in popular music and would listen religiously to Peter Tripp's WMGM Top 40 countdown every Monday to see which singles had gained or lost momentum. Songs like "Rock Around the Clock," "Bird Dog," "Venus," and "The Lion Sleeps Tonight" immediately created little vignettes of various preadolescent experiences with family and classmates.

I have vivid memories of doing dishes with Carly and Lucy while dancing wildly to "Don't Be Cruel" by Elvis, or slowly to "It's All in the Game" by Tommy Edwards. One night, long after we were

supposed to be safely tucked away to sleep, "Susie Darlin'" played over the AM radio, and I raced into Carly's room to tell her to listen. She rolled over in her unconscious state and said, "You were all the world to me; all my dreams came true," and fell back to sleep. Music was the language we all could share, and even my parents could tolerate an occasional chorus of "Splish Splash" by Bobby Darin. Those memories are permanently etched in my soul.

Due to the prestige and success of my father's publishing company, Simon & Schuster, we not only lived in the lap of luxury but were graced by visits from many of the well-known literary and entertainment figures of the day, including the likes of authors Sloan Wilson (*The Man in the Gray Flannel Suit*), Herman Wouk, and Irwin Shaw; jazz player Benny Goodman; comedian Jimmy Durante; tennis star Donald Budge; Brooklyn Dodgers superstar Jackie Robinson (who later figured prominently in my upbringing); and songwriters Richard Rodgers and Oscar Hammerstein.

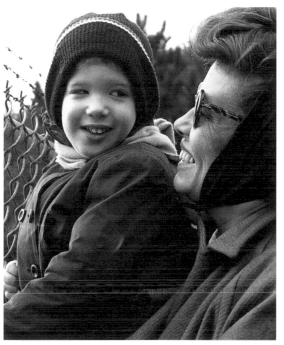 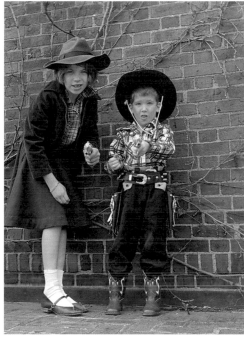 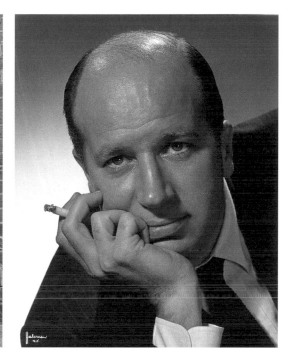

Summers in Stamford seemed like one continuous party for children and adults alike, with my father as benefactor and various friends and family members as beneficiaries. With what seemed like a cast of thousands, we reveled in dinner parties, tennis and poker marathons, magnificent bonfires with group singing, games of charades, and cricket-soundtracked escapades at midnight. There were well-staged plays amid Ping-Pong tournaments in the barn and bountiful homegrown meals at lunchtime in the "tennis house."

Winters in Riverdale, with their day-to-day humdrum of elementary school and homework, were enlivened by my father's appearance on Ed Murrow's *Person to Person* and trips into the city for Broadway plays and museum hopping. Various butlers, cooks, and chauffeurs were always on hand to satisfy our every whim. To say it was an indulged childhood would be an understatement, but little did I realize how fortunate we were compared to the "real" world.

Yet, beneath this idyllic childhood tableau was a layer of tension and dysfunction. Despite my father's wit, charisma, and larger-than-life persona, he was possessed by the demons of workaholism, depression, and anxiety, particularly when things didn't go his way. He brought the drama of Simon & Schuster power politics home at night. My mother and I would drive to the train station to pick Dad up each evening. The tall man with the derby hat had a constant look of worry on his deeply lined face. My mother did her best to instill proper values and give creative encouragement ("You must strive to be the best at whatever you choose"), but she too seemed overwhelmed by responsibility and social pressure. Much of our care was gradually relegated to nannies and house-keepers. By the time I was six, my mother, sensing my father's growing unavailability, hired a Columbia student named Ron to become my "big brother," a well-intentioned but slightly underachieving surrogate dad.

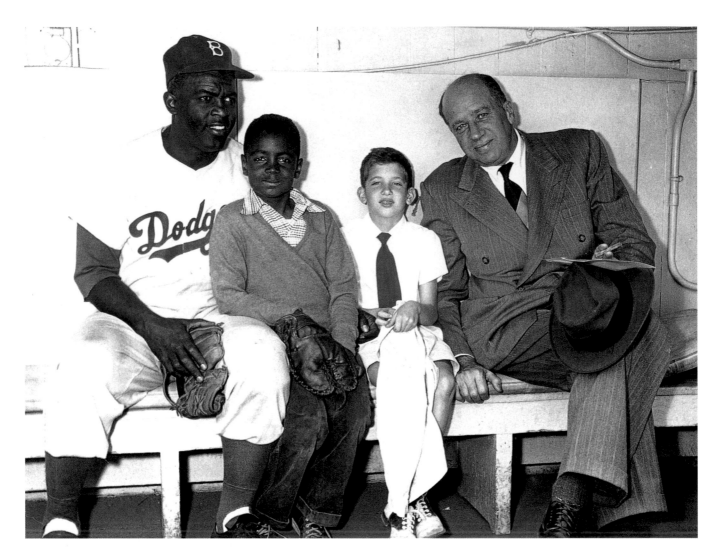

As my father's business grew, his health and mental state declined. My "quality" time with him was extremely limited. Yes, we did watch many Brooklyn Dodgers games together, and he even brought me to Ebbets Field to meet our beloved family friend and hero Jackie Robinson in the Dodgers dugout. And Dad taught me how to shave (with an old-fashioned brush and pre-safety razor), despite the fact that I was only nine at the time. He would say, somewhat aimlessly, that "we guys have to stick together." But perhaps his greatest gift of all was to bring me into his darkroom from time to time to show me the magic of black-and-white prints emerging from blank sheets of paper in the eerie amber light. I would sit for what

OUR HERO, JACKIE ROBINSON; WITH HIS SON JACKIE JR., ME, AND DAD, IN THE BROOKLYN DODGERS' DUGOUT BEFORE A WORLD SERIES GAME, 1955.

>

A CONTACT SHEET OF MY FATHER'S APPEARANCE ON THE ED MURROW "PERSON TO PERSON" TV SHOW, 1956. WE KNEW HIS FACULTIES WERE DIMINISHED WHEN HE SAID, "THIS IS OUR DINING ROOM; HERE IS WHERE WE HAVE DINNER."

seemed like hours on the counter next to his enlarger and the foul-smelling chemicals, watching the genius at work. I can still picture him muttering to himself as a print would come out too dark or contrasty. He used an old Leica and later a twin-lens Rolleiflex. I watched how he would set people

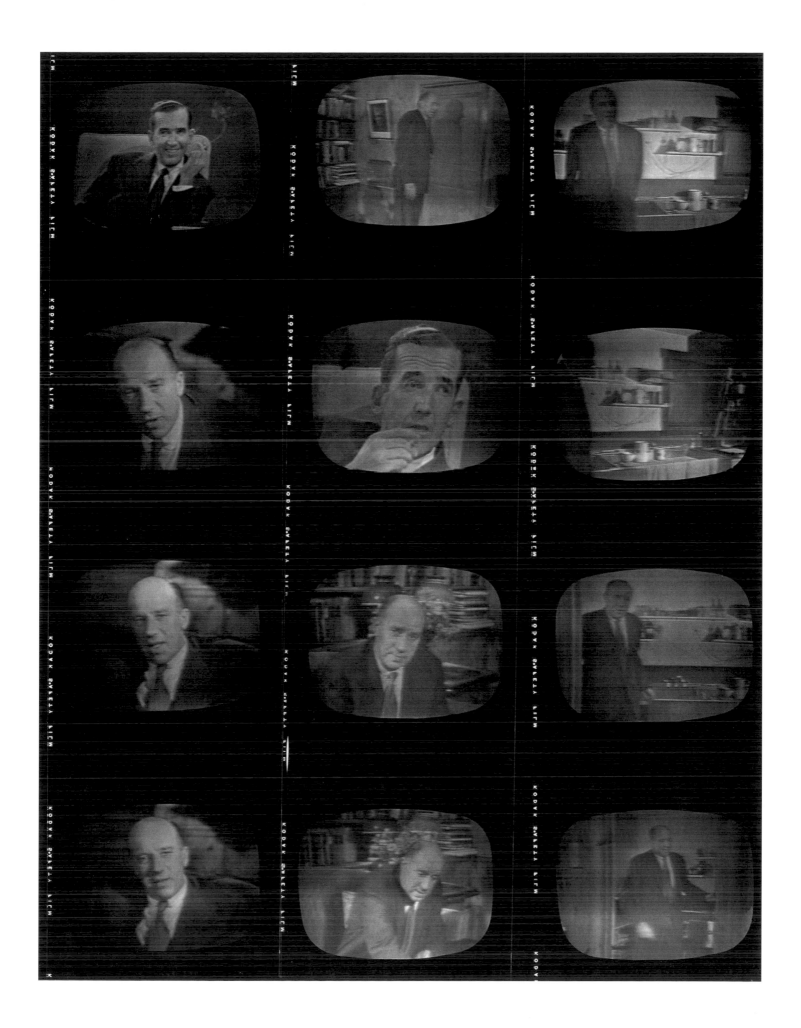

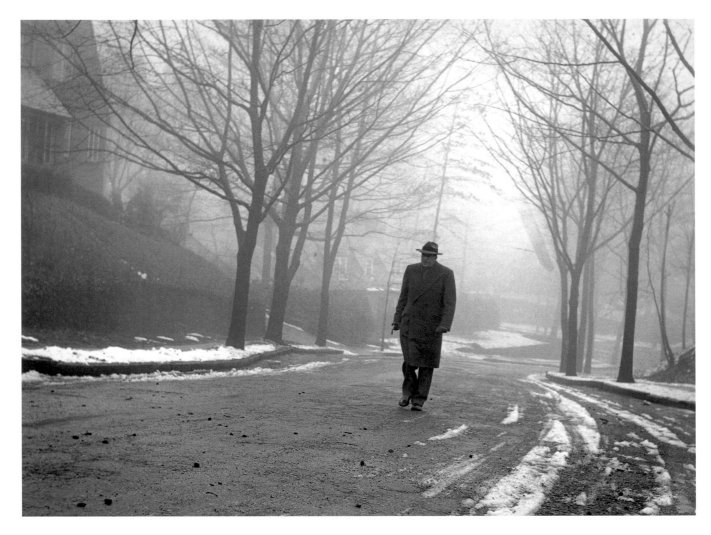

MY FATHER, WALKING THE WINTER STREETS OF RIVERDALE, NEW YORK, 1956.

(mostly family) up for group shots, then bring this weird-looking device up to their noses and study the results. Only later did I come to realize he was taking a light-meter reading. I read and reread his self-published handbook, *35mm Photography, From One Amateur to Another*. When I was ten, he bought me one of the first Polaroid cameras ever made and told me to go off and shoot as much and as often as I could. And I did.

A series of heart attacks and small strokes between 1955 and 1959 left my father significantly weakened, both physically and psychologically. I have memories of prints left in the fixer tray for days, the chemicals dried up and caked like cracked ice on a pond. And one morning, when I was about eleven, he called me into his bedroom and asked me to take over Simon & Schuster as he was no longer physically able to do it. That frightened me. As I learned later, he had been gracelessly "eased out" several years earlier and no longer had anything to do with the company he had cofounded.

As his health declined, so did all the fun and joyousness that had earmarked the earlier stages of my childhood. Our family no longer seemed to function as a unit, as each of my sisters slowly went their separate ways and formed new friendships, busy with high school responsibilities and adolescent crushes. I was sent off to summer camp. My

father was farmed out to Stamford during the winter, where he was cared for by his childhood nurse — who had also been his lover before he married. My mother, as a means of escape and survival, engaged in a passionate affair with my "big brother," Ron. Since I was too young to understand the complexities of a disintegrating family structure, the wounds felt superficial, but the imprinting ran deep.

I remember the end of my father's life clearly. I was at camp in upper New York State. Parents weekend was but a day away, and I was eagerly expecting to see my mom and whomever she chose to bring along. I had learned my part in *Iolanthe*, the Gilbert and Sullivan operetta, to the smallest detail in order to impress her.

But instead, my mother and Ron showed up unexpectedly the day before. The look on her face was one I'll never forget — fraught with both sadness and anxiety. She abruptly said, "Pete, we're taking you back to the city to go to your father's funeral. He died last night."

I tried to repress any feelings of sadness or grief — just wanting life to go on as planned. "What about the play, Mom?"

"Well, we'll have to just forget Gilbert and Sullivan for now," was her reply.

I never cried. Dad seemed like a distant memory anyway. I remember telling myself at his funeral not ever to work as hard as he had, nor to endure so much pressure as to never have any time for my own children. While following in his footsteps would have been hard enough, an inner voice said it wasn't worth the effort anyway.

I wound up inheriting all his cameras and darkroom equipment, chemicals, and negatives that dated back to the early twenties. The lessons had been taught, and the legacy had been passed.

· · · ·

As an adolescent I wasn't blessed with a particularly exemplary body. I was late in going through puberty. I had inherited a mild case of scoliosis from my father's side of the family. I had a serious case of buck teeth, exacerbated by a traumatic bicycle accident in which my mouth had hit the pavement as the front wheel of my bike came off without warning. Three years of orthodontia helped somewhat, but I was still skinny and nerdy looking. Girls laughed at me, and to the boys I was basically weak and pathetic. My dearest childhood friend, Tim Rossner, who lived two houses down from me, deliberately broke my wrist during a mandatory

RIVERDALE HIGH SCHOOL KIDS SNEAK A SMOKE IN THE BACK HALL, 1965.

football scrimmage at school. He told me it was an act of mercy. I was relieved not to have to compete anymore in a game I hated beyond belief. To compound my problems, I was an underachieving student. History seemed irrelevant and boring. Comprehending math equations, the "null set," decimal points, and six to the eighth power seemed well beyond my meager scholastic abilities.

I desperately needed a skill that would bring me the respect and admiration of my peers, my family, and myself. Photography seemed like an ideal route to improved self-esteem. Having learned how to develop film and print my own negatives (albeit in a very crude manner) at summer camp in 1961, I took over my dad's darkroom and began doing what I had learned by osmosis as a child. My early photos were mainly of classmates in their junior high school activities and my sisters provided a fertile ground for my emerging strategy of posing (and flattering females).

Armed with my dad's old Leica and Rollei cameras, I would photograph at my school on a semiweekly basis. Much to my surprise and delight,

SISTERS JOANNA, LUCY, AND CARLY WERE WILLING SUBJECTS FOR MY CREATIVE ASPIRATIONS IN THE EARLY SIXTIES.

>

MY SISTERS SHARE A MOMENT OF REPOSE ON A SPRING DAY IN RIVERDALE, 1964.

when I brought in a new batch of 8 x 10's I would occasionally become the center of attention. I was being noticed — not as an underdeveloped and underachieving middle school geek, but as someone who brought photos into class that could entertain and impress. "Simple Simon" eventually became "Shutterbug Simon."

My mother took note of my budding enthusiasm and skill, and encouraged me by providing all the darkroom paper and chemicals I needed. Mom also gave invaluable suggestions about lighting, composition, and subject matter. She had become involved with local Riverdale charities (such as mental health, civil rights, and legalized abortion), and I began selling my pictures of these charity events and demonstrations to our local newspaper, the *Riverdale Press*.

By the time I was fourteen, it was clear that my extracurricular activities were compromising my studies. I was thus switched from the academically competitive and slightly mean-spirited Fieldston School to the more creatively oriented Riverdale Country School. It was an all-boys school with a rather restrictive dress code and a formal social structure, but one that also supported the expression of individual interests. I was encouraged to bring my camera to class to shoot for the monthly school newspaper and the high school yearbook. I even started a camera club and put out an occasional mimeographed magazine called *R.C.S. Camera*. I was founder and editor, and would plead with fellow students to submit articles and photographs. The teachers gave me passing grades in exchange for my creative diversions, or so it seemed.

A big breakthrough in my early career was an article I wrote for *Popular Photography,* part of an ongoing series called "The Pleasures of Photography." I got the gig through a well-known photographer and colleague of my father's, Philippe Halsman, who recommended me to the magazine's editor, Bruce Downs. I can remember my obsessive interest in this magazine ("Hey, Mom, did the new issue come yet? Oh, no? Could you drive me to the newsstand to get it?") and how thrilled I was to be able to write something for such a renowned publi-

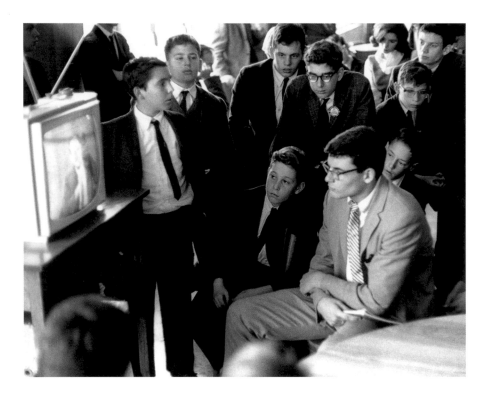

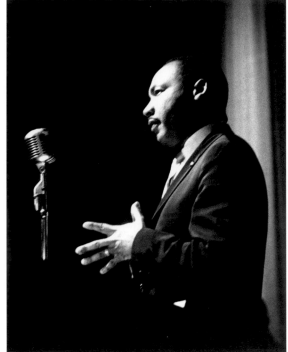

cation. I had trouble deciding how to begin the piece. My mom suggested, "Pretend you are writing me a letter, say from camp." And off I went. . . .

This article gave me my first entrée into the world of professional creative photography. I ended up conversing with and learning from esteemed photographers, columnists, and contributors of the time such as Norman Rothschild, Cora Wright Kennedy, and Ken Heyman. I even appeared on the television program *To Tell the Truth* to help promote the article. I was the *real* fourteen-year-old photographer who wrote for *Popular Photography*.

My interest in matters outside my immediate world began to expand as I covered news and social events for the *Riverdale Press*. I also took on assignments such as documenting the daily life of underprivileged kids in the South Bronx and an essay on the Hebrew Home for the Aged. Otherwise, I would probably never have realized as early on that there were many whose circumstances in life were far less fortunate than my own.

I became acutely aware of national politics for the first time when John F. Kennedy was campaigning for president in 1960. I followed every news conference and the debates with Nixon, and fell in love with Kennedy's demeanor and grace. Later, during the Cuban missile crisis, I cowered at each jet sound emanating from the heavens, worrying that it was Russia finally deciding to drop the A-bomb. Time to "duck and cover." When Kennedy was assassinated in 1963, the news reached us at school via Walter Cronkite. A large TV was placed on a cafeteria table, and my classmates gathered around in hushed despair. One of the photos I took during that painful two-hour period — a glance at the shocked and riveted expressions of my schoolmates as they absorbed the news — stands out in my mind as a milestone. The assassination left an empty space in all of us, as JFK was a role model and a pioneering hero who seemed to speak our language (at last!).

In 1964 Robert F. Kennedy came to Riverdale during his Senate campaign. Being cordoned off with all the other press photographers and competing

CLASSMATES AT RIVERDALE COUNTRY SCHOOL STARE IN STUNNED
DISBELIEF AS WALTER CRONKITE ANNOUNCES THE DEATH OF
JOHN F. KENNEDY, NOVEMBER 22, 1963.

MARTIN LUTHER KING JR. LECTURES AT RIVERDALE SCHOOL, 1964.

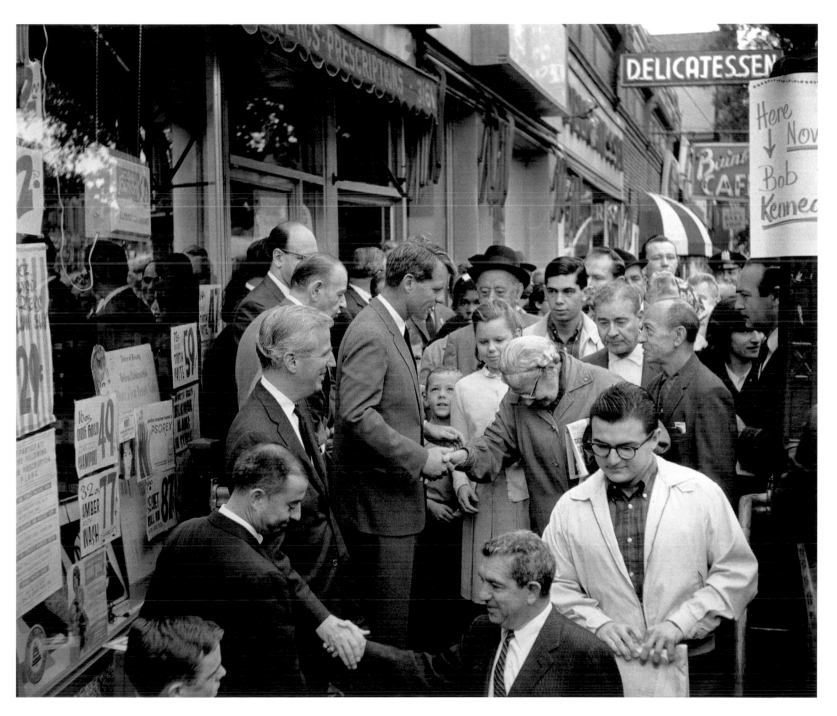

ROBERT F. KENNEDY CAMPAIGNING ON JOHNSON AVENUE IN RIVERDALE, 1964.

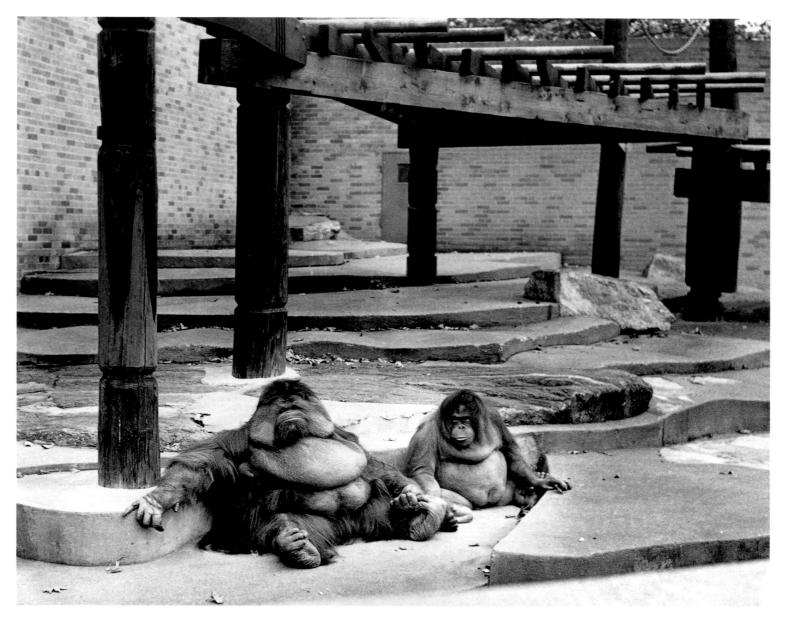

MR. AND MRS. ORANGUTAN AT HOME, THE BRONX ZOO, 1963. I WON A SCHOLASTIC FIRST PRIZE FROM KODAK FOR THIS SHOT.

for a good camera angle was a learning experience, to say the least.

But all my interest in photography and world events didn't completely camouflage other aspects of a painful adolescence. I had become quite attached (in a heightened, sibling sense) to my older sister Carly. We shared so much: music,

humor, friends, gossip, and general creative juices. Then suddenly she was off to Sarah Lawrence College and on to Europe with a new boyfriend, Nick Delbanco. I felt abandoned. My mother's lover, Ron, was in and out of the house, and I detected an underlying tension between them.

My testosterone started kicking in during

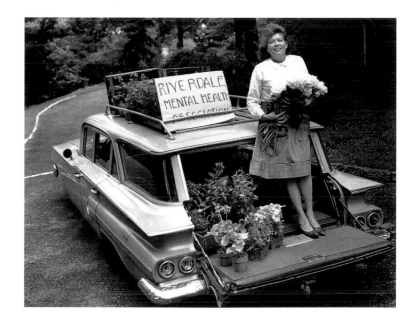

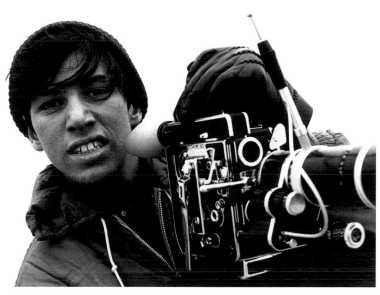

MY MOTHER, ALWAYS AWARE OF HER CIVIC DUTIES, RAISING MONEY SELLING FLOWERS FOR THE RIVERDALE MENTAL HEALTH ASSOCIATION, 1963.

RAY PENSO, HIGH SCHOOL MENTOR, INSPIRES THE CREATIVE SPARK, 1964.

tenth and eleventh grades. While some of my classmates started dating and making out with girls, I was too insecure to be aggressive on that front. While they dated, I sublimated in the darkroom. I eventually turned my attention to a friend, Ray Penso, who shared my artistic sensibility and creative passions. He inspired me to be less involved with meaningless photos of boring school activities and speakers at podiums, and to go out and shoot the hard life, as it really was, on the mean streets. He showed me masterful books by Cartier-Bresson, Robert Frank, and Harry Callahan. He said, "Pete, these are your mentors. Go out and update their work. Make a statement. Your camera can be a vehicle for social commentary and change."

Inspired I was, but intimidated as well. How could I possibly follow in the footsteps of these geniuses? Ray and I had a close relationship that I cherish to this day. Only recently did I learn that he had died of AIDS. Little did he know how he helped me through those awkward years.

I somehow graduated from Riverdale in 1965. I didn't have a date for the senior prom, but my photographs hung prominently on the corridor wall leading to the school's dining room. I had gained the respect of my classmates and teachers. And I had managed to get accepted to Boston University — a major triumph, considering my academic record.

COLLEGE FRIENDS "PASS IT ON" DURING ONE OF OUR MANY AFTER-SCHOOL GATHERINGS, BOSTON, 1968.

College Daze

1965–1969

I entered Boston University an overwhelmed, under-achieving, and insecure teenager. I graduated four years later as a fully blossomed, trippy, curly-haired hippie, a BMOC, ready and wishing to change the world. That metamorphosis was fascinating for me, and universal for almost any college student who participated during those tumultuous times. The personal and cultural changes came swiftly and without warning. All we could do, as a nation of undergrads, was to wing it, prompted by our intuitions and aggravations.

My mother and Ron drove me and my miscellaneous belongings to Boston on September 8, 1965. I was finally leaving the confines of home — "bye-bye." I had never been to Boston. The highways and oddly named avenues were a confusing maze. We got lost, went too far south, and spent the night before my day of freshman orientation in a satellite hotel in Braintree. What a curious name for a suburb, I thought. Taking a bath in our room, I heard Dylan's "Positively 4th Street" for the first time. Hey — Boston couldn't be all that uptight, I thought. At least WBZ radio was hip.

The next morning we drove into Boston, making our way to Myles Standish Hall in Kenmore Square. Up to the eighth floor we went, with suitcases, a small color TV, a makeshift stereo, a gaggle of family photos to tape on the empty walls, a type-writer, and a few books, mostly novels like *The Catcher in the Rye* and *Of Mice and Men*. And the records — Sinatra, Beethoven, the Beatles, Peter, Paul and Mary, and the Simon Sisters — all reminders of my life now past, a security blanket of sorts.

As my mom and I said our good-byes, she started to cry, right there in the lobby of the dorm. Why? I asked. She said it was hard to cut the cord. Only years later did she admit the real reason: The dorm room was totally depressing and my room-mates seemed like total fools. She felt sorry for me.

That first semester *was* pathetic. Classmates avoided me. Roommates made fun of me. I had made it my goal to eventually become photo editor of the *Boston University News* and the yearbook. But the first night I ventured to the *BU News*, they gave me a depressing assignment to photograph freshmen at some fraternity hazing event. And the chief photographer started bragging about how many times (seven) he had had intercourse the night before. I was still a virgin. I felt on the outside, seeking a way in.

Sexual and identity insecurities aside, I also felt overwhelmed by the sheer magnitude of BU. The campus was sprawled along nearly twenty city blocks of Commonwealth Avenue, hardly the quaint suburban landscape of my adolescence. Any freshman kid has his moments of despair, but mine

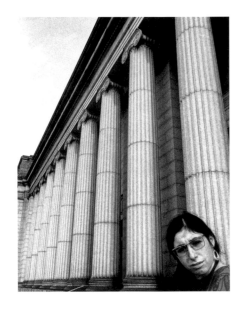

seemed magnified. I began keeping a daily journal as a way to vent my loneliness. A typical entry, dated October 23, 1965, went like this:

Stark cold lights sneer down at me, emitting possibly poisonous, dart-like rays that splatter like cold steel upon the geometric buildings which abound. Don't look up for fear that they will take away my visions. Don't look ahead, just flow along with the tidal masses of humanity. Don't look down for fear of being melted into a faceless oblivion. There are just bundles of uninspired professors who surround me, push and pull me, thwart my creativity, carve me into conformity. And what about what I'm supposedly learning? Hardly anything worth remembering for later living. There are fragmented conversations, various doors to open or shut, anonymous corridors of human quicksand. What are we all doing here? Is there any future? What forces have brought me to this hideous, unflinching, and unfeeling state of anonymity? Who am I behind this mask of eyes, ears, nose, hair, arms and legs, a curved back and useless penis? Will I somehow survive this factory, not swirled and blended in a Waring mixer into a meaningless organism?

My three roommates made fun of me because to them I was some stuck-up, rich Jewish kid who seemed gay — not a particularly attractive resumé. We did play a lot of cards, hearts to be exact, and watched the World Series together that fall. But that was it. The rest of the time I hid in my room, watched TV, wrote in my journal, listened to music, and studied a bit. I brought my camera with me wherever I could. As in my junior high school years, photography was my only salvation. It was teenage angst to the max.

I did manage to make a few friends, mostly in my photojournalism class. One of the emerging photographers, Ed Rozzo, had a lovely girlfriend named Kristin, who hailed from Pennsylvania. She had chiseled features and a loving smile. During a moment of emotional candor, I told her that I had never had a girlfriend and felt incredibly horny. She sweetly said, "Then you've got to meet my sister Karen. She's only sixteen, but you'll love her. She's ready to meet a nice boy like you."

Over Christmas vacation, Kristin, Ed, and I drove down to the little mill town of Spring Grove, Pennsylvania, to meet the object of my fantasy. The open, rolling hills of Pennsylvania's patchworked landscape intrigued me. During our trip I must have stopped the car ten times to pop out for a shot. All the lonely barnyards, where did they all come from?

Karen did not disappoint. She was tall, thin, and blond, with major cheekbones framing her Northern European features. There was a shy humility to her smile, and her personality somehow mixed a sophisticated wit with a simple sweetness and charm. She wore White Shoulders perfume, the same one my mother had worn during my childhood. Karen was extremely affectionate and very sexy. I was hooked immediately. The Beatles' *Rubber Soul* had just been released, and songs like "Norwegian Wood," "Girl," and "In My Life" are forever woven into the tapestry of the first night I ever felt I could be falling in love.

A month and a half later, Karen took a trip to Boston to "visit her sister." We connected on all levels, and she became the first love of my life. I would parade arm in arm with her around campus like a proud peacock for all to see, especially my detractors. She elicited oohs, aahs, and whistles from strangers passing by. Deep down, I wondered what such a gorgeous bombshell was doing with the

geeky likes of me. But my self-esteem skyrocketed, and I was no longer an object of derision but rather of what appeared to be envy. And Karen obviously loved the adoration and attention.

My sophomore year revolved around Karen. No longer did I mind BU. I was appointed photo editor of the *BU News*. I made friends and influenced people. Karen and I missed each other, but we wrote long, passionate letters nearly every day, and the Spring Grove, Pennsylvania, phone connection became an expensive hotline. We made up a secret language all our own, odd terms for body parts and sensations, and we incorporated song lyrics of the day into practically every sentence. A typical long-distance dialogue could have gone like this:

> P: *Babe, we've got a groovy kind of love, don't we?*
> K: *Wild thing, I think you move me, but I want to know for sure!*
> P: *Well, they'll be coming to take me away, away, if I don't see you soon. Right now, I see a red door and I want it painted black.*
> K: *Well, when a man loves a woman, what would you expect?*
> P: *Honey, you don't have to worry — we'll be in a world of our own.*
> K: *Well I would not be so all alone, because everybody must get stoned.*

And speaking of getting stoned, my high school pal Ray from Riverdale turned me on to that for the first time during spring break in 1967. Everything changed at once. Driving around Riverdale with Ray that first night I saw colors and details, even in the rusty, neglected handrails of the 242nd Street subway station, that I couldn't believe I'd never noticed before. Songs I usually hated (like "Sunny" by Bobby Hebb) sounded superb over the car's AM radio. Later on I walked into my mother's house and gave her a loving/stoned smile and a big hug. I had never felt so much compassion and appreciation for her before. All past conflicts were forgotten. She said, "Peter, what's gotten into you? You seem so loving." My reply, as Ray started laughing, was, "I'm not sure, but I hope you never find out." That left her speechless.

That spring, Boston seemed to get "turned on" as a college community all at once. Word spread from BU to MIT to Harvard to Radcliffe to Tufts to Brandeis to Boston College to Emerson that there was something in the air.

As the tulip blossoms adorned the Boston Public Garden, newly awakened hippies converged for afternoons of be-ins and love-ins. Joints were freely exchanged between total strangers. There was a certain innocence, wide-eyed enthusiasm, and mutual trust of one another, as if we were all in this groovy thing together, but we didn't know quite what it was just yet. But it was a blast!

College buddies of mine were either "straight" or "stoned." The straight ones seemed boring and pathetically constipated. The stoned ones were endlessly fascinating, loving, and enlightened — they saw the big picture. I lost a few straight friends along the way.

The Summer of Love started off on a good note when *Sgt. Pepper's Lonely Hearts Club Band* was released to great fanfare and expectation. It had its official worldwide premiere over radio station

WNEW in New York. I used the occasion to light a joint and get into the bathtub, bathed by afternoon June light filtered through newly greened leaves and a pastel window shade. I lay still for the entire album. The last chord of "A Day in the Life" stayed with me for days. The music transported me. The Beatles were ushering in a new era. Some of it was beyond my comprehension (LSD visions and yogi visitations), but I wanted to be a part of it. I wanted to meet George Harrison. I wanted to know "The Word." Music had become my religion.

That summer of 1967, I traveled with a bubble-gum rock group, Every Mother's Son, as the tour photographer (a fairly dubious distinction, considering they were destined to become a one-hit wonder with "Come on Down to My Boat"). We hit mostly West Coast cities like San Francisco (where they participated in a rock festival at Mount Tamalpais), Portland, Seattle, and Vancouver. I got to see the girls with the flowers in their hair, Haight-Ashbury in action, and tie-dyed T-shirts. The smells of incense mixed with patchouli oil wafted about, and maybe fifteen people all hugged at once somewhere and everywhere. I was too high at times to even bother with the camera.

In the fall of 1967, the BU campus became a prime-time host for the counterculture. We were one of the first colleges to have a "radical" news-

paper. The *BU News,* inspired by its brave editor in chief, Raymond Mungo, became a vehicle for political and social change in Boston, if not on the entire East Coast. Ray organized rallies against Vietnam and ROTC recruiting on campus, pro-pot smoke-ins, and sit-ins to prevent Dow Chemical (makers of weapons of war) representatives from holding recruitment meetings with students, and gave voice to abortion advocate Bill Baird, all with his brilliant editorials. When Ray called for the impeachment of Lyndon Johnson for promoting war crimes in Vietnam, the BU administrators tried to quiet down our leftist rag. It didn't work. What the Beatles were musically, Ray was politically. A small, skinny guy, he was a chain-smoker and sucked down dozens of coffees daily. I never could figure out where he got his inspiration and dedication — but wow, could he write! His charismatic humor, exaggerated mannerisms, and worldly inflections were outrageously contagious. He was able to transform our campus from a somewhat mindless muddle to a potent political force. A journal entry of mine from May 22, 1968, proclaims that

Raymond "Pisspot" Pinko Mungo has the grand effect on me to (1) liberate my mind, (2) encourage me to do great work and effect change through imagery, (3) free me from simple hang-ups

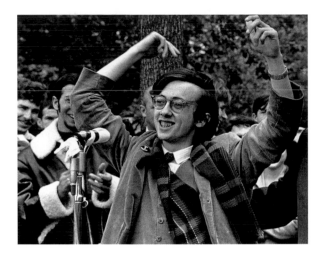

<

FROM FAR LEFT:

BOSTON "BE-IN," BOSTON COMMON, 1968.

A GROOVY THING GOIN', ALLSTON, MASSACHUSETTS, 1968.

LOVE–IN, HUG–IN, CENTRAL PARK, NEW YORK CITY, 1969.

RAY MUNGO GIVES A RALLYING SPEECH ON BOSTON COMMON,
OCTOBER 1968.

BELOW:

HOORAY, HOORAY, LBJ DROPPED OUT TODAY, MARCH 31, 1968.

and worries about mundane details. Ray's mind is incredibly original and amazingly uncluttered by ruinous, distracting, petty jealous thoughts. He is free, natural, precise, witty, and appreciative. We should get married. But he snores and has smelly shoes. Oh well, life can't always be perfect.

With a sparse budget funded by the indulgence of our well-heeled parents, a group of reporters, art directors, photographers, political advisers, and "nubile chickies" (our arrogant, pre–women's liberation term for our coterie of news semigroupies) would travel to New York City, D.C., and points in between to cover every demo we found worthy. There was the draft card turn-in at Boston's Arlington Street Church (not without some trepidation, I turned in mine; my mother wasn't pleased when I told her an FBI agent had paid me a call); the "resistance" rally on Boston Common on April 3 ("1,200 showed, 249 turned in cards," my journal reports); the spring 1968 antiwar rally at the United Nations; and solidarity day in Washington, to raise consciousness about civil rights (after which I returned to my car to discover all my stereo equipment stolen).

I was asked to cover the race riots in Roxbury caused by the Martin Luther King assassination for *Time* magazine. I was honored to be asked but politely declined. I was too much of a coward,

afraid of being one of those photojournalists killed in the line of fire. For a hundred dollars, the risk didn't seem worth it.

Then there was the spontaneous outpouring of student revelry the night in March 1968 that LBJ announced his decision not to run for reelection. My journal caught the vibe:

Hooray hooray. Celebrations. Spontaneous rally on Comm. Ave. I was lucky to find it and participate within it. Say a prayer to the unknown soldier, the war is over! We actually can change the world! Optimism's overflowin', and I think it's gonna rain today.

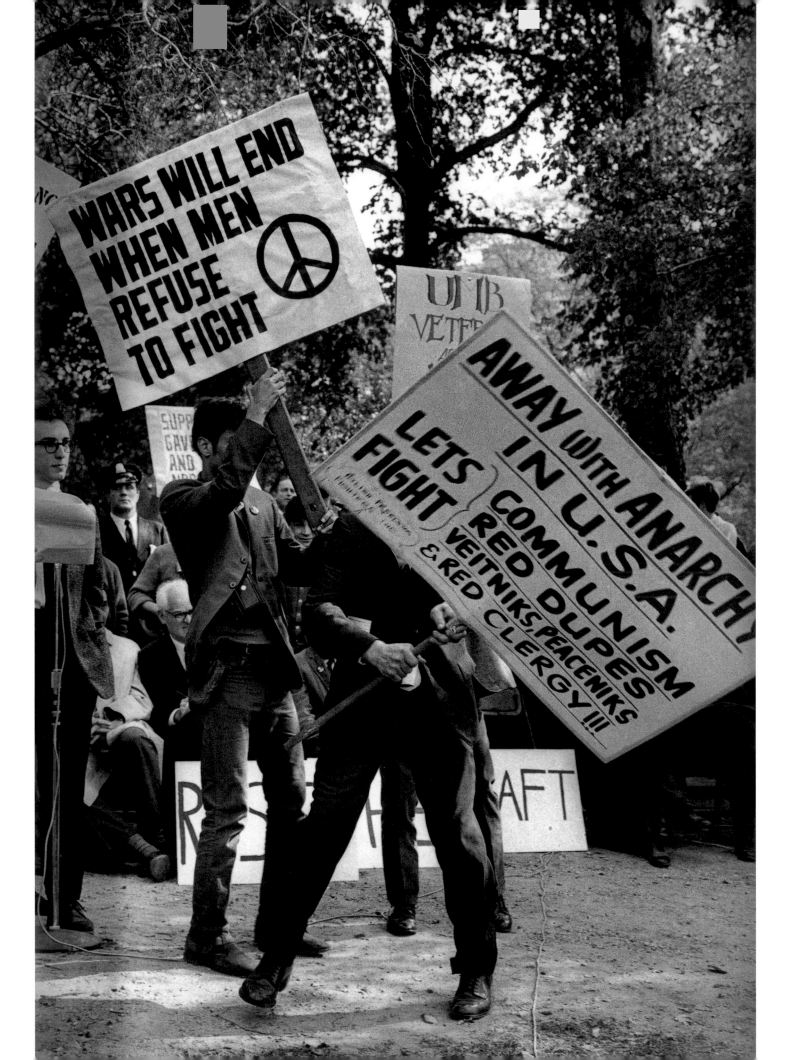

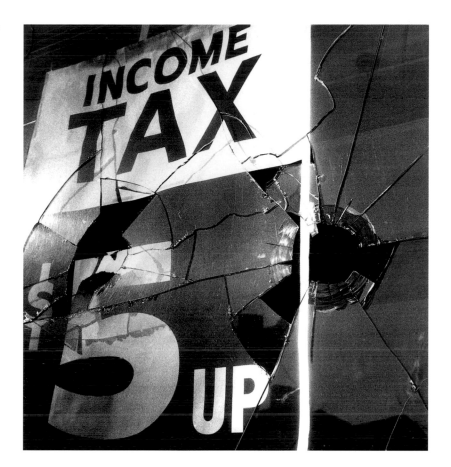

Those were heady days indeed for my budding career and the *BU News*. Our contingent was considered the hipp(ie)est, most committed around. There were all-nighters in the *BU News* darkroom, surrounded by helpers and photography devotees who liked hanging around in the amber light to see what magic would emerge. We would smoke pot all night and listen to newly made music mixes on my reel-to-reel tape machine. Many talented and eventually renowned photographers emerged from the haze. David Doubilet, one of my roommates, became a star for *National Geographic*. So did classmate Cary Wolinsky. Michael Dobo and Jeff Albertson showed their talents in music photography. On the editorial side, Ray Mungo wrote an influential political manifesto, *Famous Long Ago*. Ed Siegel, one of Ray's *News* editor successors, is now in charge of the Arts section of the *Boston Globe*. Clif Garboden is now an editor for the *Phoenix* Newspaper Group in Boston.

Finally, there was Stephen Davis, my closest friend and confidant from the late sixties. He was managing editor of the *BU News* and went on to write many books about music, including his collaboration with me, *Reggae Bloodlines*. Stephen and I wound up sharing an off-campus apartment just over the BU Bridge in Cambridge, and we seemed to go through every phase and phrase together during those crazy years. We saw each other through the highs and lows, shared a million jokes and tokes, and remain close to this day, as we age ever so gracelessly.

My once all-encompassing relationship with Karen became tangled within the tensions of long-distance communications, parental pressure, and changing lifestyles. She attended Syracuse University and we managed to see each other every month or two, when we would try to cram everything into a

quick weekend. It was a slow, painful detachment through laughter and tears. I was going through monumental changes within, but without her. Still, I will always cherish our keepsake of memories and photographs, and be thankful for the love she gave and the love we made. A first love lives forever.

Almost every night our semideranged apartment became a gathering spot for our ever-expanding "fambly" (our term for nonfamily who felt more like real family). Someone would bring some weed, I'd supply the tunes, and Stephen would make sure enough munchies were around. Various women would come and go, some lovers, some not.

One of the focal points of our get-togethers was to watch a weekly television program on our local PBS affiliate, WGBH. It was called *What's Happening Mr. Silver* and was probably the first hip, countercultural TV show ever produced. Each week

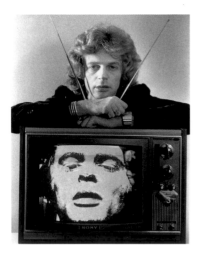

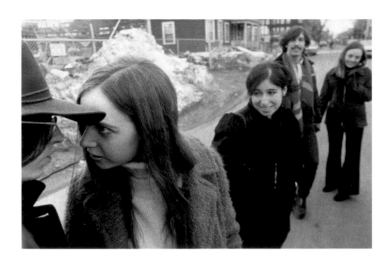

<
DAVID SILVER, "MR. WHAT'S
HAPPENING," IN 1968.

>
"FAMBLY" FRIENDS DAY-
TRIPPING IN CAMBRIDGE,
1969.

host David Silver would combine his quick-witted British quips with bizarre footage of hippie events, political affairs, and promising rock stars like Frank Zappa. He would occasionally just goof on straight behavior by interviewing, without notice, innocent people passing by. I remember him asking an old lady carrying her bag of groceries home if she had ever thought of taking acid. The show was a complete hoot, and used the medium to the utmost. David's long blond curly locks and warm smile could charm anyone. On those Thursday nights at 8:30 sharp we all gathered with pillows on the floor to gaze at and groove on this wizard of odd.

I wanted to meet Mr. Silver in a big way. Maybe not as much as I wanted to meet George Harrison, but a lot. I got my shot the night he had Ray Mungo, a disc jockey from the trendsetting new FM rock station WBCN (till then only Top 40 had ruled in Boston), and the publisher of *Boston After Dark,* the local youth-culture tabloid, on the show. The subject was "the media" and how we could send out "the message." Stephen Davis was writing an article about the groundbreaking show for the *BU News,* and I went along to shoot the photos. Every once in a while during a guest's earnest rap, Silver would suddenly have the producer make the speaker's face melt into a sea of solarized colors and give repeating delay to his voice. This unnerved the well-

spoken panel no end, and resulted in a totally spontaneous, trippy show that gave deeper meaning to the phrase "the medium is the message." In the case of *What's Happening Mr. Silver,* the phrase was brought to life. Stephen and I just looked at each other agape.

I became a Silver minigroupie. He was the first TV personality I had ever met, or wanted to meet. As I got to know the man behind the screen, I picked up on how his creative juices just would flow, without restraint. His sense of timing and useful experimentation amazed me. Our paths have been entwined ever since. I would still watch that show if it were on today.

My senior year at BU was marked by much better grades (I was finally studying subjects that actually interested me — film, photography, broadcasting, and creative writing). My freelance photo career began to blossom, with magazine assignments from *Life, Rolling Stone,* the *Atlantic Monthly,* and the *Village Voice,* and I fell in love with an irresistible sophomore named Lacey Mason. We moved in together, my first experience at coupledom. Obviously we were too young to raise our own family; instead, we became part of a neighborhood "fambly." There were about eight other student houses that dotted a small five-block radius in Cambridgeport, the part of Cambridge nearest BU. The land-

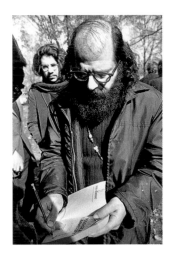

lords there seemed to think BU kids were an acceptable risk. Stephen Davis and his girlfriend, Jude, lived downstairs. Harry Saxman was across the street. Eddie Siegel lived around the corner. My childhood friend Tim Rossner, who had attended NYU but switched to BU, moved in down the block with a *BU News* cohort named Elliot Blinder. Bonnie Fisher, an old girlfriend of Ray's and a fellow photographer and Otis Redding lover, moved three blocks away. Then Jeff Albertson, with his girlfriend, Dodie, found a place nearby. We all had our separate lives, but we gossiped and partied and shared our deepest thoughts and revelations.

Our "fambly" survived another year or so after I graduated, but most of us then wended our ways to parts unknown. Some of us are still in touch. The bonds made in college always seem so enduring.

However, the promise of the sixties ended on a few sour notes for me. First there was Nixon's election in the fall of sixty-eight. I dropped acid and prayed with my friends that Humphrey would win. I stared at the colors of the TV reflecting the results on our ceiling. The swirling and twirling going on in my brain did not achieve the desired effect. As I came down from that "bum" trip, I melted to sleep in sheets wet with tears — tears that all we had worked for was seemingly gone. Tears for my friends who were planning to go to Canada to avoid being drafted (I had pretended to be gay and had been disqualified). Tears for the underprivileged and the weak, for whom Republicans showed little compassion. And tears that I'd have to look at that ugly, crooked face and tight-lipped, phony "smile" (sneer and smile) for at least four years.

Another sour note was the antiwar Moratorium in Washington, D.C., on November 16, 1969 (where I took my best photograph of that era, hoisted high on some scary scaffolding, of the Washington Monument beneath a red-filtered, cloud-dotted sky). A coterie of college mates and journalists went to the demonstration to cover it and to show unity and strength in numbers. I was always one for political change, but not through the militant radical tactics I first witnessed in Chicago during the 1968 convention and saw again that day. I hated blood and violence. Making war to stop war made no sense to me. Although my photos were good, my feelings were not. Reflections from my journal entry, November 16, 1969:

The effect of yesterday's demo was a large one. It split "the movement," at least in my own head. There is the militant faction (which was manifested by cop brutality, tear gas, and screams at Dupont Circle) and the more moderate "give peace a chance" group. I fit myself (and most of my friends, I'm glad to say) somewhere in the middle: frustrated with working within the system,

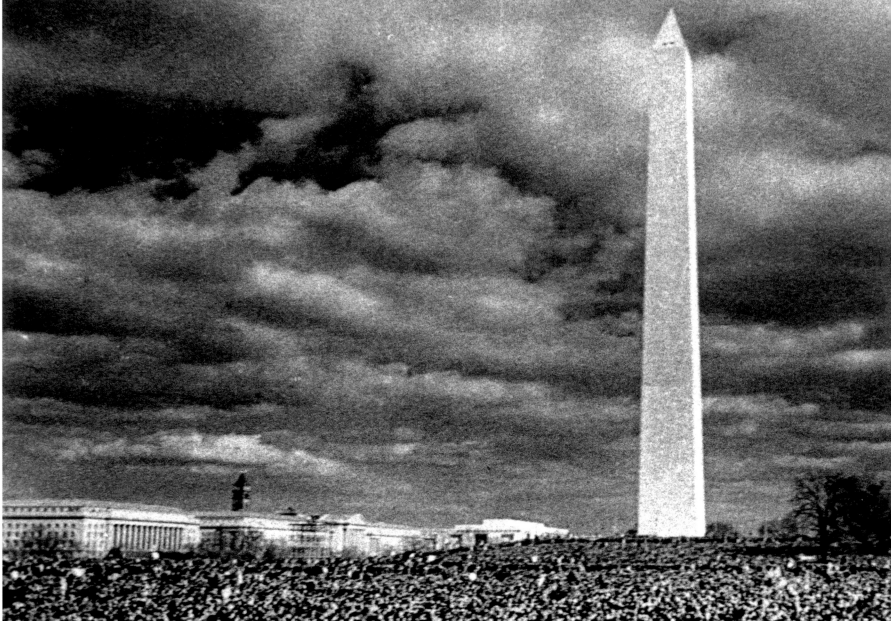

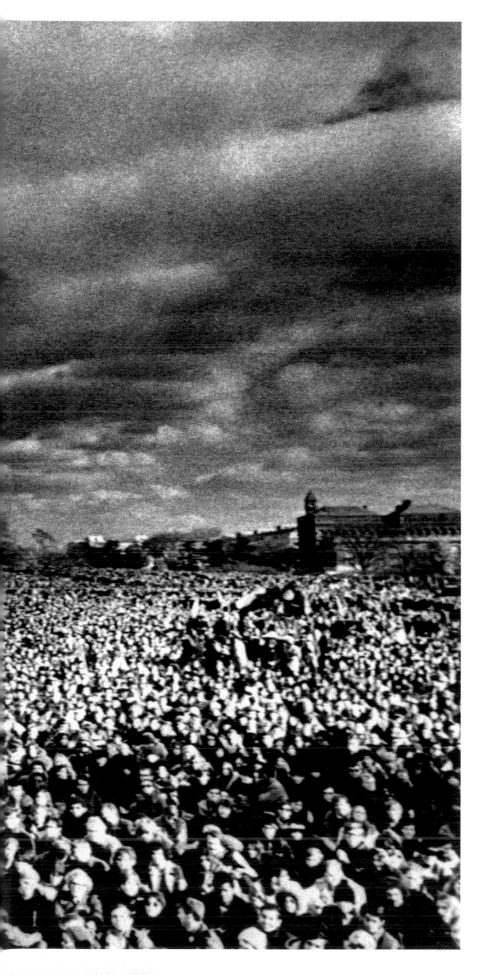

and yet awed and scared to suffer the consequences of being militant. Jumping Jack Flash is not a tear gas stoned blast. The almighty pigs have it all over us. They could have done us all in had they but tried. Merely ten tear gas grenades and we all fled in panic — even the Weathermen, who knew which way the wind would blow it. Those toughie radicals were obnoxious anyway. I wouldn't want to throw rocks at windows, man. I mean Christ, the whole radical group is being stupid by alienating us freaks, i.e., the middle-class, slightly independently wealthy kids whose parents have somewhat supported us, thus we have the time to put into this so-called movement. Yes, there's a lot at stake. It would be a wildly different scene if the radicals actually took over the government. But ain't it clear that they can't? And if they did, I wouldn't be loyal to Abbie Hoffman anyway.

And finally, there was Altamont. A free concert with the Stones and the Jefferson Airplane, icons of our changing culture, ruined by Hells Angels causing violence and death. I, thankfully, didn't attend. But the episode came as a shock. How could this happen to "us"?

. . .

My college years saw me go through so many changes so quickly that I'm astounded I even managed to graduate, with a B average no less. The changes were exciting and powerful, but dizzying. If nothing else I made wonderful friends, captured some historic images, learned much about love and life, and kept all this stuff near to my soul.

MY MOST DRAMATIC ANTIWAR PHOTO, WASHINGTON, D.C., NOVEMBER 1969.

ROBERT MCNAMARA CONFRONTED BY
HARVARD STUDENTS IN THE "YARD,"
CAMBRIDGE, 1965. HE WAS CONSIDERED
THE ULTIMATE WARMONGER AT THE TIME.

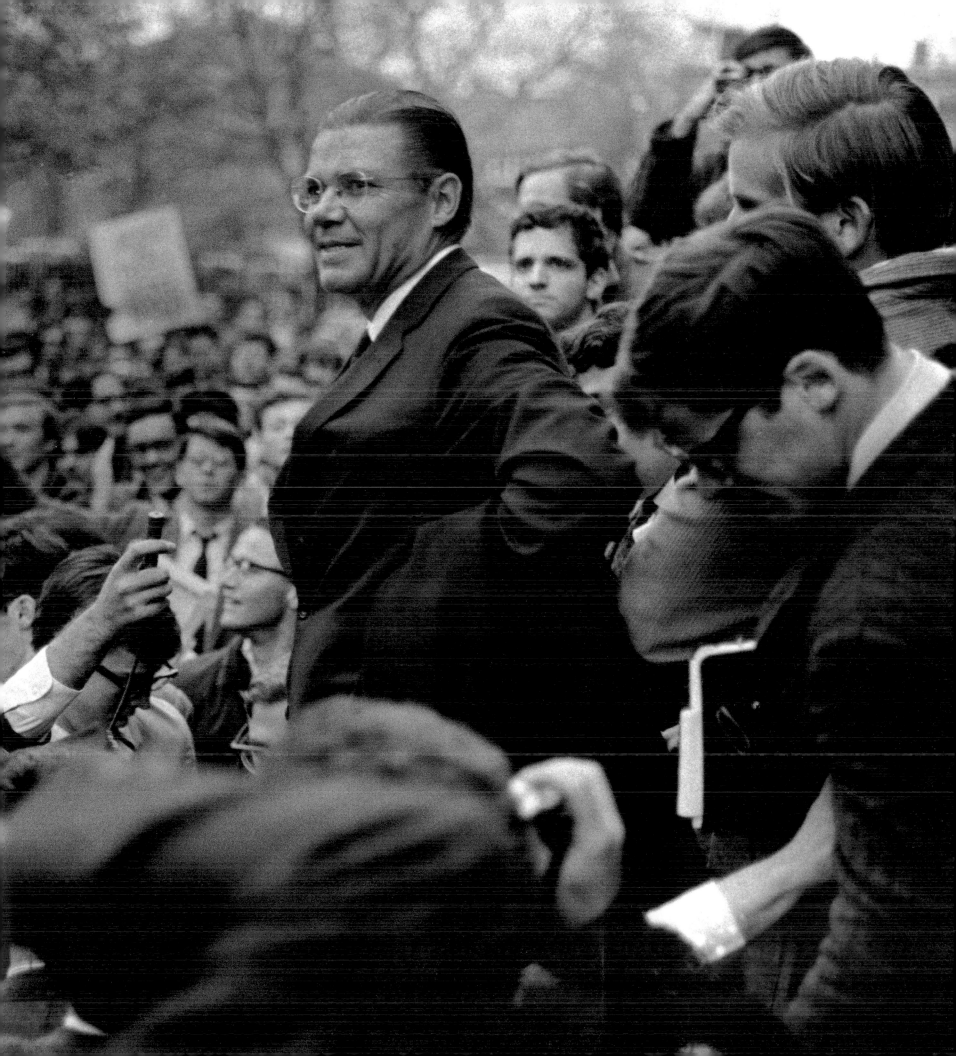

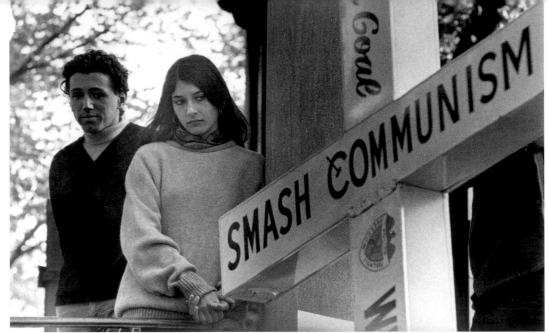

DICK AND MIMI FARINA
AT AN ANTIWAR DEMO IN
BOSTON, 1966.

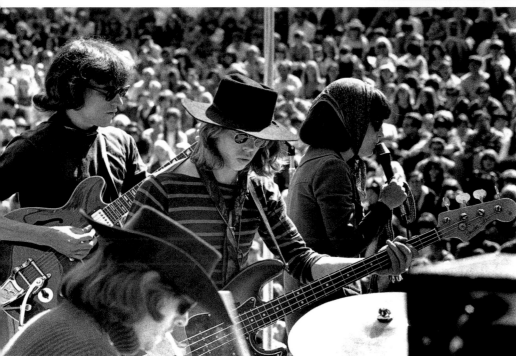

THE JEFFERSON AIRPLANE
AT A MARIN COUNTY ROCK
FESTIVAL, 1966.

>

RICHIE HAVENS PERFORMING AT A
COLLEGE NEWSPAPER CONFERENCE
NEAR BALTIMORE, 1966.

TIME HAS COME TODAY:
THE CHAMBERS BROTHERS
ROCK, BOSTON, 1966.

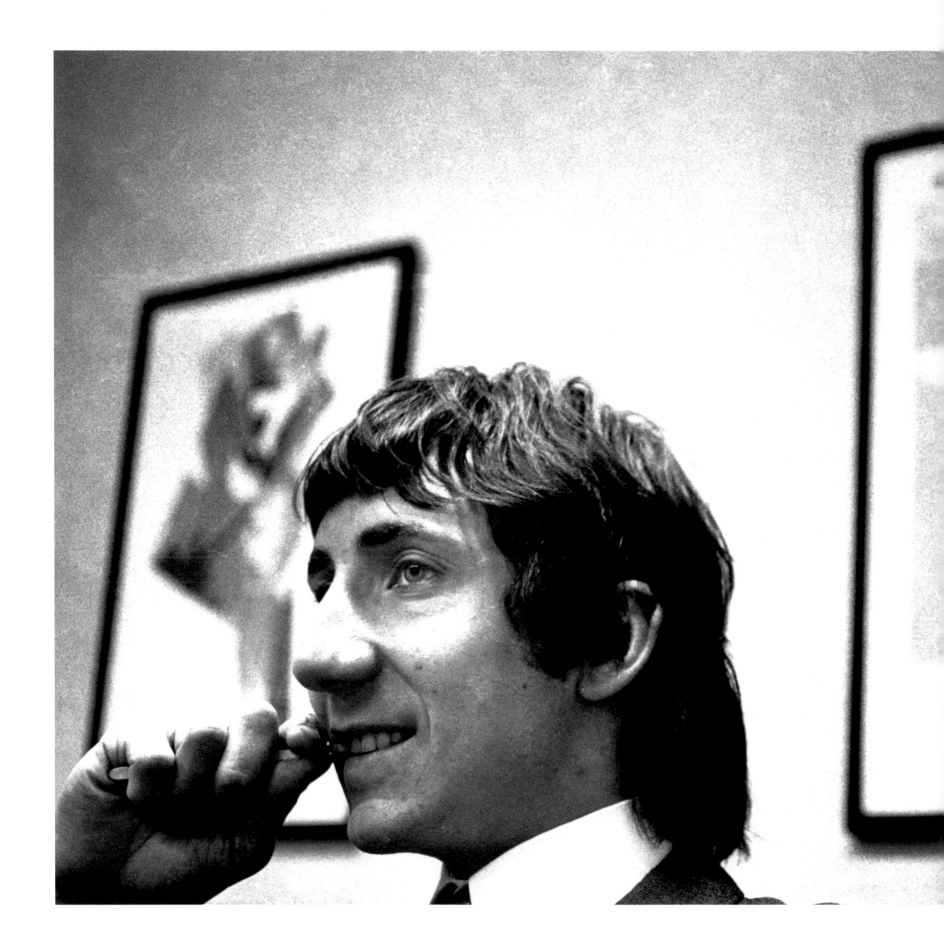

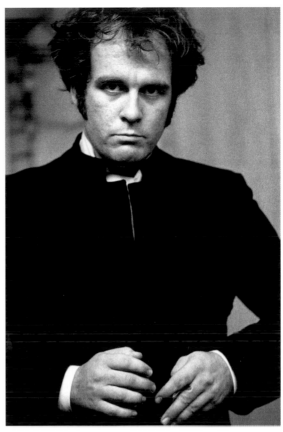

> TIM HARDEN CAPTURED
BACKSTAGE AT CLUB 47
IN CAMBRIDGE, 1967.

< PETE TOWNSHEND DURING
AN INTERVIEW IN A
NEW YORK OFFICE, 1968.

> RAY DAVIES, LEAD SINGER
OF THE KINKS, AT THE
BOSTON TEA PARTY, 1968.

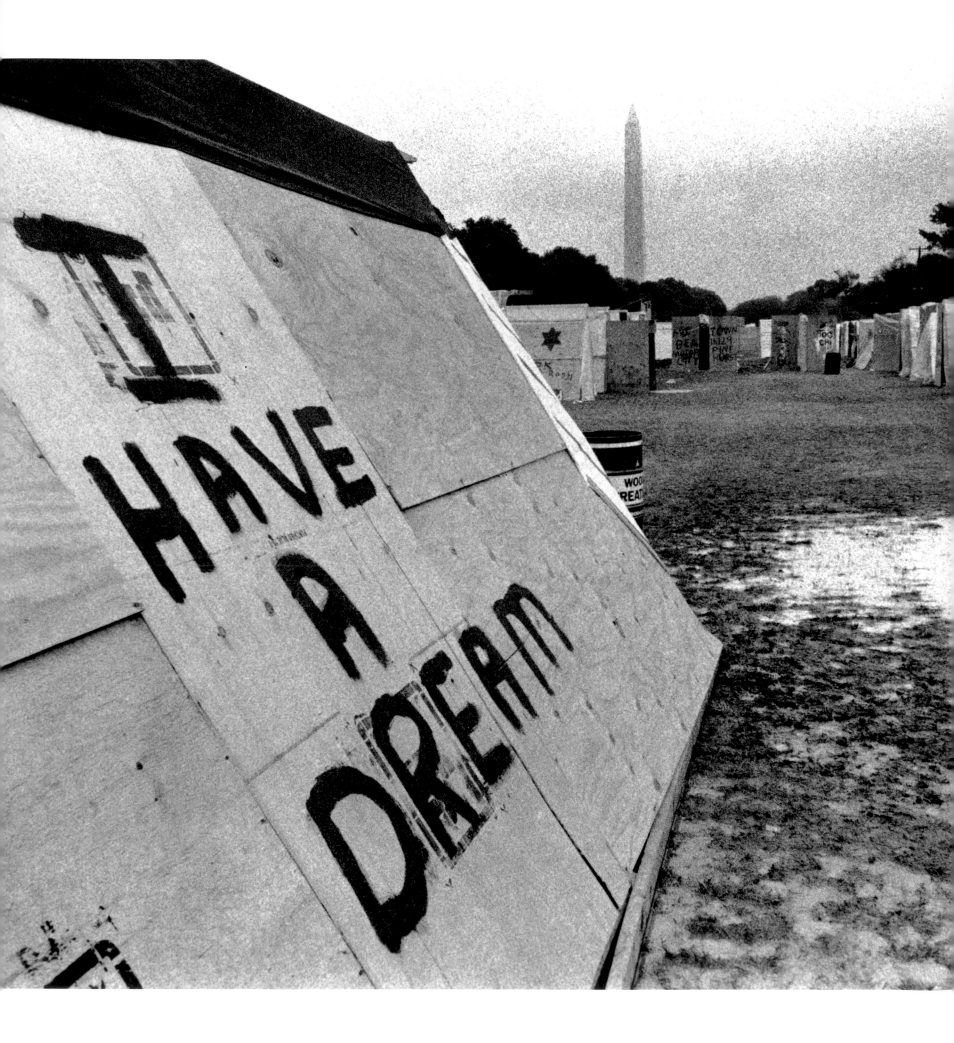

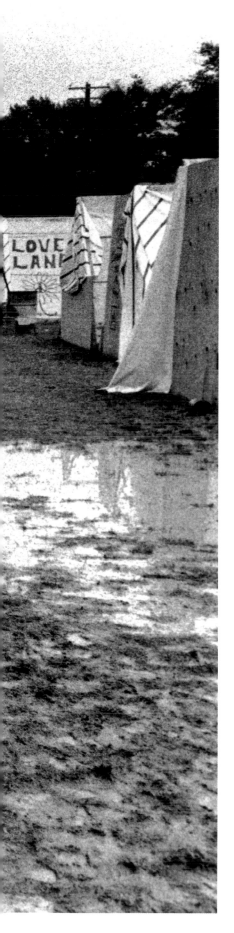

RESURRECTION CITY STAGED AT THE
REFLECTING POND, WASHINGTON, D.C.,
1968. THIS EVENT BROUGHT WORLDWIDE
ATTENTION TO THE GROWING CIVIL
RIGHTS MOVEMENT. I COVERED THIS
HISTORIC HAPPENING FOR RAY MUNGO'S
LIBERATION NEWS SERVICE, THE AP OF
THE UNDERGROUND PRESS.

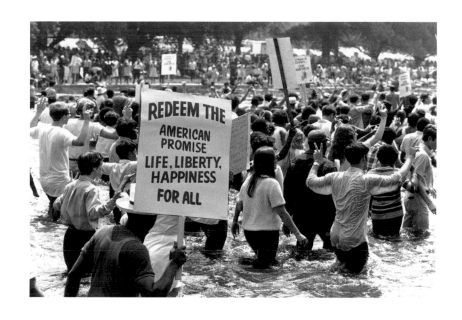

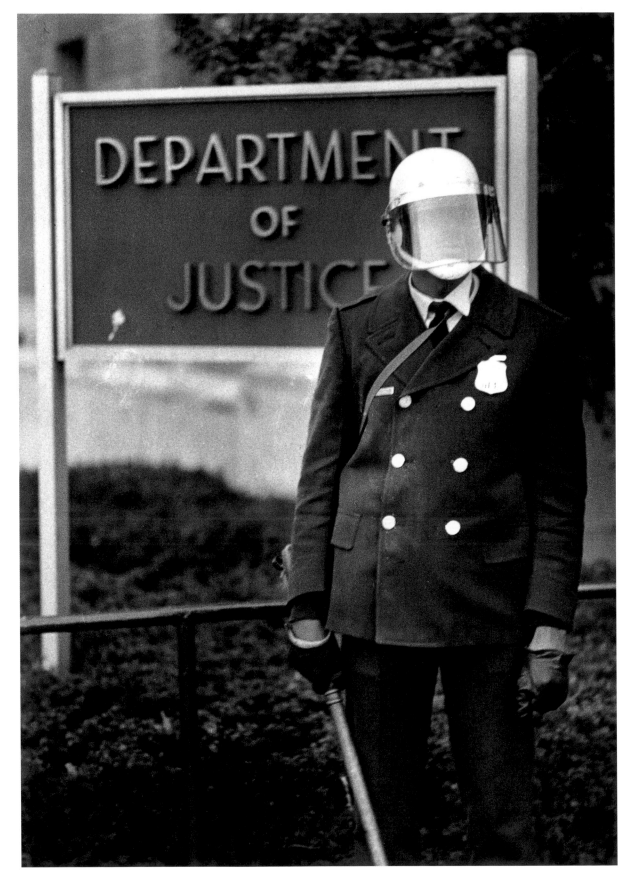

<
WHOSE JUSTICE?

>
A MESSAGE ON THE FIRING LINE.

AN IMAGE OF POLITICAL UNREST,
BOSTON, 1968.

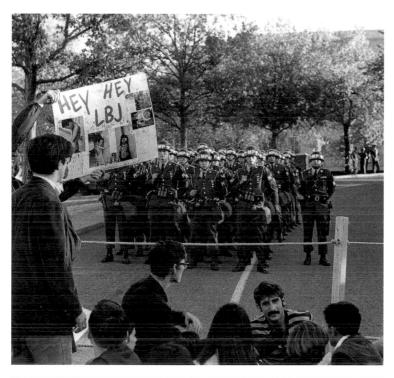

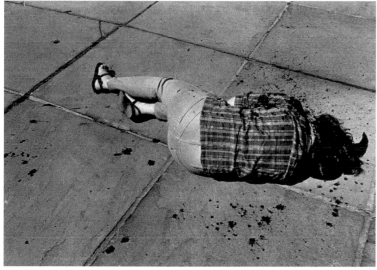

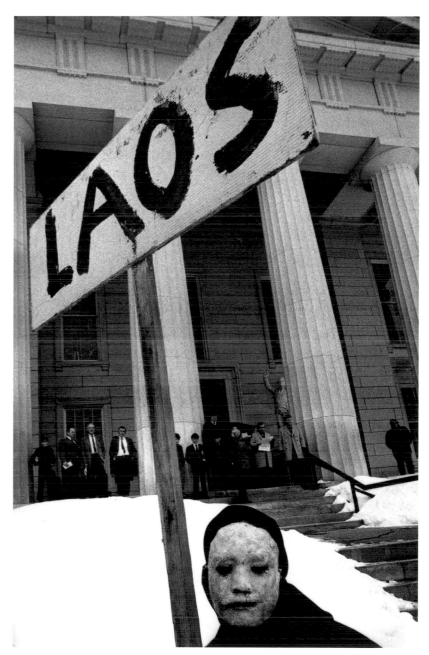

DEMO AT MONTPELIER, VERMONT, 1970.

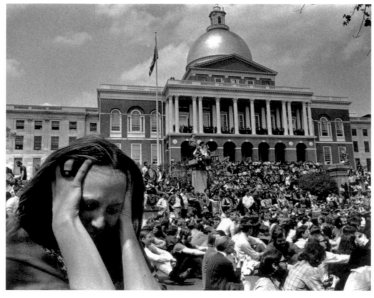
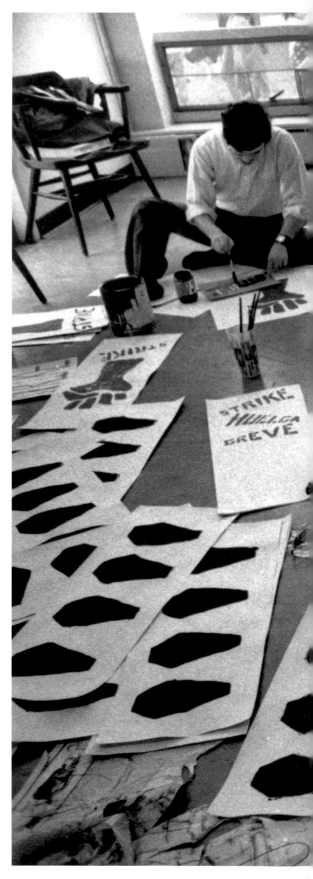

"FOUR DEAD IN OHIO." THE BOSTON/CAMBRIDGE COMMUNITY
REACTS TO THE KENT STATE KILLINGS, MAY 1970.
ABOVE RIGHT: DEMO AT THE MASSACHUSETTS STATE HOUSE.
FAR RIGHT: BU STUDENTS GEAR UP FOR THE STUDENT STRIKE.

FRIEND OR FOE, WHO REALLY KNOWS? BEACON HILL, BOSTON, 1970.

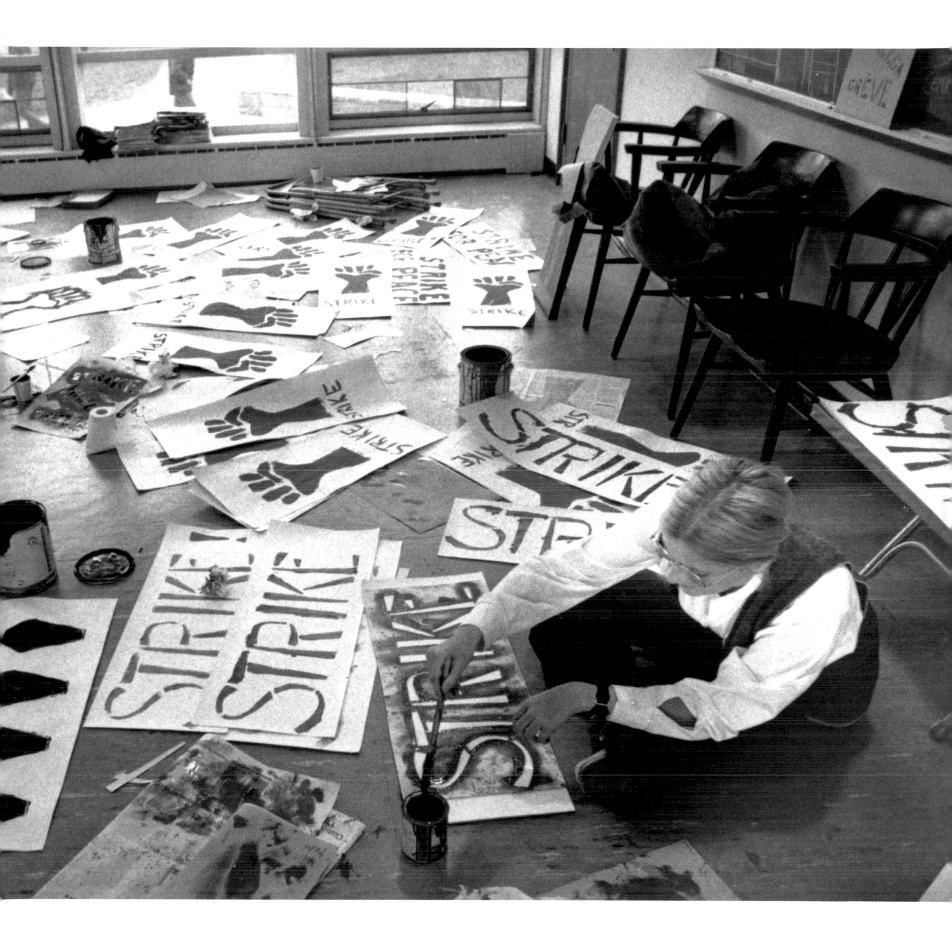

DRAFT CARD "BURN–IN" AT
THE ARLINGTON STREET
CHURCH, BOSTON, 1967.

>

JENNIFER THOMAS, SIXTEEN,
WEARING THE AMERICAN FLAG
FROM HER FATHER'S COFFIN AS
A SHAWL. SHE WAS BEATEN,
ARRESTED, AND CHARGED
WITH DESECRATION OF THE
FLAG, BOSTON, MARCH 1970.
THIS PHOTOGRAPH APPEARED
ON THE FRONT PAGE OF
"ROLLING STONE."

<

GENERATION GAP AT A
COCKTAIL HOUR ON
MARTHA'S VINEYARD, 1969.

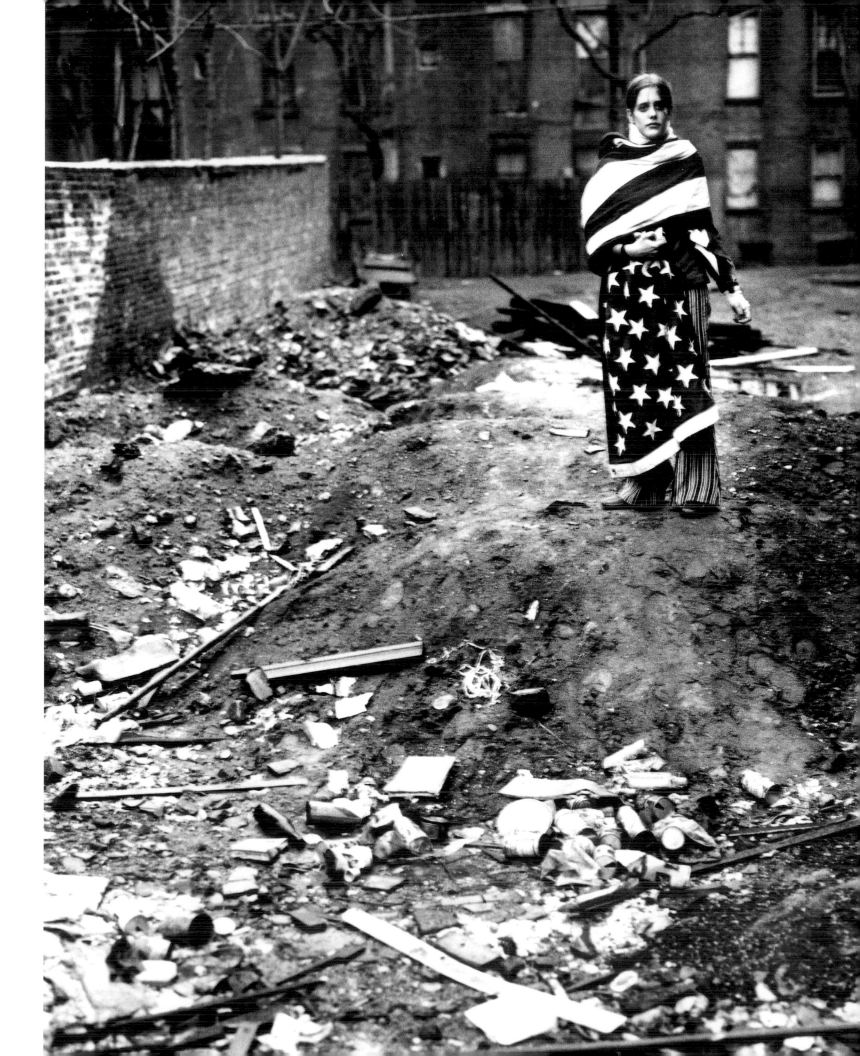

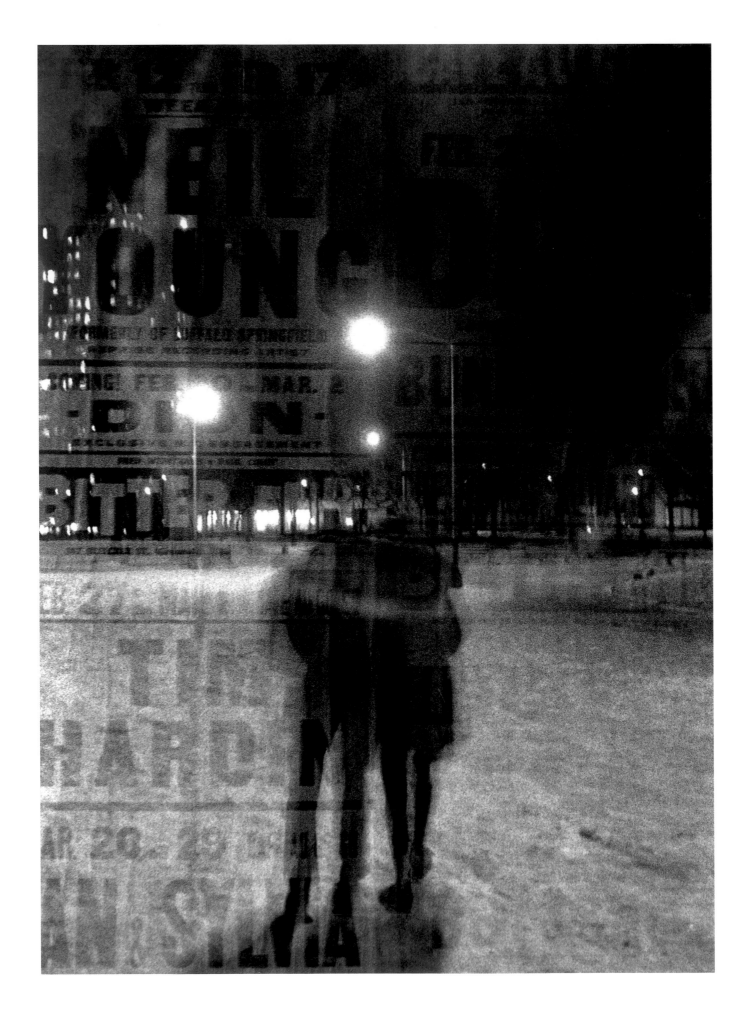

Street Life

1968–1971

I was born in New York City. I loved the brashness and arrogance of the city. Nevertheless, I always felt my true nature was as a naturist — barefoot, smelling the fresh-cut grass and rich soil, admiring the daisies. Eventually, the city became a prison to me, and I constantly needed to escape to the woods or ocean: the metaphors of my life.

During my junior year in college, I celebrated my twenty-first birthday at my sister Joanna's apartment in Sutton Place South, a swanky neighborhood on the Upper East Side of Manhattan. My major gift that night was a brand-new Wollensack reel-to-reel tape recorder. I had gotten into recording music mixes, interviews, and live performances on tape, pretending I was the hip deejay of a make-believe free-form FM radio station. I played these tapes constantly to relieve the boredom of all-nighters in the darkroom of the *BU News*.

As I carried my new toy from my sister's apartment building to my car, parked a few blocks away, three Spanish-speaking thugs approached me. One of them said, "Hey, man, you got the time?" As I started to respond, another one held a knife to my back. I was ordered into the backseat of my old Chevrolet wagon and told not to move or speak, or else. While one held me at knife point, the other two rifled through the car looking for valuables. Since I had taken Spanish in high school,

I could understand them arguing among themselves about what to take and whether to kill me or just tie me up. One suggested that they force me to take off all my clothes so I couldn't immediately go chasing after them; another thought that would take too long.

I eventually blurted out that they should forget all the darkroom chemicals in the back and just take my watch, my wallet, and the new tape machine, and get going before the police spotted them. They agreed with my logic. I stripped as ordered, and they ran down the side street carrying the stolen property and my clothing. In the rearview mirror I observed them dropping the clothes in a nearby gutter. The whole incident seemed like a bizarre movie scene that I was viewing from a seat in the theater.

Once they were out of sight, I got out of the car and started running down the block to fetch my clothes. My birthday is on January 26, and this was not a particularly mild winter. A cop car just happened to pass by. They quickly stopped and proceeded to arrest me for "streaking." As I protested and showed them where my clothes were, they finally took off the handcuffs and allowed me to dress and explain. We went to the nearby precinct station and I reported what had happened. I did my best to describe what the guys had looked like, but it was dark and they had kept my eyes covered most of

A GHOSTLY VIEW FROM A BOSTON BEDROOM.

ing. There were the relentless parking tickets, the long lines at the supermarket checkout, the gloomy days of fog and smog, a constant drone of honking horns and police sirens, the occasional acts of violence that created an overlay of mistrust and fear, and the bored and sullen faces that passed by on the anonymous sidewalks.

Later, when I was actually living in New York full-time, I ended up giving at least ten dollars a day to the homeless, whom I tripped over during my daily routines, or to the "squeegie" types who would scrape my windshield, without invitation, at exits off the West Side Highway. Living on Martha's Vineyard during the summer, I had developed a habit of saying hello to complete strangers as I passed them on the street. On the Vineyard, I'd usually provoke a nice smile or a "How ya doin?" Not so in New York. People avoided me like the plague.

Finally, there was the inherent pressure to move up the ladder of success. It no longer seemed worth the climb. The disparity between the haves and the have-nots was particularly jarring in New York. I was saddened by the emptiness and difficulty of many people's lives.

Since I saw life there from this jaded viewpoint, my photographic images of the city took on a surreal, disjointed quality. I picked up on the alienated "social statement" style of those photographers my high school friend Ray Penso had turned me on to five years earlier and made it my own. I no longer wanted to be part of this reality, nor did I feel I could change the nature of it, but at least I could expose it for what it was through my photographs.

the time. The chief officer told me that I was extremely lucky because it sounded as if these were the same three men who had been killing most of their victims in the area.

This episode fed my growing distaste for the city. I was less and less able to cope with the pace and demands of urban life. New York in particular seemed claustrophobic. Just the mundane day-to-day hassles became overwhelming and dishearten-

MONEY CHANGES EVERYTHING: RIVERDALE, NEW YORK, AND ROXBURY, MASSACHUSETTS, 1968. >

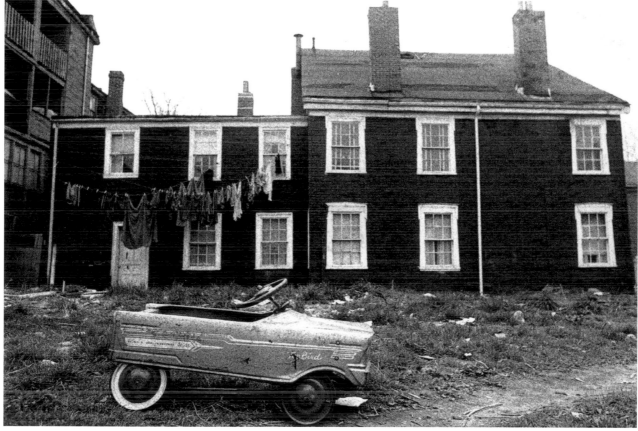

NEWSSTAND MAN, NEW YORK CITY.

AFTER HOURS AT A BOSTON NIGHTCLUB.

SIDEWALK SLICE OF LIFE, YORK, PENNSYLVANIA.

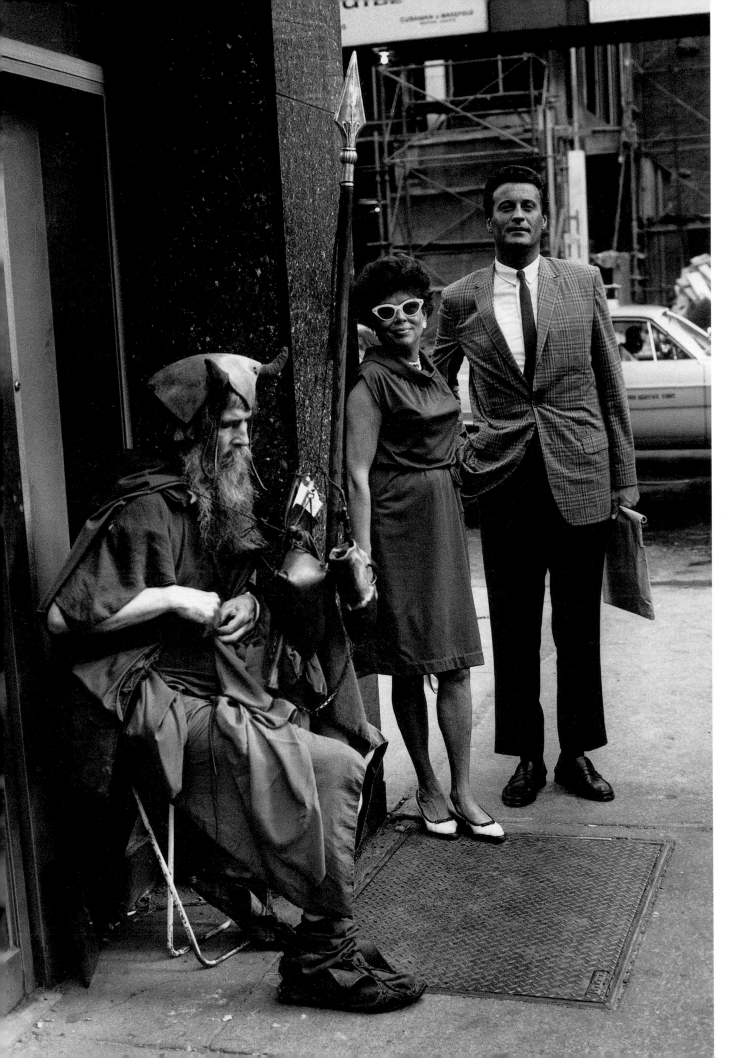

MY MOTHER AND RON
OBSERVE THE
OMNIPRESENT SIDEWALK
VISIONARY "MOONDOG"
OF NEW YORK CITY.

>

ANOTHER DAY IN
PARADISE, BRONX,
NEW YORK.

REFLECTIONS OF THE
WAY LIFE USED TO BE,
NEW YORK CITY.

EVERYDAY PEOPLE,
ALLSTON,
MASSACHUSETTS.

BUS STOP, WET DAY,
SAN FRANCISCO.

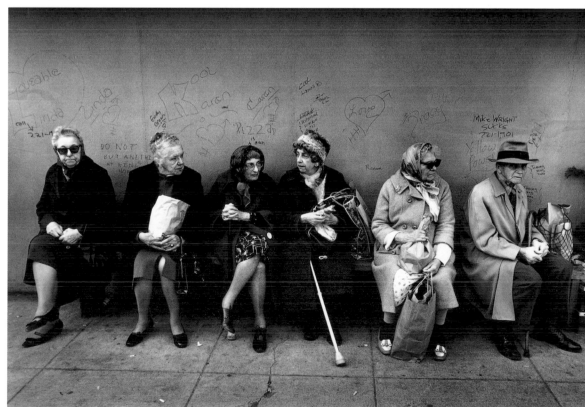

STREET LIFE, 1968–1971 47

SIDEWALK DESPAIR,
PARK STREET, BOSTON.

ON THE INSIDE LOOKING OUT,
ROXBURY, MASSACHUSETTS.

HARVARD SQUARE,
CAMBRIDGE.

A STROLL IN THE BRONX.

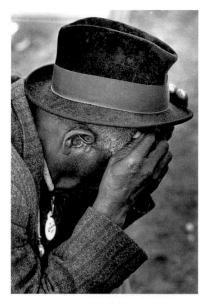

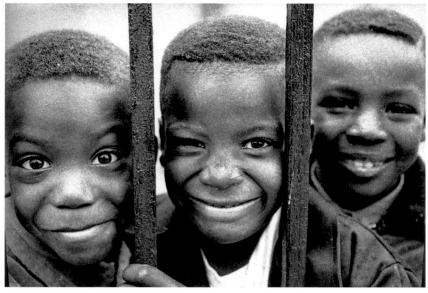

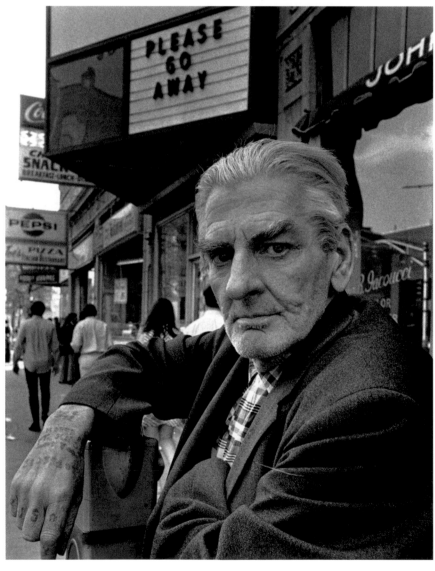

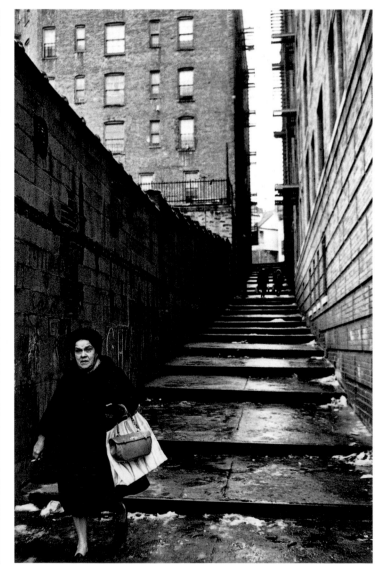

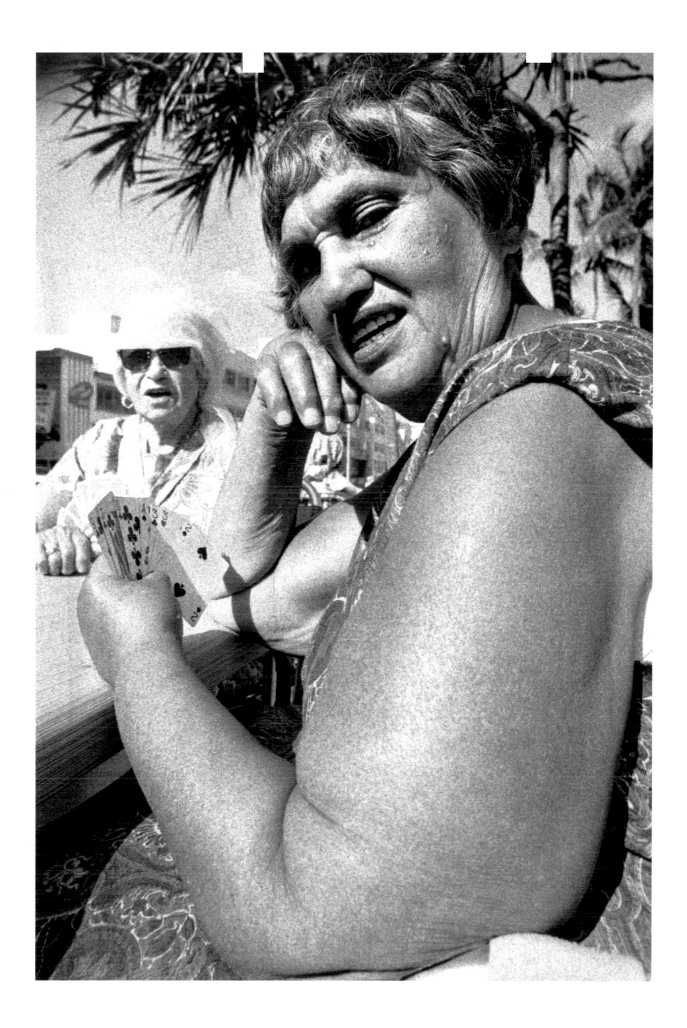

ANYONE FOR CANASTA?

MIAMI BEACH.

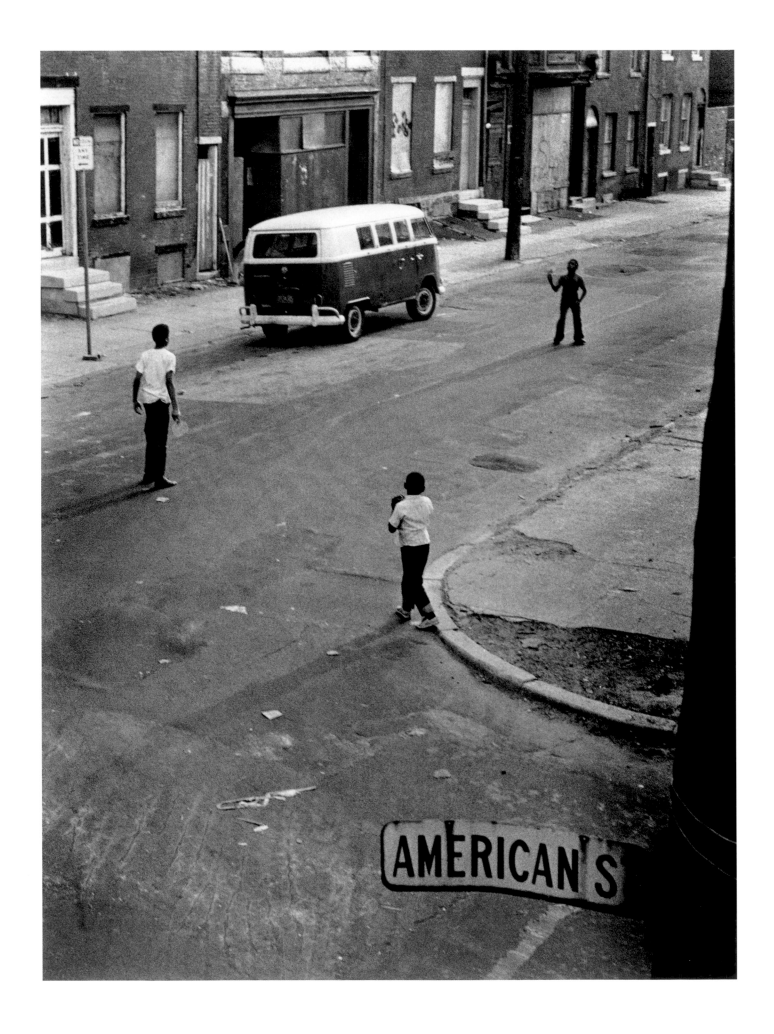

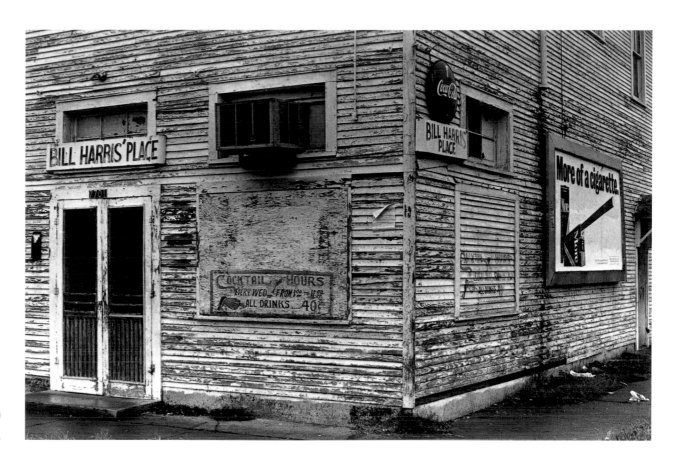

BILL HARRIS HAS SEEN
BETTER DAYS, NEW ORLEANS.

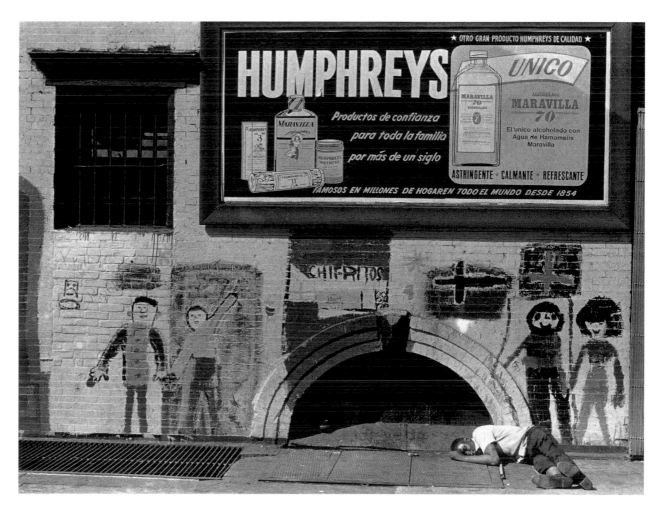

OUT ON THE STREET IN
SPANISH HARLEM,
NEW YORK CITY.

<

INNER CITY AMERICANA,
PHILADELPHIA.

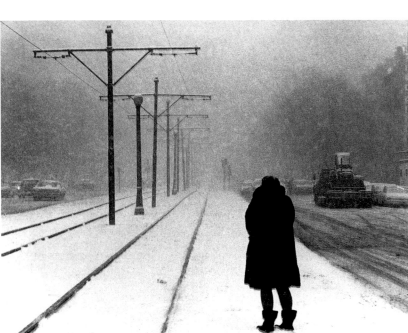

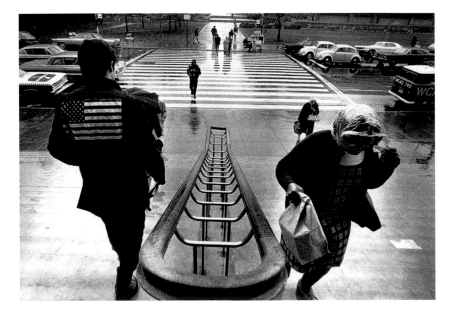

<

ALL CLOSED UP, OCEAN CITY, NEW
JERSEY.

WAITING FOR THE "T" ALONG
COMMONWEALTH AVENUE,
BOSTON.

GEOMETRIC PROGRESSIONS AT MIT,
CAMBRIDGE.

>

THE ONLY LIVING BOY IN CENTRAL
PARK, NEW YORK CITY.

A TREE FROG "FAMBLY" PORTRAIT.

Tree Frog Farm

1970–1972

During the early months of 1970, I was still living in Cambridge, having just graduated from Boston University. I was eager to begin my career in the "real world." My history as an aspiring photojournalist had enabled me to obtain assignments (mostly in the ever-popular counterculture arena) for *Rolling Stone,* the *Atlantic Monthly, Time, Newsweek,* the *Village Voice,* the *Boston Globe,* and various underground rags that permeated the Boston area. I could see that my stock was on the rise, and my life as a plugged-in, well-connected, career-oriented hippie was becoming acknowledged. My immediate family was duly impressed ("Looks like he's following in his father's footsteps"), my Cambridge compatriots were encouraging, and the editors who hired me thought my work was admirable. Yet an influential contingent of my radical friends (Ray Mungo, Verandah Porche, Harvey Wasserman, Steve Diamond, et al.) who had fled "the movement" for farms and communes in 1968, ahead of the pack, viewed my scene through their country looking glass and told me my life was a "real mess." I was stuck inside of Cambridge with the Boston blues again.

I had visited Ray's farm in Vermont, Packer Corners, many times during those two years. And, as an original investor (Ray had "borrowed" two grand for a down payment), I was made to feel quite special and at home every time I traveled down that long and winding road. During these visits they would proselytize the magic of livin' in the country with well-meaning comments like, "Payte — don't you get the big picture yet? The cities are crumbling! The movement is dead! All you guys are doing is feeding your collective egos like all the other lost souls who are arrogant enough to think you can change the world. C'mon, lad, join us in the country! This is where reality is!"

I would respond with, "Hey, what's the point of sticking your heads in the dirt? There's a war to be won! This is just escapism. Don't give up now! Don't you guys care about the rest of the world?" But this fell on deaf ears. These folks wanted no more of the movement.

The Cambridge scene still had a hold on me. Besides, Total Loss Farm (affectionately renamed in Ray Mungo's second book) did seem to me, at least in part, a total loss. Despite the rural beauty and sense of "leaving it all behind," the place had an Appalachian, hard-life look. I really wasn't ready to take a crap in the ramshackle outhouse, where my butt would stick to the toilet seat when the temperature was below freezing. With no telephone or television to be had, the step back in time seemed far too great for me. Thanks, but no thanks. I needed indoor plumbing.

RAY MUNGO WITH ELLEN WEISS: A COMMUNAL UPDATE OF "AMERICAN GOTHIC," USED

ON THE COVER OF RAY'S GROUNDBREAKING MANIFESTO, "FAMOUS LONG AGO."

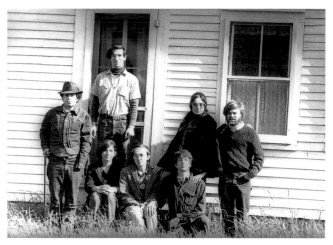

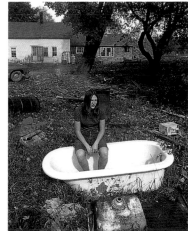

THE ORIGINAL CREW AT PACKER
CORNERS FARM ON THE DAY WE
BOUGHT THE PLACE, MAY 1968.
MICHELLE CLARKE, RAY MUNGO,
PETER SIMON (SITTING);
RICHARD WIZANSKY, MARTY
JEZER, VERANDAH PORCHE, AND
LAURIE MILLER (STANDING).

THE AUSTERE LIFE OF TOTAL
LOSS FARM.

But as the city winter months melted into spring and the dirty slush clogged the sewers, the call to the country became louder. My insides too began telling me it was time for a change. After recurring bouts of nausea, I was diagnosed with an ulcer. I would awaken each morning in a cold sweat, dreading all the phone calls I had to make, grappling with my girlfriend Laccy's desires and my shortcomings, wondering where or what we would eat for dinner, or whether I had blown the assignment for this week's paper (had I even remembered to load the camera with film?).

In addition, the manner in which many of the people with whom I conducted business related *at* one another was becoming unreal and hypocritical. It all became a big ego game with no apparent winners. We were playing roles in order to climb up the social and economic ladder, despite our generation's desire to change that system, and it seemed like a cop-out. Yes, it was true that we were all stoned freaks, thought the war in Vietnam stunk, and disliked authority with its attendant set of rules and regulations. But even with our long hair and bell-bottom pants, paisley shirts and John Lennon shades, we all seemed just superficially changed. Taking acid became more of a social-acceptance tab than a commitment to a higher awareness. Boston's "free-form" alternative radio station, WBCN, was

bought by some faceless corporation and started caring about ratings, making money, and playing "the hits." Gone was the creative spark that had rocked our city to new heights for a few great years. Instant Karma was surely gonna get us.

Each spring Ray's farm would host a May Day celebration at which the upstart communes in the area (Montague, the May Day Farm, the Wendell Commune, and the Johnson Pasture) would gather to party, play music, swig acid, and dance around the maypole. Relatives of flesh and blood and like-minded hippie freaks were all invited. It was a rite of spring that we anticipated with a passion.

In previous years, I had been apprehensive about LSD. I knew May Day clamored for group trips. While grass seemed fairly innocuous, acid seemed too powerful and mind-boggling for me. I had tried LSD a few times in college but had always been sure to take small, controllable doses. At the May Day 1970 gathering, I took a risk, took a major hit, and became totally blitzed. We played softball in a cow pasture. So what if we got manure all over us? Who knew where second base was anyway? We were in this together, free as a flock of birds, circling the bases with a carefree enthusiasm. The springtime blossoms shimmered with psychedelic colors when viewed against the dazzling sky. There was love in the air. I felt the serenity of the scene,

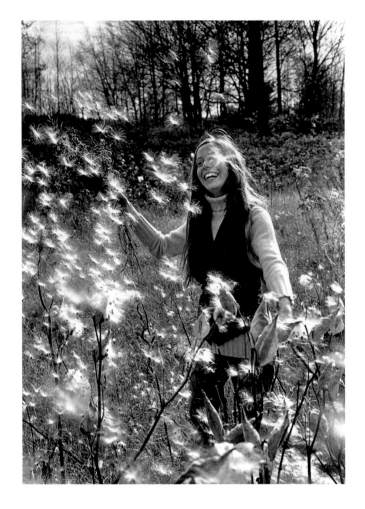

Ray's settlement. Since I never could picture myself living under his austere set of circumstances, this new option seemed overwhelmingly attractive. I could live in the lap of country comforts, partake of the "back to the land" movement, but not suffer the harsh living conditions of Packer Corners.

While the actual farmhouse wasn't particularly enticing, and a huge red barn dwarfed the tableau, the rolling Vermont hills, accented by two highly photogenic birch trees, sealed the deal. I could escape to a laid-back, earthly existence among the sun, moon, stars, plants, and "animules" (a word we enjoyed). I had just inherited twenty-five grand due to the passing of my grandmother. Harry Saxman, a Cantabrigian neighbor who was the only friend I had who seemed even slightly financially endowed, went in on it with me. We shook hands and bought the place — forever brothers in a new adventure. Our motto became: Buy the place and they will come. Indeed they did.

After a fun summer on Martha's Vineyard, we packed up our belongings and headed for the hills to forge a new life. Our "fambly," consisting mostly of college loved ones who had no other distinct direction at the time, included Harry and myself (the landlords); my cherished girlfriend, Lacey (who had warned me that if we didn't move to Vermont, she'd break up with me); Harry's girlfriend, Jenny; my best friend from childhood, Tim Rossner; Elliot Blinder (a journalist and friend from BU days); his girlfriend, Catherine Marriot; her little girl, Michelle, from a former marriage; and Bonnie Fisher, a colleague from the *BU News* and a former girlfriend of Ray Mungo's (the tenants). We inherited Betsy (the cow) from a nearby farm, a charismatic cat, and Eeyore, a multicolored dog from Harry's past. It was a loving, slightly demented

gazed at the incredible apple orchard on the agonizingly gorgeous hillside directly above the old farmhouse. I conversed with the cows about our future in the universe. And when night approached, lit by a huge bonfire, I looked to the Milky Way for guidance. With it streaky and soft, cosmically superimposed against the Boston skyline of my mind, I finally realized the time was ripe (even if the vegetables weren't) to let my career and urban diversions go. While the rest of the world was burning, Vermont was budding. I was hooked, and Ray was right, as usual.

Timing is usually everything. A beautiful panorama of a hundred acres of land, complete with a farmhouse and barn, had just hit the market for a mere $62,500. This mind-blowing property just happened to be a scant half mile away from

crew, willing to take a chance and ready to forge a new lifestyle on the threshold of a dream.

We shared common goals — to change our lives dramatically, to live off the land in harmony with nature, to be in touch with the ever-amazing universe, and to be as open and giving to one another as possible. Our years of drug taking and consciousness raising had taught us a new golden rule: What's yours is mine, and what's mine is yours. That not only included food, shelter, ideas, goals, and secrets, but intimacies of body and soul. We universally agreed to call our farm Tree Frog, after the little cuties that would emerge in spring. That decision was made on a stoned and foggy night. I'm still not sure why we all felt so strongly about the name, but it had a nice sound.

Some of our lofty goals had to be put on hold while we got our ramshackle farmhouse into some kind of order. It was hard work just getting our act together as a working farm. We were a contingent of mostly middle-class, educated, Jewish, urban types who suddenly had to grapple with chopping

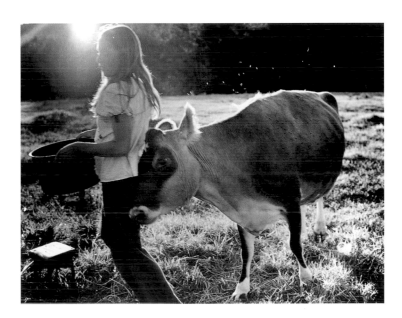

BETSY BUTTS LACEY.

wood, building a chicken coop, and renovating our barn for the cow. We then had to learn how to milk Betsy (who for some strange reason had only three tits). Then we had to sterilize the milk (oy vay!) and separate the cream, only to turn some of that cream into butter. That was an undertaking in itself. Then we had to shovel Betsy's shit onto the compost heap on a daily basis. That seemed almost too much to ask of ourselves. Our hens needed maintenance as well. Each day we collected at least thirty eggs. What would we do with them all? One unexpected bonus that we all shared to varying degrees was the opportunity to help raise Michelle, who was only three. She received more loving attention than any kid I ever knew while growing up.

As a group, we knew little about child rearing and farm responsibilities. These were daunting

<

MICHELLE, ME, AND LACEY,
SELF-EXPOSURE.

KING HARVEST MUST SURELY COME.

>

HOME COMFORT.

THANKSGIVING DINNER
AFTERGLOW, 1971.

assignments. At best it all seemed a joyous exercise, at worst totally overwhelming. Most days were somewhere in between. Chore lists would be compiled in great detail and posted upon our outmoded refrigerator. Then days and weeks would go by with absolutely nothing checked off. A day trip to nearby Brattleboro to get provisions for nine hungry mouths seemed arduous enough.

Meanwhile, we were trying to sort out who was meant to be with whom. As a united group, we tried to break down the walls of possession. But while the love was flowing, age-old feelings of ownership and jealousy were growing. A journal entry from November 16, 1970, describes this dichotomy:

Tonight is one of the happiest nights I could ever imagine. . . . Although painfully aware of the pathos that surrounds me: killings, apartheid, and the Ed Sullivan middle-Americana that pervades and invades us, all that is in the background. I'm so much in love with the life that I'm living that everything else seems illusionary. My head is in such a fine flame. I feel as "New Age" and un-disillusioned as ever. All the disparate vibrations of all our kind seem to be coming together so beautifully. Where it leaves me with the rest of the universe I cannot say for sure. All I can say is that I am capable of endless love to many of these beautiful beings that surround me. It's all so far out. But watch out! While some bliss exists, there are also waves of unrest among the inmates, unfortunately. Tim has "stolen" Jenny's heart away from Harry

and [they] appear to be a new entity. Chaos and anarchy have reigned as Harry has gone haywire and threatened harm. Two nights ago he went down to Jenny's shack with an ax to chop it down. I couldn't totally blame him. After all, he did build it all for her. Panic has struck. Jenny and Tim have fled to the May Day Farm for refuge. Harry now wants to sell the place to yoga people because he resents Tim. Catherine and Elliot are fighting and possibly splitting up. Bonnie is distraught in general and wants stability. Lacey doesn't know where she stands, but the future seems upsetting. I adore her, but could I share her? Suppose Lacey slept with Tim. . . . Where would I stand — an innocent bystander or outraged lover? Would I behave like Harry has? What are the rules? At times it seems as though we are all being held together by a tenuous line of sanity and love. I do hope we can make it all work.

That crisis passed, and we moved on to the next season. During the first winter, we were socked in for weeks at a time with nothing to do but bare our souls. And bare we did. Everything came out — each person's hang-ups and fears, feelings of jealousy and persecution, and, thankfully, the unraveling of the layers of protection that we all had worn for most of our lives. It was a cleansing process. Near the winter solstice, we decided to take a "fambly" acid trip and to sled down the hillside, all piled up together. We felt joyous and renewed. Late at night we gravitated to the fireplace, shed our clothes, and thought about having group sex, as an experiment. After some

discussion, we all decided to have a group hug instead. Affection was always a very important aspect of our communication.

Meanwhile, we had visitors dropping by constantly from Boston and New York. Kindred spirits from the neighboring communes would also come by for food, drugs, friendship, or a glance at all the pretty women. I would often ask what they thought of our commune, which at times seemed like an insane asylum for the downwardly mobile. Except for some well-intentioned needling ("This isn't really a country commune; you use oil to heat, have real bathrooms and plumbing, and look at you, Peter, with your color television in your room — what a joke!"), most guests thought the whole scene was a gas, a great escape. We enjoyed sharing the amenities of our country escape and reveled in the positive feedback. It was a delight for us to play the role of hosts of a hippie commune, though it was exhausting at times.

Always one to photograph my immediate environment, I replaced my harsh city images with pastoral, soft-focus, silky pictures of the natural beauty that surrounded us. I also took some intimately bizarre snapshots as we went about our daily life — from menial chores (cooking, cleaning, feeding the animals, mowing, raking, planting, harvesting, and so on) to extracurricular activities

(holiday feasts, dancing, and tripping). Everyone loved my role as the overqualified house photographer and eagerly awaited my semimonthly showings of slides and prints around the large dining room table. I placed my career on hold. No longer was I on the "firing line" of the movement, seizing all the historic moments I could find. My income took a nosedive, but so did my cost of living. Nine could live cheaper than two.

Despite the protestations of my fellow communards ("Your career is just your ego getting in the way"), occasionally I would leave the compound and steal into Boston or New York for a magazine assignment or to pitch a book idea. But soon I would head back to the hills. Between the disapproving rhetoric of my mother and her "old-age" contingent and missing Tree Frog, my tolerance for city life hit an all-time low.

During one of my midwinter trips to Riverdale, my mother, always one to express her feelings about my lifestyle, questioned Elliot about the strange financial setup we had in place. I taped the conversation, just for the hell of it:

> MUM: Elliot, how do you feel living off Harry and Peter?
> ELLIOT: It's not off, it's with. We work the land, and they pay the bills.
> M: But where is your self-esteem? Don't you want more out of life?

E: *Not for now. They provide, and we give.*

M: *But Elliot, don't you feel like an indentured slave at times?*

E: *Yeah — but what a wonderful drill. We're all in this as one. We share everything, soup to nuts. Everyone feels equal.*

M: *You can't be serious. . . .*

E: *But Mum, we work our butts on that land. We build fences for our livestock. We put up various shacks and barns. We paint and decorate. We feed the chickens, weed the plants, we rake and mow. Don't you think we deserve something in return for all that hard labor? Harry and Peter have never actually paid us for all of that. . . . It just seems to work out well, for the most part. . . . Have you ever heard of the phrase "The love you take is equal to the love you make"?*

M: *No, but it sounds disgusting. I really feel you are taking advantage of my son. He is an innocent, naive kind of guy. For my sake, please don't soak him up.*

E: *Look, Mum, we all love Pete. What else could he be doing now?*

M: *Well, he's a talented fellow. He could be on assignment for* Life *or* Look *magazine. He could be taking photographs for* Magnum *[a prestigious photo agency] and making a name for himself.*

E: *But Mum, he's obviously chosen a different path. Can't you see it?*

M: *Well, I've tried to accept it, but it's hard. He has so much potential.*

E: *Look, your son is doing the best he can. Just let him be. . . . This is a new age. Old expectations have gone by the wayside. Just appreciate him for who he is — a talented, warm, and loving person. What else could you want?*

M: *A wife, a grandchild, a steady income, and a sense that he's contributing to the world, not just your little commune, all tucked away. Peter could really help mankind with his art.*

E: *Boy, those are big aspirations. I just hope he milks the cow along with the rest of us, and shovels the shit once in a while. . . .*

A journal entry dated January, 29, 1971, put some of my mother's reservations in perspective:

It's a fairly quiet late Sunday night in Frogland. Elliot is in his room cleaning up some recently harvested pot. Lacey is in great comfort on our bed, haphazardly designing and sewing a nifty new dress. It's so soft here, a wood-burning fire crackling to a background of Clapton riffs. Michelle just took a bath with me while Harry put up a parking lot and a new thermometer. Our dinner tonight brought us all together for grace and then discussions upon our day's creations and private revelations. Catherine is finishing off the kitchen patrol while Timmer is off in a cranny, mumbling something totally absurd. Jenny is drinking wine and dancing madly with Bonnie, who also is searching for her dog Kilo. It's such a gloriously unglamorous life we lead, really. I wouldn't try to change a thing.

But the challenges of country living hit us big time as our first spring approached. For one thing, the melting snow produced mud beyond my wildest dreams. We couldn't even drive our cars down the road. We'd leave them about a mile away and lug groceries back home. No one had warned me about mud season. Then, gooey dog shit, camouflaged underneath a wondrous coat of snow, appeared without warning. If that wasn't disgusting enough, the unexpected advent of mayflies inflicted numerous red bites about the face and feet. We could hardly go outside from mid-May through Memorial Day — just as everything was sweetly blooming.

Most important, the constant pressure of maintaining interpersonal relationships began to take its toll. Our experiments beyond monogamy had practically everyone sleeping with one another at least once. At times, after a sumptuous dinner, one of our main concerns became "So who gets to

sleep with whom tonight?" If I didn't happen to be one of the chosen, I underwent terrible feelings of rejection and jealousy, especially when confronted with the familiar sounds of lovemaking wafting through our thin plaster walls. In the aftermath, we would play the unattractive game of "get back." This meant: If you wouldn't have sex with me last night, watch out for tomorrow night. A prettier, more expressive partner might be imported shortly.

This "free love" atmosphere, which had been embraced by some of the braver and more "up for grabs" members, soon led to unattractive breakups and reconfigurations. For example, Lacey, my main squeeze for at least two years who had coaxed me more than anyone (besides Ray Mungo) to believe that "space was the place," finally had enough of our misfiring relationship and moved out of my room for good. The next room down the hall was the "blue room," usually reserved for important guests such as Carly, David Silver, Stephen Davis, and friend and writer Sara Davidson. But Lacey, the "ace from space," wanted her place. She redecorated the blue room with new linens and a recycled area rug. Soon thereafter, a new guy to the commune, Bill, moved in with her virtually overnight. I had no say; this was a commune, after all.

Meanwhile, I had grown quite close to another couple, Lonny and Cathy Brown, from the nearby commune Hidden Springs. I invited them to join our "fambly" to fill a karmic void. They had a transcendental quality that I felt was missing. We called one of our big meetings to decide our policy about future members and democratically decided that no one else could move in unless a two-thirds majority was in favor, or the candidate was a significant new mate, as in Bill. The ladies of the house, worried that Cathy's charismatic and flirtatious manner would distract the men, voted against

her and Lonny. Thus, my cosmic couple was rejected. I had to adhere to the rules, but this was a particularly difficult defeat.

If I couldn't be with the ones I loved, I decided to be with the one I found next. She turned out to be Kiki, an angelic girl from Bayside, Queens. Twenty years old, she lived with her parents and worked as a clerk at a local bank. It wasn't long before I convinced her to move to Vermont and partake of the good life. Kiki, also a good friend of Lonny and Cathy's, was able to bring their vibe to the farm instead. Our spring and summer were flush with new romance.

Bringing a new girlfriend "back home" was akin to introducing her to one's parents. Fortunately, Kiki's warm smile and easygoing manner won everyone over, and she was immediately embraced by the attending ladies (Lacey, Bonnie, Catherine, and Jenny). Finding her place within the female hierarchy was a task. Catherine clearly controlled the kitchen. Jenny was the artist, Bonnie was the chore leader, and Lacey had sovereignty. No problem! Kiki fit right in. The only obstacle was her former and potentially future attraction for

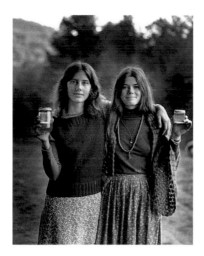

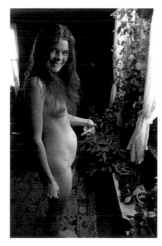

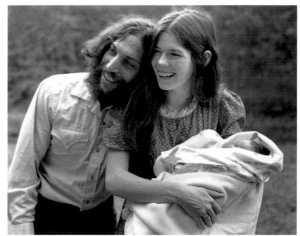

< KIKI AND CATHERINE TAKE
THEIR "PEE BOTTLES"
TO A LAB IN BRATTLEBORO
— ARE THEY PREGNANT?

>

CATHERINE GETS PREGNANT.

AMOS COMES HOME, A NEW
ADDITION TO THE FARM.

Elliot, and vice versa. I tried looking the other way, for a while.

The summer of 1971 was full of fun and frolic — badminton and volleyball games in the late-afternoon shadows, midday ladies' teas, skinny-dipping in the beaver pond, dinners outside while watching grand sunsets over the rolling Vermont skyline, and seeing our huge garden grow — tomatoes, cabbage, carrots, broccoli, pole beans, lettuce, cauliflower, eggplant, multicolored corn, and squash. I would blast my stereo out to the garden below, and we'd weed to the tunes of Joni Mitchell, Elton John, Carly, Eric Clapton, and the Band. There was absolutely no need to keep up with the news on TV, and we disconnected our semiworkable telephone. The movie we saw was Tree Frog Life. That seemed to be all that we needed or wanted.

However, when the first nippy nights of autumn caught us by surprise, summertime ecstasies went downhill rather quickly. Despite our abundant harvest, which included apples, peaches, and pears in addition to what we had planted, there was discord. Three of the original "fambly" members defected to Canada, where land was cheap and there was no central heat. Tim, Bonnie, and Jenny felt, understandably, that the farm wasn't really theirs. They had become mere serfs in an informal feudal society of which Harry and I were the benevolent lords. This was the first indication that our experimental utopian society had sprung some serious leaks.

We tried to regroup and carry out our manifest destiny. With whatever money we could scrounge up (some of us actually had paying jobs by now, and I had landed a contract for a new book), we built an addition to our barn and at long last renovated our fifties-style kitchen, giving it a "handmade home" look. And then, by some divine coincidence, three ladies got pregnant within the same two-week period. Only one child, Amos, was eventually awarded entry into our precious little world.

Despite these dark considerations, we had a highly spirited Christmas Day (the first one away from my "real" home) and an outrageous New Year's bash, cavorting around our living room to Clapton's "Layla" and Harrison's "My Sweet Lord." We went belly sliding outside on the ice totally naked, and then came back inside for spiked cider and a group massage by a roaring fire. Couples arranged and rearranged. I wound up on the living room couch, cuddled up with someone I had never met. By that point, Kiki and I had decided to break up. We loved each other deeply, but felt there wasn't enough in common to share. She stayed at Tree Frog anyway, as had Lacey.

During the awesomely cold January of 1972 (twenty degrees below) a distant friend of Catherine's visited Tree Frog from Colorado. His name was Tom, a burned-out, slightly catatonic wanderer, looking for refuge. He brought with him a striking nymphet named Lottie. At first they seemed like just another couple passing through our ever-expanding halfway house for loved ones and lost loves. However, that evening as we gathered around the fire I managed to sit next to Lottie. It was as though we had known each other a lifetime. She ran her long, slender fingers up and down my skinny, hairy legs. I sensed that we had a future together. I knew not of her relationship with the wandering Tom, but Lottie made it clear that he was merely dropping her off for a widening experience at communal living. Wow — what a gift! We relegated Lottie and Tom to the "bordello," an alcove off the living/dining room area, separated only by a beaded curtain. It was a single-bed situation.

The next morning, young and tender Lottie hit the floor with a thud. I happened to be passing by on my way to the kitchen for a morning cup of ginger tea. I couldn't help but take notice. She was absolutely stunning, and naked at that! Despite the fact that two of my former lovers, Lacey and Kiki, were still under our roof, I was unable to divert my attention.

It took me weeks to conquer Lottie body and soul, but it was worth the agonizing wait. We fell deep and hard, and all Tree Frog concerns seemed boring and irrelevant. Love was Lottie, and Lottie was life. First it was Lottie in Canada (where we visited the "defectors"), then it was Lottie in Seattle (where we visited her sister and I photographed my sister Joanna performing in an opera), then it was Lottie in San Francisco (where we discovered a glo-

rious place and space), Lottie in Colorado (where her Latvian-English features and waist-length blond hair highlighted the snowcapped peaks of the Rockies), and finally Lottie on the Vineyard (where I always sought refuge when times in Vermont got rough).

By the time we returned to Tree Frog for the annual May Day celebration, no one would even look at me. How could I just leave this place? Was I just a gentleman farmer after all? Was Lottie worth all my attention? I distinctly remember our first night back. My room had been taken over by interlopers, and we slept in the back of my Volvo. Tree Frog had become an itinerant crash pad. I felt out of place and time — like one of the many guests just passing through. Lottie and I eventually escaped to the Vineyard for much of the summer. We both felt unwelcome at Tree Frog.

In late August we returned. Lottie's former boyfriend Tom visited. I arranged to have one of my former girlfriends from college there to soften the blow. The outcome wasn't exactly picture-perfect. I found Lottie making love with Tom in one of the outer shacks. They were tripping on mescaline at the time. I said, "Lottie, does this mean you don't love me anymore?" My heart was beating triple time. She said, "Peter, I don't know. All I know is that I can't stay here. Tree Froggers don't like me. Besides, I'm looking for a guru." My fellow communards were relieved. It was clear to them that Lottie had been taking me for a ride — just another one of Peter's young blondes.

Two days later, Lottie escaped to Colorado with Tom. I wrote a message on my car window, which was layered in dust: "It sure was fun, wasn't it, Lot?" I'm still not sure if she ever saw it. But the handwriting was on the glass — Tree Frog had failed me, or I had failed it. What did I know? All I knew

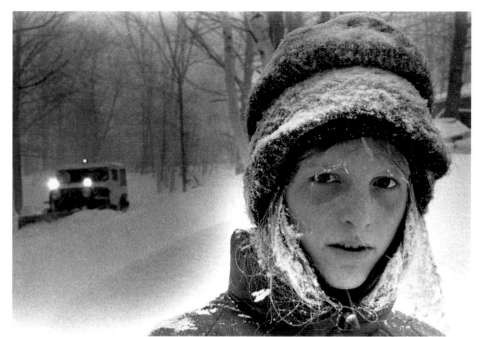

LOTTIE BRAVES A
TYPICAL MIDWINTER
BLIZZARD.

ELLIOT AND CATHERINE
MAKE THE MOST
OF WINTER.

was that the love of my life, to that point, had rejected me *and* Tree Frog.

It took me many months to recover. As our new goats would bleat upon the first glow of the morning sun, I would roll over in my bed and tremble. I felt all alone and unloved. Though I tried, I could never really warm to the new people. The place had lost its magic. We were just a bunch of roommates living together without a common thread.

Meanwhile, the other communes were also beginning to lose their original members. Ray Mungo was long gone, off to some tropical paradise to seek a new direction. Packer Corners was just eking by, no longer the "in spot" for country-comfort seekers. It missed Ray's charisma and camaraderie. The Montague Farm was in disarray. The Baby Farm, also known as the Johnson Pasture, had burned to the ground. Someone had forgotten to blow out a candle before going to bed. The May Day Farm was losing members here and there. And Hidden Springs, a New Age bakery in nearby New Hampshire, where Kiki had migrated to, was barely breaking even. One of its members even took his own life. Clearly, our alternative way of life had run its course. It no longer was so far out to create a new order in the wilderness, despite the hype and overripe expectations.

Predictably, money inequality proved to be the fatal blow for Tree Frog. Harry and I did our best to run the place as an equal opportunity household, but the fact that we paid most of the bills and injected upkeep money when necessary put us in a more powerful position. Although I spent many of my waking hours relentlessly cleaning up the mess that my slovenly housemates created (I was, and remain, a total clean freak), that wasn't enough to offset the fact that I didn't help, for the most part, with the weeding, harvesting,

RAY MUNGO PLAYS THE RECORDER WHILE A CAPTIVE KURT VONNEGUT LISTENS, MAY DAY, 1969.

canning, winterizing, and other chores inherent in our hardworking lifestyle.

On Halloween day, Elliot and Harry had an explosive confrontation about a rut that Harry was making with his tractor across the driveway. Elliot was upset that he was being inconvenienced without warning, and pissed at Harry's general practice of using his machinery (toys) to destroy nature's perfect balance. This led to a shouting match in the kitchen, and all members of the commune drifted

THE ORIGINAL TREE FROG "FAMBLY," 1970. TOP ROW (LEFT TO RIGHT): BONNIE FISHER, HARRY SAXMAN, LACEY MASON, MICHELLE PERKINS, JENNY ROSE, CATHERINE MARRIOT, AND ELLIOT BLINDER; BOTTOM ROW: PETER SIMON, TIM ROSSNER.

in to hear what the commotion was about. It came down to Harry's feeling put upon and taken advantage of by his "tenants," which reinforced Elliot's claim that Tree Frog was never really a commune in the true sense of the word but just a gentleman farmer's home with unpaid farmworkers who worked on the premises for free room and board. It was the single most heated exchange any of us had ever had. Perhaps egged on by his new girlfriend,

who wanted the place for Harry and herself, Harry finally threatened that we all had to be out by December 1 or he would get a court-ordered eviction. Everyone looked to me to make some sort of counter move or retaliation. I felt oddly passive and just let everyone keep yelling for a while. Finally, I asked Harry, "In that I half own the place, aren't I just as entitled to evict you instead?" Harry then produced the title to "our" home, which had only his name on it. I had never looked at the document, always assuming that we co-owned the farm. Apparently back in 1970, when we had agreed to purchase Tree Frog, Harry had me sign an IOU

stating that my $25,000 would be returned to me upon termination of the "experiment." Being the stoned-out, naive little hippie that I was then, I never read the fine print or got a clear understanding of our partnership. Everyone was stunned except for Harry — who had known all along that he had the upper hand and could take ultimate action when the time arose. The tractor incident, so symbolic of all the conflicting ideals that had constantly eroded the group identity of the commune, was the last straw.

At first I was shocked and resented Harry's actions, but I was also relieved that finally someone had had the strength to put an end to a deteriorating situation. Breaking up was hard to do, but I secretly thanked Harry (and his girlfriend) for taking a stand. Maybe we were just attempting the impossible. Perhaps I was trying to live out a country fantasy based on other people's expectations. In the end, I was glad we had tried. We went through experiences with human intimacy, openness, and sharing, frailty and forgiveness, that were sacred and special. Had I stayed in the city and continued my fast-paced career, I might have accomplished more, but I probably would have learned far less.

Of the original crew, Tim, Jenny, and Bonnie remained in Canada for about three years, then chucked it. Tim moved to western Massachusetts and began a teaching career. Jenny moved back to Vermont to raise her kid and pursue painting. Bonnie married an orthodox Jew and rechanneled her life completely. Harry sold eighty of the original hundred acres, took a profit, and built himself a big house on an adjoining hill. Elliot, Catherine, Michelle, and little Amos moved to a smaller commune in western Massachusetts, Hill House, which lasted a few years. I loaned them ten thousand for the down payment, visited there periodically, and

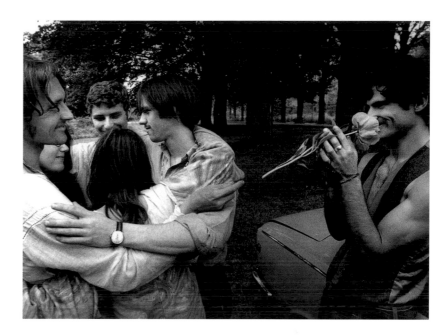

A COMMUNAL FARE-THEE-WELL, VERMONT.

even considered living there. However, sharing a home with a group of people had lost its appeal altogether. Lacey eventually fell in love with a tennis court entrepreneur and moved to Connecticut. As for me, I took the money that Harry "paid back" (without interest — that was rent and for putting up with all my "no-good" college friends) and bought a little shack on Martha's Vineyard. It was time to live my own life by my own rules.

My last night at the farm was spent all alone on New Year's Eve, 1972. Everyone else had moved out by then. I had hit an all-time emotional low. An ice storm had knocked the power out. I could hear the wind whipping and crackling through the branches as they crashed to the ground. As I gazed at a solitary candle that sent shadowy tremors across the ghostly walls that had once enclosed a majestic, love-filled room, all I could sense was that it was time to turn the page. As Armageddon raged outside, I could picture "The End" written across the desolate, hilly horizon.

A BREAK DURING THE BADMINTON TOURNAMENT HELD AT THE ANNUAL LADIES' TEA.

< DOUG PARKER, STEPHEN DAVIS, AND JUDY ARONS: A CASUAL PORTRAIT DURING A TREE FROG VISIT.

LACEY, CATHERINE, AND KIKI SHOW OFF SOME DRESSES FOUND STASHED AWAY
BY THE PREVIOUS OWNER IN THE ATTIC OF OUR OLD FARMHOUSE.

TREE FROG FARM, 1970–1973

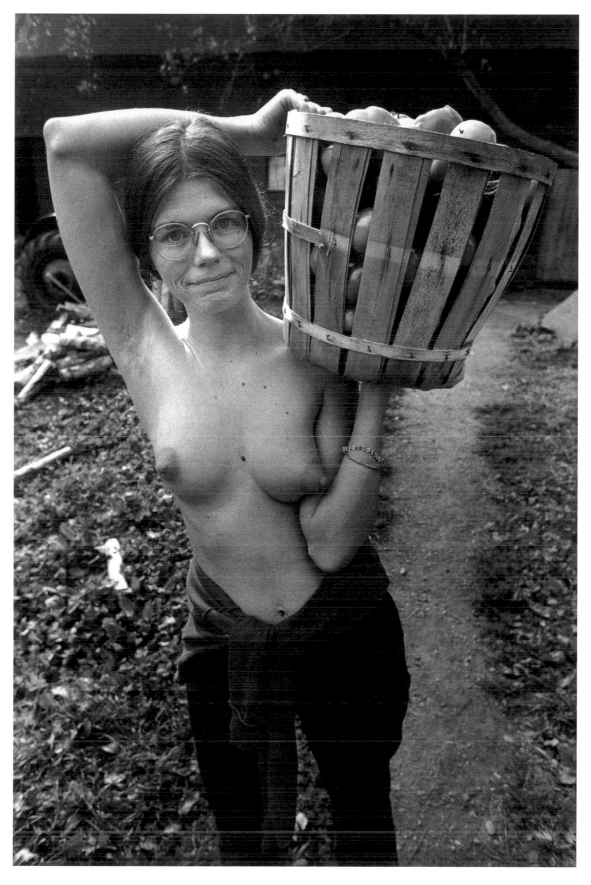

BRINGING HOME THE TOMATOES.

TIM DEALS WITH OUR HENS AS BEST HE CAN.

< APPLE-PICKING TIME.

A TRUCK FULL OF APPLES —

TO SELL OR ELSE TO CAN.

ANIMAL ANARCHY ON OUR COUNTRY ROAD.

THE YIN/YANG OF COMMUNE LIFE.

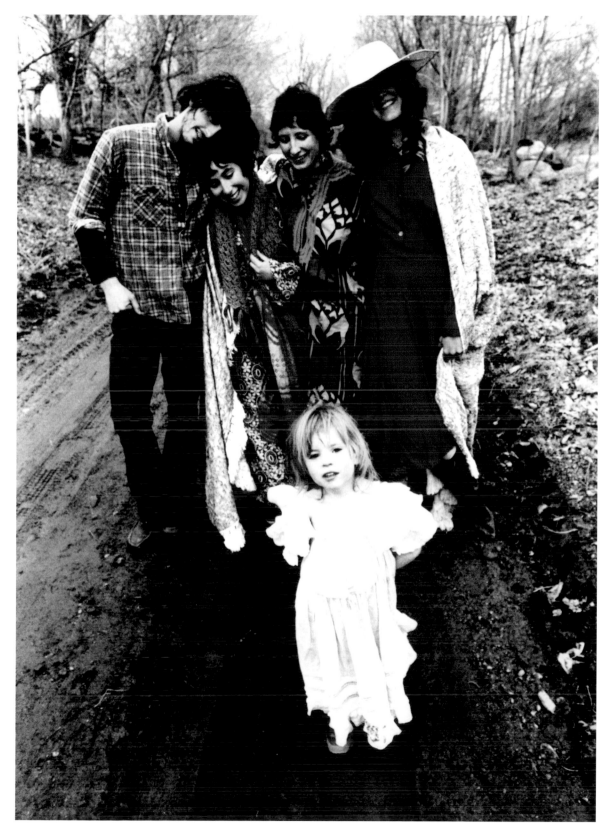

A "FAMBLY" TRIP, MAY DAY, 1971.

<ELLIOT AND CASEY THE GOAT WITH JENNY IN THE FARMYARD.

Decent Exposures

1970–1974

One of my final photo assignments before I left Boston involved a controversial urban commune, tabbed "the Lewd Commune" by the Boston media. This group of perhaps eight or so regular folks had made it their purpose to go about their daily household routines without clothes on, if they so chose. That meant, among other things, making beds, doing dishes, carpet sweeping, cleaning closets, cooking, listening to music, and watching television unclothed. Sometimes it included sex, but not necessarily.

The commune had gained attention because its members had just been busted for indecent exposure and lewd and lascivious behavior and were to be put on trial. Some of these nudists were lawyers and doctors and could have lost their licenses for these dastardly crimes.

What they had actually *done* was to sunbathe on their glassed-in porch one early spring afternoon. An uptight neighbor caught sight of a bare breast and a flaccid penis and immediately called the police. The lewd people had been arrested and jailed, and were out on bond when I visited them, along with my friend Elliot Blinder, who wrote for the *Cambridge Phoenix.*

As we arrived at their North Cambridge home in a respectable, middle-class neighborhood of well-maintained private homes and two-family

DAILY LIFE AT THE "LEWD COMMUNE" IN CAMBRIDGE, 1970.

houses, they were marching around the living room chanting, "Nude is not lewd." We interviewed them about their experiences with the police, the jail, the courts, and most important, about the philosophy behind their lifestyle.

We learned that the group had formed around a couple who had placed a classified ad in the *Phoenix* that read, "Cambridge commune seeks new members. Don't apply if A. You don't love your body, or B. You love only your body."

Their house was carpeted wall to wall and had plastic insulation over the windows to keep out drafts. They had constructed a very comfortable environment for year-round nude living. We were

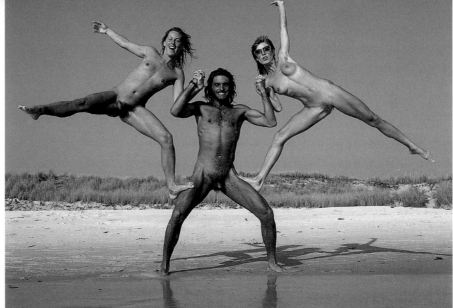

immediately moved by their charm and wisdom, and attracted to their openness and warmth. We were startled, however, that they didn't mind making love right in front of us on the living room couch. But the initial shock soon wore off as we saw how lovingly natural and at ease they seemed. They were simply trying to make us feel at home, as if to say, "Would you care for some tea?"

As we spent more time with them that day, many of our man-made inhibitions faded. We found their mutual affection infectious. We were soon naked ourselves. We came away feeling that we had made some great friends and that we were as close to their bodies as we were to their souls. It was my first encounter with group loving, and I wished to turn my loved ones on to it too. It all seemed so natural: a new level of interpersonal contact.

Subsequent visits to "free beaches" on Martha's Vineyard, Cape Cod, Rhode Island, Hawaii, and in the Caribbean only reinforced the special feeling of openness and trust to which I was a witness for the first time that day. Of course, as I spent time on nude beaches I became fascinated by the wide variety of human forms, and could easily see to whom I was or wasn't attracted. Naturally, there were fleeting mental comparisons as to whose was bigger or better than whose, but soon this

activity became superfluous. Mostly, I felt as though I were in the middle of a huge garden full of living organisms in all their variety, reveling in the perfection of the master plan.

The rule of these naked beaches was clearly defined: You could look, but you better not touch — at least not without permission. Much to my delight there was little self-consciousness or sexual unease. It wasn't long before I began bringing my camera with me to these enclaves. I was acutely aware of not invading people's privacy, and I tended to photograph mostly good friends who were also engaged in this new sense of community, freedom, and openness that these places instilled. It was gratifying to see people of all ages, races, and social strata baring their bodies — and souls. Once all the skin was exposed, how could we protect our little bubbles of separation? Nudity was the great equalizer.

The only time I've ever been in jail, or arrested for anything for that matter, involved a nude beach. In 1970, a bunch of us who were renting a funky house on the Vineyard for the summer spent the day on a huge, empty beach (now owned by the Onassis/ Kennedy estate). At the time we were running a small but innovative movie series on the island called Martha's Mid-Summer Film Festival.

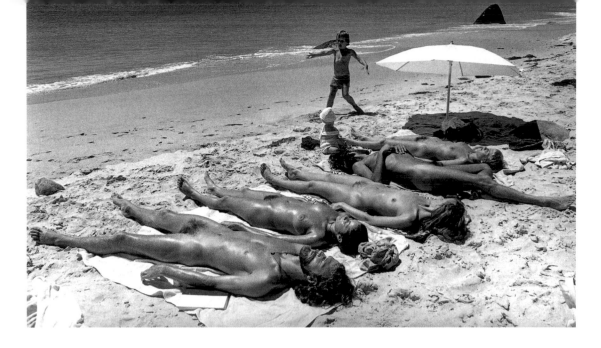

WINDSUFRING AU NATUREL.

LOOK, MA, NO CLOTHES!

>

LET THE SUNSHINE SURROUND
YOU. . . .

SOMETIMES YOU WIN, SOMETIMES
YOU LOSE.

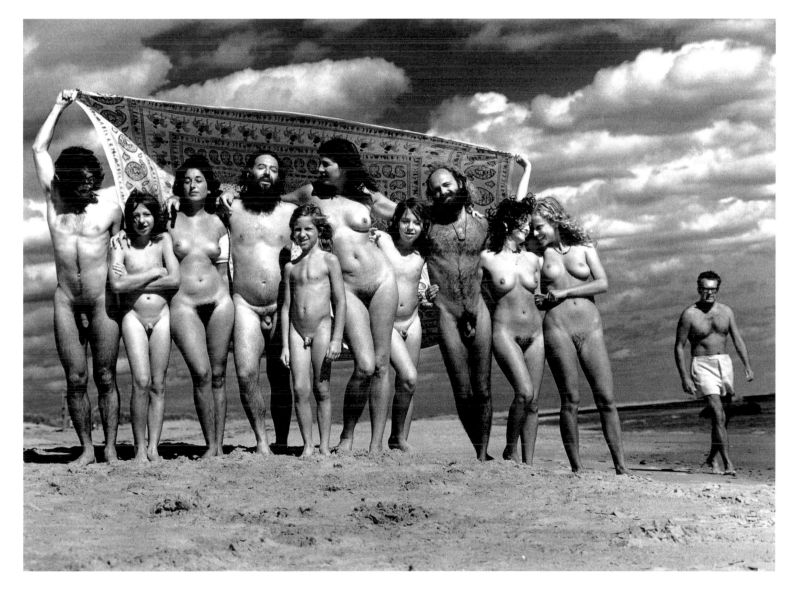

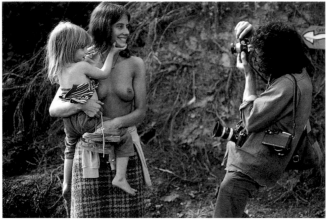

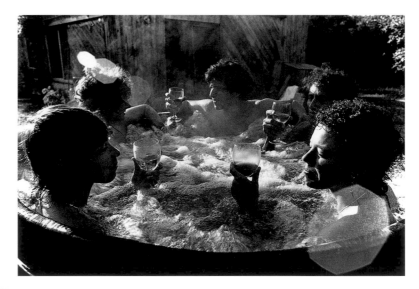

< A MOVEMENT IS BORN, WELLFLEET, MASSACHUSETTS, 1982.

> LET'S MAKE A TOAST TO THE SALT OF THE EARTH.

On that fateful August day we were enjoying the splendor of Zack's Cliffs, stoned, and marveling at the complexities of the universe while surrounded by the majesty of ocean, sand, skin, and sky. Without warning, a police squadron of four-wheel-drive vehicles paraded down the isolated beach and started rounding us up. We were told to get dressed immediately and that we were under arrest for trespassing and indecent exposure, but that we had the right to remain silent. We argued with the officers that we had no idea we were breaking the law, but that tactic was to no avail. We departed sadly but didn't try to resist arrest. Paddy wagons arrived at the main road to cart us off to the Edgartown jail. What a bummer! We remained in a tiny cell, all ten of us scrunched together, for quite

some time. Fortunately folksinger Tom Rush was among our motley crew, and he helped to kill the claustrophobic four-hour wait with heartfelt versions of "The Circle Game," "Both Sides Now," and, most pointedly, "The Urge for Going."

Eventually the bailiff arrived and let us out on five dollars bail per person and a promise to appear in court a week later. That night we had to cancel our presentation of Fellini's 8½ due to this unanticipated incarceration. Our audience was bemused.

Our court appearance was itself like a scene from a surrealistic film featuring attorneys, judges, and policemen drawing circles and arrows pointing to where we had been, what we hadn't been wearing, and the high- and low-tide water marks (below the low-tide water mark there is no such thing as private property; apparently we all own the ocean but not the sand). Eventually the judge discontinued our sentences without finding, but he warned us that if we were caught again with our pants down, he wouldn't be so kind. We had learned our lesson — nude *was* lewd, especially on private property.

But I took the free beach movement on as a cause. So enamored was I with the naked lifestyle that I emerged as one of the chief photographers

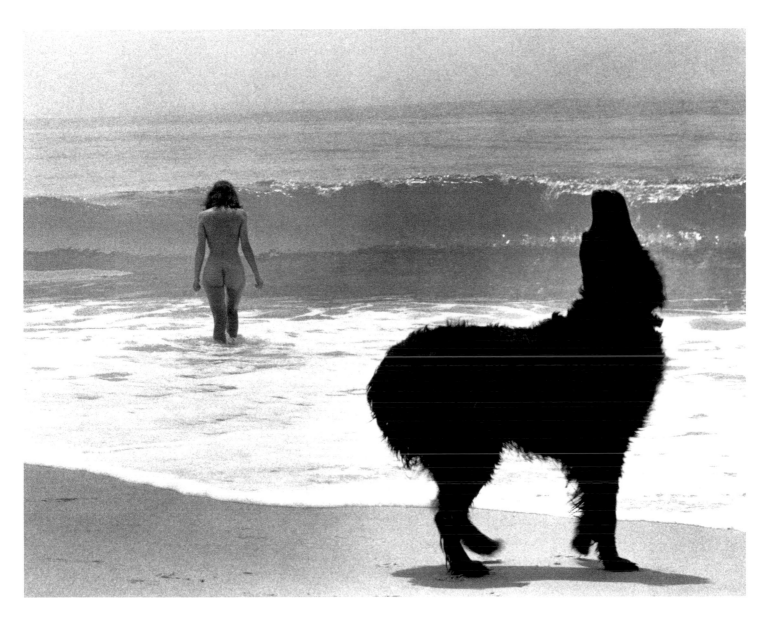

BEAUTY AND THE BEAST.

for a national monthly magazine, *The Naturist*, that trumpeted the glories of public nudity and became an informal bible for the naked traveler. Soon there were nude retreats, conferences, spas, and resorts springing up worldwide. I visited many and always felt welcome and respected. In 1974 I published a book about this growing phenomenon, *Decent Exposures*.

Unfortunately, many of these places were subsequently shut down or brought to court by people who felt public nudity was an insult to civilization. In many of these instances, however, the right to be indecently exposed was upheld and became "decent." At long last bodily freedom!

To this day, there are many "clothing optional" beaches and lakes across the more liberal cultures of our land, particularly in Europe. The instinct/need to cover up still escapes me. As Dylan once said, "If dogs run free, why not we?" What *are* we hiding, after all?

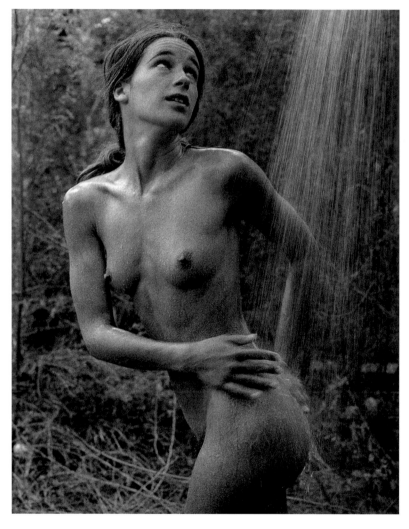

AFTER THE BEACH.

ONE LOVE, ONE HEART.

WHO FEELS IT KNOWS IT.

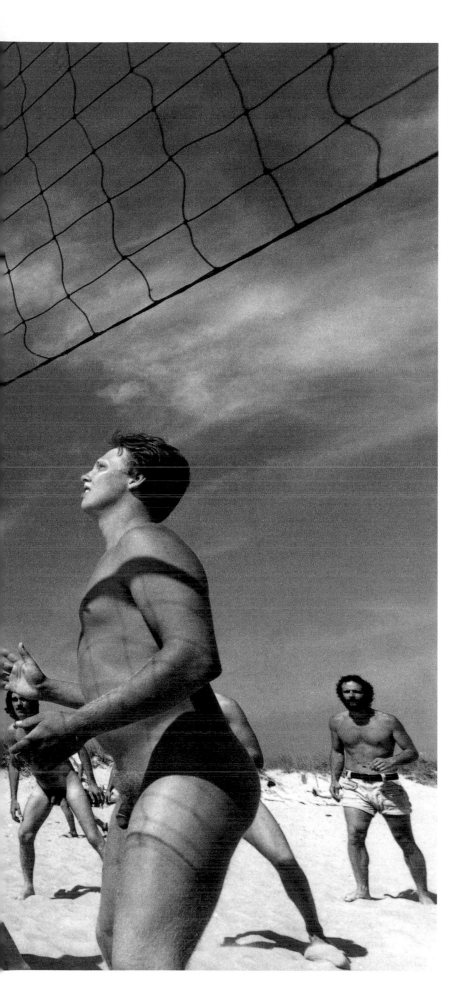

FUN IN THE MUD.

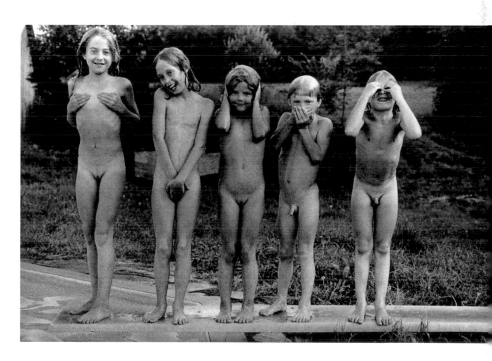

SENSE OR NONSENSE.

BEACH BALL VOLLEYBALL.

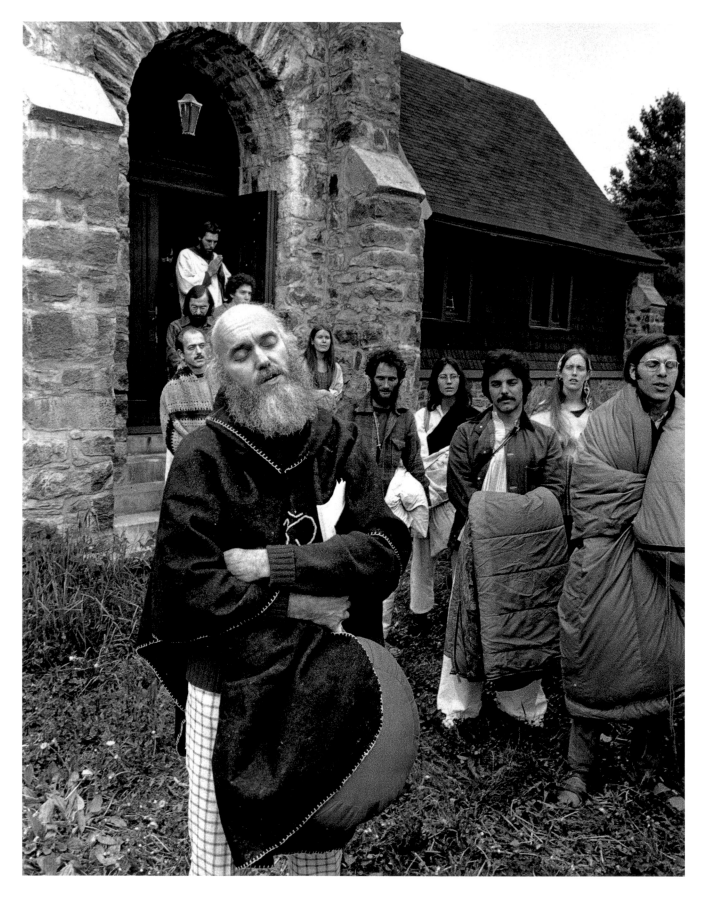

RAM DASS, CHANTING WITH HIS FOLLOWERS AFTER HIS ULTIMATE "SPEECH"

AT THE ROWE (MASSACHUSETTS) SPIRITUAL RETREAT, MAY 1975.

Searching for the Spirit

1973–1977

I never had any formal religious training. My
father was a nonobservant Jew and my mother a
disillusioned Catholic. To me, organized religion
was clueless and boring, and to a certain degree
frightening. I just didn't get it.

Even so, I yearned for a higher awareness of
the universe. Especially during my occasional acid
trips or moments of depression, I longed for a
greater understanding of our reason for being.
Some of that insight began to appear during my
Tree Frog era. One of our occasional guests, Peter
Strong, would read to us at night from a skinny
book called *The Lazy Man's Guide to Enlightenment*. And
Lacey Mason began a daily meditation on our living
room floor. She was into Eastern religion quite
early on. Had I caught on faster, our relationship
might have lasted. Lacey said I was too attached to
the material world to let go and be free. Addicted
to too many machines, she declared.

After Tree Frog broke up, I was desperate for
a new purpose. My hippie phase and druggie daze
left me bottomless. Cathy Brown, the woman from
the Hidden Springs commune who had been
denied admittance to Tree Frog, was finally single.
During one of my visits, we connected on all levels.
She was the perfect combination of stoned freak
and spiritual adviser. During the winter of 1973, I
took a chance and invited her to join me on a spir-

itual journey across the country. She was game,
although she warned me that she wasn't "easily
bought and sold." I was ready for enlightenment.
She showed me the way.

We made quite the electric couple as we mean-
dered about San Francisco, Marin County and
Mendocino. Cathy was oozing with energy, and
tended to draw people with her vibrant, cosmic,
spiritual glow. A highlight was attending a Ram
Dass lecture in Berkeley. We replayed a tape of that
lecture over and over again during our West Coast
bops and Hawaiian drop-ins.

Ram Dass, born Richard Alpert, had sub-
jected Harvard kids to LSD as an "experiment" with
co-conspirator Timothy Leary in 1963. He was
subsequently fired from Harvard and proceeded to
go on a pilgrimage to India, where he studied

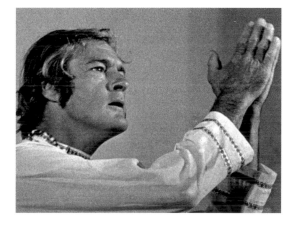

TIMOTHY LEARY
SENDS OUT HIS
MESSAGE, 1967.

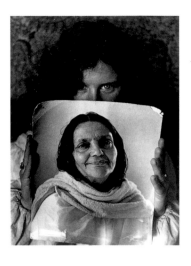
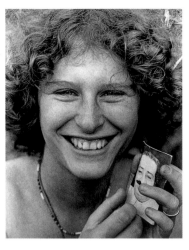

under guru Neem Karoli. He came back renamed and robed in white, a beaming, blessed being who could serve Eastern spiritual teachings to a Western audience. His groundbreaking 1971 book *Be Here Now* became a bible of sorts for New Agers who were longing for a deeper truth about God and the universe.

The "religion" Ram Dass taught was complex but laced with humor and self-deprecating examinations of his own journey toward spiritual awakening. All that he spoke of seemed at once real, exciting, rich with wisdom, and life enhancing. At that first lecture, I was attracted to his close followers, the audience, even the people selling literature and T-shirts in the lobby — the whole package. Cathy felt the same sense of connection. He was the perfect translator of Tibetan Buddhism and ancient Hindu teachings for a Western, educated audience. He preached unconditional love, letting go of attachments to existing "models" of the way "it" should be. Most of all he showed us how to transcend the "illusion of separateness" and become more aware that indeed, we are all one.

Ram Dass reminded me a lot of my father physically. I was drawn to him as a leader on many levels. I eventually hung on every word the man spoke, bowing at the feet of the master, as it were, and tried to incorporate all that he handed out into my soul. At the end of his Berkeley lecture, I meekly went up to the stage to give him a copy of *Moving On / Holding Still,* my first book of photographs. I so desired his acknowledgment and approval. He gave the book a gentle kiss and stashed it in his woven bag of spiritual gizmos.

The following fall, after having memorized and dissected hours of Ram Dass tapes, I attended a three-day "dharma festival" in Boston. It was a spiritual extravaganza with lectures by various well-known masters, including Ram Dass. There was sitar and tabla music everywhere and a plethora of beaded, loving beings. Incense was in the air and massages were given at random. I had never witnessed such intense energy, en masse, in my life. I wanted more.

After one of the sessions, I followed Ram Dass back to where he was staying, at a semicommunal compound in Cambridge. After a few false starts, I approached Ram Dass about helping me with a new book I was formulating, *Encounters Along the Spiritual Path.* He liked the idea and remembered the book I had handed to him the previous spring in Berkeley. He indicated that there was another photographer, Rameshwar Dass, a longtime member of the *satsang* (congregation), whom Ram Dass trusted implicitly. If we were to collaborate, then he would consider writing the text. This was a big deal for me. The

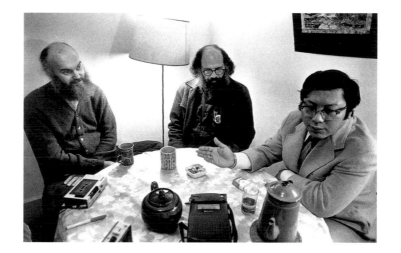

notion of producing a new book about the emerging spiritual community, with Ram Dass at the helm, was beyond my wildest expectations. My journal entry, about a three-way press conference between Ram Dass, Rimpoche, and Allen Ginsberg on October 29, 1973, observed:

So much has gone down these last three days that my head is absolutely reeling in the years. I feel so emancipated and freed from such a HEAVY LOAD — looking into R.D.'s eyes and sensing the oneness and human dilemma, and seeing my own path so much more clearly now — not only in terms of the spiritual book but a sense of my own worth and Karma. During a question-and-answer session between the assembled media and the three gurus / teachers / masters, I humbly raised my hand and asked, "Do you have the answer as to why we are all alive, on the planet, and living the kind of lives that we do?" Each one hemmed and hawed, and finally Rimpoche blurted out, "That's not for us to know, at least during this lifetime." Was that a cop-out? Who's to know?

After that encounter, all I could think about were gurus. I had a new passion and wanted to explore all the angles. In that I liked to create book projects out of personal fascinations, the spiritual journey book seemed like a perfect marriage. A new "master" on the circuit, Guru Maharaji, who was only fourteen years old, was making quite a splash at the time, and a humongous gathering was scheduled in the Houston Astrodome. I made plans to

attend with a few objectives in mind: (1) Get magazine assignments to pay for the trip. (2) See what all the commotion was about — was he the real thing? (3) Check out as many so-called gurus as possible to see if, in fact, Ram Dass was my first choice. It was somewhat like going to a spiritual supermarket to choose from the latest products. On my plane trip to Houston, on November 2, 1973, I wrote:

Why do people need gurus? I've been puzzling over that one for a few days now — seeing Ram Dass, Bhagawan Dass, Rimpoche, Hilda [Charlton], and Satchedenanda, and reading up on Guru Maharaji — somehow the majestic force that causes people to surrender EVERYTHING (including Rolls-Royces) to a holy spirit hasn't completely made sense to me yet. . . . Although I'm digging the messages / teachings as they are being handed down through the words of these wise beings, and do become "blissed out" by the end (mostly due to the combined group love and higher vibrations present), I don't feel so attached to the person that I feel compelled to bow and pray at their feet. I do get "that way" from a Ram Dass session, mainly because I love his way of phrasing / sense of humor / wisdom and the amazing caliber of beings he brings together. . . . I see him as an uncle / father / human and teacher — all in one.

The Guru Maharaji phenomenon at the Astrodome was Eastern religion at its commercial worst. There were slogans on the scoreboard hailing the chief, banners and posters of the teen's

radiant, glowing (and airbrushed) face for sale. The media was there, including *Rolling Stone* and the *New York Times*. I tried to imagine what it would be like to be a "premie," an in-crowd name for a follower. I looked at the premies with a detached curiosity; at least they were searching for knowledge, and who was I to judge? Ultimately, the beauty of the master's plan was in the eye of the beholden. The three-day scene did prove full of photo-ops. So not all was lost, although I felt that I was more the seer than the seeker.

Though my interest in spiritual growth was not dampened by that episode, I became more choosy. I began going to a weekly meditation class in New York, led by a glorious elderly lady named Hilda Charlton. Many of my newly made Ram Dass guru buddies went to her meetings too. Her meditations were powerful and uplifting. I would leave that little church on the Lower West Side of Man-

hattan full of love and light. My ride back to Riverdale was so floaty at times that it was a wonder I made it home. I would smile so broadly at the tollbooth people on the Henry Hudson Bridge that they must have thought I was either inane or insane, or both!

Fairly abruptly, I decided to go back to California over the winter of 1974 to continue my search for the spirit. Ram Dass had mentioned that he would be spending the winter out there and that if I was really serious about doing a holy book, it would be a good place and time to define the project. Again, I took Cathy Brown along as a companion — the perfect choice, a guru-seeking traveling mate.

Soon after Cathy and I descended upon the Bay Area there was a three-day Celebration of Consciousness festival at a downtown San Francisco auditorium. I was in awe of the extent to which the New Age movement had developed in California — health food stores and organic supermarkets everywhere, New Age bookstores scattered through the city, people wearing holy clothes walking the streets with the hoi polloi. At the festival, there were perhaps two thousand seekers attending lectures and demonstrations covering every facet of the new age: Rolfing, biofeedback, yoga and tantric exercises, rechanneling sexual energy up the chakras and out the top of the head, tabla players, and incense producers. People in attendance seemed very open to meeting one another and eye contact was intense — each one trying to give that "third eye" hit of awareness.

We eventually wended our way up the coast of California to the small village of Guerneville, where the Ram Dass contingent had set up shop. It was a strange compound — a group of small cottages in a grove of huge redwood and eucalyptus trees.

SAINTS FOR SALE, 1974.

THE HARE KRISHNA PEOPLE,

BOSTON, 1973.

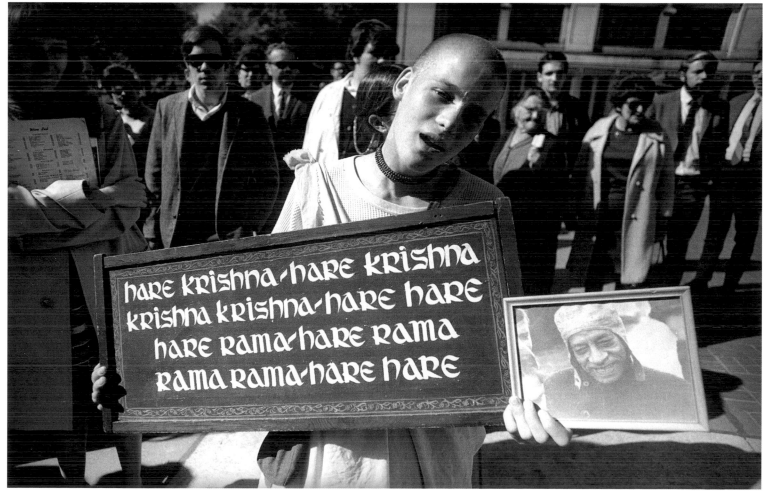

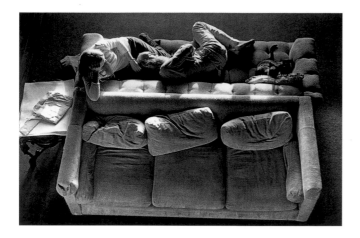

RAM DASS AND FRIEND, OFF DUTY AT OUR BERKELEY HOME, MARCH 1974.

Cathy and I arrived unannounced late one stormy afternoon. Ostensibly, I was there to discuss the spiritual book project with Rameshwar Dass, and Cathy was my traveling companion. In reality, we were both spiritual refugees in search of a new extended family. Among the Ram Dass *satsang* were musicians of varying degrees of talent but who were serious about putting out a double-record set of traditional Indian chants mixed with contemporary compositions — an eclectic brew. Most of the members of this *satsang* dated back to 1970, when they all met in India while taking *darshan* (auspicious viewing) from their guru, Neem Karoli. It was a tightly knit group with well-established in-jokes and frames of reference. While I felt myself an outsider, I knew in my gut that I had finally found my true ancient brothers and sisters.

The feeling wasn't all that mutual, at least at first. There was an inherent, built-in defense mechanism that seemed to keep newcomers at bay. I understood, having dealt with people who wanted to visit Tree Frog for the pretty women, nude gardening, home cooking, and a place to crash. Here the two of us were, in almost the exact same position.

The first night, there was a marathon slide show. First we sat through perhaps three hours of

shots taken in India of the wonderfully obese, blanketed Neem Karoli, with a shaved head and a walrus mustache. I sensed the extent of their love and devotion to this being and the enormity of their shared experiences. The slides, mostly by Rameshwar Dass, glowed in the love and warmth they projected. When I finally put on my tray of slides (a quickly edited assortment from Tree Frog and the Vineyard), there was no way I could hold my own, although the assemblage seemed to get a kick out of my images and the "hedonistic lifestyle" they portrayed. They would taunt, "Let's see more of those naked teenagers!"

After a few more days of group activities (preparing food, praying and chanting, running errands), we became more comfortable with one another. Guerneville itself, though, was a dark and clammy enclave, and the living conditions were marginal at best. In that the group wanted to record in Berkeley, Cathy and I were elected to scout out a home there that was large enough and whose landlord was willing to rent to a bunch of whacked-out New Age exponents.

Such a headquarters magically appeared — a magnificent homestead high on a perch overlooking the Berkeley hills. Amazingly, the landlord turned out to be a friend from my childhood days on Martha's Vineyard. And so the deal was consummated and the house was ours for three months.

Living at 181 Vicente Road had its ups and downs. The comings and goings of Ram Dass's friends and groupies and the convergence of the *satsang* reminded me a bit of Tree Frog with its constant chaos and close proximity of humanity. The main difference was the common link — a sometimes spoken but usually unspoken sense that we were together to share our spiritual evolution via

varying forms of teaching and practice. Also, the house was more tightly run — there was a higher consciousness abounding — and Ram Dass saw to it that we all kept honoring and respecting one another's differences. There were many moments that were as loving and spirited as any in my life (such as chanting and praying around the fireplace at night, or just gossiping with warm laughs among friends in the kitchen while doing the dishes). While I *knew* this was a special chance to experience the spiritual path, I was also able to stand apart, observe this new phenomenon, and judge it against my past experiences:

I no longer see "the path" as a means to an end but rather an attachment to a form / lifestyle / common goal for people to

connect themselves with. But I must say, here in print, that there is uptightness and hypocrisy here, as there was at Tree Frog, at my childhood home in Riverdale, or even in the Nixon White House. But this "adharmic" element is on a much higher level. We are probably more conscious about attempting to work on ourselves / be honest / be loving / be real with each other. Yet my own idealism about R.D. and his satsang is slipping quickly into realizing that the human predicament is still right here with us all: ego / gossip / drunkenness / lust / guilt trips / money-and-power trips / false pretense and all the rest. We all have a lot of stuff to get through during this incarnation, and there is no hiding it away in the closet or under the rug. Wearing holy clothes, chanting and praying, reading spiritual books, and bowing and scraping are all very nice forms of acknowledging the spiritual quest, but it doesn't make us better people, instantly and on all levels.

Ram Dass took a trip over Easter to Hawaii, where he delivered a series of lectures. I went along for the ride and conducted a long Q&A interview aboard a 747 for the *New Age Journal,* a new magazine devoted to higher consciousness. We spoke at length on all the subjects of which I had sought a deeper understanding. Who is God? Why do we care? Does meditation really help? If we can't love someone, is it a shortcoming? Is sexual desire a distraction? Why are we afraid of death? How does one let go of attachment to material things?

Ram Dass answered each question as specifically as he could, but the overriding theme was always the same: Let go of attachment to the form. All is goodness, all is grace, and it all blends into one eventually. That is the ultimate path to God. Individual differences are a distraction. The higher we get, the less all this stuff means. If the plane we're on crashes the next minute, so be it.

While we were in the glorious tropics, a sexual tension developed. In that Ram Dass was openly gay, I had sensed that this predicament might arise at some point. I was both flattered and mortified. I politely declined. He graciously accepted the rejection, but a slight emotional tension then set in. He wound up needling me a lot about being a "lazy seeker" — attracted to the scene for social reasons rather than paying attention to some of the harsher disciplines. He suggested that I get more serious about my *sadhana* (spiritual practice) or else get off the bus.

As usual, Ram Dass was right, if uptight. I tried to uplevel my daily rituals — meditating longer, reading more holy books, putting up photos of various masters on my wall, and redirecting my thoughts away from women. I realized I spent far too much energy searching for Mrs. Right as opposed to God. These were lessons worth learning, and I did feel more God-intoxicated the more time I spent being less distracted. It was a blessing to receive Ram Dass's teachings so directly.

Springtime in the Bay Area came alive with Grateful Dead concerts, swarms of hippies and devotees strolling along Telegraph Avenue, excursions to spiritual retreats with friends from the *satsang,* and work in the recording studio for an album called *Swaha.* The entourage was called Amazing Grace. The music, a cross between folk and Indian chants, was achingly beautiful — trancelike and meditative but also melodic and hooky. A rare combination indeed. George Harrison's album *Living in the Material World* had just been released and sent me to the same place. I would drive around

the Berkeley hills, windows open to breezes flush with the smell of eucalyptus trees, soaring to the sonic energy of the notes.

On one memorable night, we rented out a concert hall in San Francisco called Winterland to help raise money for the completion of *Swaha*. Although we barely broke even, the occasion was an experience of thrills and chills. Along with a few others, I took a bit of acid (my last trip ever), and the night melted into a dreamy winterland of merging red and blue lights, slides of Neem Karoli in a thousand various poses and expressions, hypnotic drones of the sarod and vocal incantations, tablas galore, and timeless anecdotes from Ram Dass spaced between the music and chanting. The audience of New Age and Ram Dass devotees was willing to stay till six A.M. It was an eery, ghostly night that brought up images of my life passing before me.

Backstage, while I was reeling through the cavernous corridors of Winterland, my eyes fixed upon a lady who I noticed was giving me a good look-see as well. Both extremely high from all the shared energy in the hall, we just hugged each other very warmly and tightly — feeling the place where we were one, cutting through the initial uptightness. We stayed close for the rest of that enchanted, bleary predawn daze, eventually wending our way back to the stage. She was totally starstruck. We just smiled and cuddled, drifting in and out of consciousness, until the end of the show. Ram Dass officially ended the occasion by saying, "I think we've all had enough by now. Go home, get some rest, and we'll all get together again in some other lifetime."

Grace became my girlfriend for the next two years. Cathy and I, the cosmic couple, had separated. Cathy was looking for a true guru, and that I

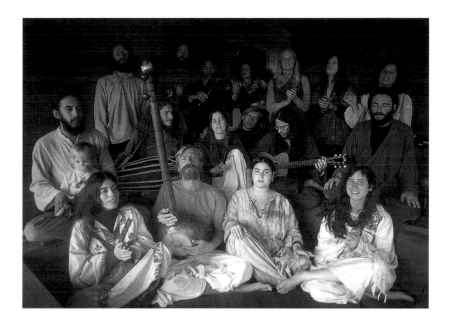

MEMBERS OF THE RAM DASS SATSANG POSING FOR THE AMAZING GRACE MUSIC GROUP PHOTO, BERKELEY, 1974.

was clearly not. I was just another traveler. She got hooked on one of Ram Dass's former lovers and exponents, Bhagawandass, whom she eventually married. Five years later her marriage dissolved in great discord.

Before I left Berkeley, I had one last meeting with the Dass brothers (Ram and Rameshwar). We agreed to stay in touch and to determine whether there was a market for a book about "the path." After all that I had absorbed over the past year or so, I was convinced that a book would be worth the effort — if not for the money, at least for enlightenment's sake. They suggested that I keep shooting.

Grace and I spent a nourishing summer on the Vineyard, filled with love and spirit. We meditated, did yoga, drank herbal tea, and practiced healing techniques. But we missed the group experience. Many of the Ram Dass devotees moved to New York in the fall of 1974. Why? Because Ram Dass had discovered a "totally realized being" there. He sincerely felt that Joya Santanya (formerly Joyce Green), a fairly crass, uneducated woman from Queens, was the nearest thing he had found to God

KEN KESEY AFTER A
LECTURE IN HAWAII,
1974.

WAVY GRAVY, NEW
AGE HIPPIE
SPOKESMAN, ON
HIS BACKSIDE,
SANTA CRUZ, 1974.

since Neem Karoli. He said that "God doesn't always come in perfect packages."

We went to check it all out that winter. The first thing we did was to attend a Hilda class in Greenwich Village. Ram Dass, Hilda, and Joya were a triumvirate by then, each one feeding off the others' *shakti* (spiritual energy). I was zapped. February 7, 1975:

My spiritual quest is picking up steam once again. The Neem Karoli satsang is in full force. Hilda's meditation tonight had me soaring. I really did feel my body dissolving. For a while there, I really felt totally swamped with God's nectar. I never wanted to come back to earth. Usually I'm slyly checking my watch to see how much more time there is left to the meditation. This time, I didn't even know what time was.

Grace and I spent the rest of the winter traveling around the U.S.A. with a booklet in hand called *The Spiritual Community Guide.* It listed all the yoga and meditation retreats, all the organic New Age restaurants, and all the masters who had head-quarters in the United States. We must have stopped at twenty such destinations. I had an eye toward my possible book with Ram Dass, but I was also literally following "the path." Each scene had its own guru and set of rules. A few of the situations seemed like total rip-offs, where the resident guru hoarded Cadillacs while asking his followers for all their money. Most just seemed not my style, which I came to realize was more "Jewsy-schmoozy."

That spring, I attended a four-day retreat in Rowe, Massachusetts. Ram Dass led the series of lectures. May 29, 1975:

Today, my teacher gave his finest lecture I could imagine. He spoke of the fact that all the spiritual sacraments and symbols have a real life of their own; we only need to tune our awareness onto

their level of reality. As we all left the little church, chanting and wailing, we were literally in heaven. The springtime air was thick with love and devotion. I wish I could just jump right into the whole "God Squad" — be totally celibate, meditate four hours a day (breathing out the heart shakra, in through the nose, out the third eye), and performing all the asinas as Krishna Dass described. The love we share, even for people I have never met, is truly rare. There is an unspoken knowledge that we all have the desire to be pure, simple, loving beings, just emanating love and life as humanly possible, and to scatter it in all directions. A cosmic glance is so nourishing, like giving a wilted plant sunshine and water. What holds me back from simply moving to New York and sucking it all in? I guess I'm just not ready to give it all up, just yet.

"It" was another summer on the Vineyard, full of tennis, golf, softball, photography, and sex — all the earthly desires. In August, I organized a Ram Dass *darshan.* Many of his followers migrated to the island for it. My little property became a New Age

MASTER GUITARIST JOHN MCLAUGHLIN LOVES HIS GOD, NEW YORK CITY, 1973.

tent city. I had perhaps a hundred people staying overnight, cooking, eating, sharing, and believing. I had my first personal discussion with Ram Dass since Hawaii (a year and a half earlier). August 19, 1975:

Eyes tearing, voices wailing, hands touching, eyes gazing. A staggering display of human potential — all happening on my front lawn, no less. At times it all seemed so powerful, so all-consuming. At other times I felt like I was just posturing. Both the same? I doubt it. I asked R.D. about moving to New York, was I ready? He said flatly — no. If I had any desire to keep my current life intact, I might as well forget about it. He said he doubted that I was willing to make the sacrifice. As I drove him to the airport, he really surprised me by saying he actually admired my lifestyle, and encouraged me not to go celibate because women seemed to need me so much.

I lived the rest of that summer surrounded by women, a playboy's dream come true. Ram Dass had turned me loose. My little "love shack" was filled with holy trinkets, spiritual posters, tapes and books about God, trancelike music, and loving voices. At one point I recall some "orange people" (followers of Bhagwan Shree Rajneesh, an Indian master who ran a center in Oregon) showed up to conduct a "chaotic meditation" on my lawn. One of them fell into the pond and almost drowned. That was the end of that idea.

As winter approached, all the sun-tanned glory of my summer faded away. Grace enrolled in a ninety-day meditation retreat. I tried being celibate, as I knew that was a requirement for the Joya group. I became terribly lonely. I called my dharma friend David Silver for some advice. He said,

MY FIRST PICTURE OF RONNI, WALKING ALONG THE VINEYARD DUNES, NOVEMBER 1975.

"Look, Pete — what you have out there on the Vineyard is all illusionary. Come join us in the fire of growth." David (renamed Shirdi Ram, incidentally) was enmeshed in the Joya scene as well. If he could do it, why couldn't I? I had always considered David a good barometer. I asked him if people really had to stop sex altogether. He said, "Have fun trying."

With all my baggage packed for the trip to New York, I took a fateful side trip to Boston. I was invited to a friend's carriage house in Cambridge for a "World Serious" party — the seventh and deciding game between the Red Sox and the Cincinnati Reds. Most of the people there were familiar faces from the Boston Ram Dass contingent. But there was a new face in the crowd. A haunting face. A beautiful face. Who was she?

Someone told me her name was Ronni Berman.

When I first caught sight of Ronni that night, everyone else in the room seemed to slowly fade. Hers was the only face that remained in full detail. By the ninth inning, I made my move. With the Red Sox losing 5 to 3, I suggested that we all hold hands to give the Sox an energy boost to stage a comeback. This was the perfect excuse to hold Ronni's hand without coming on to her. Alas, the Red Sox didn't rally and the evening seemed like a total loss. Luckily, I happened to be on the press list to see a reggae group, Toots and the Maytals, that night. I asked if anyone wanted to join me. Finally, after an agonizing fifteen-second silence, Ronni, with a hesitant voice, said, "Okay, I'll go."

For the next five hours Ronni and I jumped right into each other's lives and exchanged all the

nitty-gritty details that it sometimes takes months to uncover. Toots had come and gone by the time we showed up at the club, so we just walked along the Charles River, exploring our possibilities. She too had been raised in New York, and we shared many frames of reference. She was married, but had recently separated. She had moved to Boston to further her career as a potter and was taking classes at Boston University. Ronni was young, only twenty-four, but she had taken psychedelic drugs and gone to India seeking spiritual enlightenment. And if all that wasn't enough, she was a vegetarian and loved to cook.

Later on, when we returned to the carriage house (where she was living), Ronni wasn't about to invite me in. I asked for some tea, and she relented. Since she lived in a group house I suggested we drink the tea in her bedroom. After some gentle persuasion she agreed. I sat on the edge of her bed for an hour, it seemed, continuing the dialogue. Finally she said, "Well, Peter, I've got school in the morning, and it's two-thirty . . ." That was my hint to get up and go. But I was transfixed, so I decided to reason with her. "Ronni, I really like you, I have nowhere to sleep tonight, and I'm practicing celibacy. Will you let me stay with you on those terms?" I really had a choice of many places to stay but was too tired and too entranced to move. She relented again. We wound up cuddling and sleeping in spurts. It was a joyous sharing. A good start. The next morning she left early. I slept late and then left her a note under her pillow — "Ronni, if you ever come to New York, please call me. Maybe we can go to see Hilda together."

The Ronni episode was crucially timed. Just as I was about to be swallowed up by the New York God Squad, my total surrender was tantalizingly sidetracked. With my memory of Ronni tucked

sweetly in my back pocket, I presented myself to Joya and Company one melodramatic Friday morning:

A bite out of the Big Apple — one of the heaviest days in my life. After comparative smooth sailing and undeserved grace, the shit has hit the fan. At 9:40 I was whisked into a small, cramped room with THE Joya Santanya, Ram Dass, and Hilda sitting on a platform with twenty or thirty of the closest followers gathered around. It was my day of reckoning. Someone said, "Joya, Peter Simon is here to see you." Joya said, in a grating Queens accent, "Yeah — will you please bring the phony in." I feared all my secrets and pathlike affectations would be exposed at last, and I would stand naked for all to see.

Joya held both R.D.'s and Hilda's hands as she lit into me as I have never been dealt with before. Her approach, or should I say modus operandi, is to be as fierce and hostile as possible. This, I am told, is the fastest way to let go of ego illusions and defense mechanisms that only preserve the attachment to false values. To me, it was blatant sadism. Joya used her screeching voice, menacing expressions, and dramatic gesticulations to get across her various points. She seemed to be almost foaming at the mouth. At one point she slapped me across the face. She asked me various questions that I felt too intimidated to answer properly. . . .

Joya then asked Hilda what she wished "to do" with me (since Hilda had already branded me as one of her own students). Hilda couldn't decide and asked R.D. to make a decision. He closed his eyes for three minutes while he meditated on the answer. Then, in almost a whisper tone with little compassion, he said, "Peter shouldn't be in this Friday group. I'll take him into my monthly class." Phew. At least someone wanted me. After that, Hilda changed her position on the stage and sat down in a new spot and wound up sitting on and crushing a framed photograph (used for devotional purposes) of Joya. People were too scared to laugh or react to this. Other words and half-phrases/glances/breaths were exchanged. It all seemed so surreal — I kept expecting Rod Serling to suddenly appear and inform me that this was indeed the Twilight Zone.

Here were all the people I had thought of as family and it had come to this. No one dared say anything or even give me a smile. Eye contact was avoided. I felt so alone and confused. Hilda came to my rescue at that point and led me to the door, speaking softly in my ear, saying, "Don't worry too much about Joya. This is just her way of showing love. The meaner she is, the more she cares." . . .

Aimlessly, feeling only half-conscious, I managed to find my car. I drove about the city streets and realized there is a whole universe full of people coming to and fro, some wealthy and successful, some homeless, all at different stages of evolution, all looking for liberation in one way or other. There seemed to be so many paths to enlightenment and self-realization, why was I so attracted to this (Joya/Hilda/Ram Dass) particular form?

All this confusion carried over into the early phase of my relationship with Ronni. After one weekend in New York, we decided to take it slowly for a while, but the pull to be with her was too strong, and we spoke on the phone as soon as she got back to Cambridge. We made a plan to rendez-vous on the Vineyard the following weekend. On a glorious, unseasonably warm Saturday, we went to the beach, came back to the house, and finally made love as the hazy afternoon sun soaked into our skin through the window. Despite breaking the "rule," it felt like the right thing to do. It brought us so much closer, and I felt quite in love with her and not at all guilty. I was happy to have overcome the Joya spell.

The next week, the monthly Ram Dass class took place up in Cambridge in, of all places, the carriage house where I had first met Ronni and where she lived. There are no coincidences, or are there? What could be more perfect? I basically moved into Ronni's attic/loft space, and we did our best to prepare for the classes. This entailed keeping a daily journal detailing how much time was spent meditating, chanting, praying, sleeping,

THE "GOD SQUAD" IN NEW YORK DURING THE EXTREME SHAKTI PHASE: RAM DASS, JOYA SANTANYA, AND HILDA CHARLTON, 1976.

and eating. We were not allowed to smoke pot, have sex, or sleep more than six hours a day. We obviously didn't adhere to some of these restrictions, but Ram Dass was more lenient than Joya. For this I was grateful.

In mid-December, Grace finally emerged from her meditation retreat. She knew nothing of my relationship with Ronni and was fully anticipating getting back together and planning our future. It was difficult for me to tell her the whole truth all at once. As we walked along the lovely tree-lined streets of North Cambridge, I told Grace slowly that during her absence I had fallen in love with another woman and that I could no longer consider her a lifelong mate. She began to cry. We hugged for a long time. I still loved Grace, and were it not for the seventh game of the World Series, we could have been heading together for one of those *satsang* apartments in Queens.

SUFI DANCING AT THE HILL HOUSE COMMUNE IN
WESTERN MASSACHUSETTS, 1974.

TANTRIC YOGA CLASSES IN AMHERST, MASSACHUSETTS, 1977.

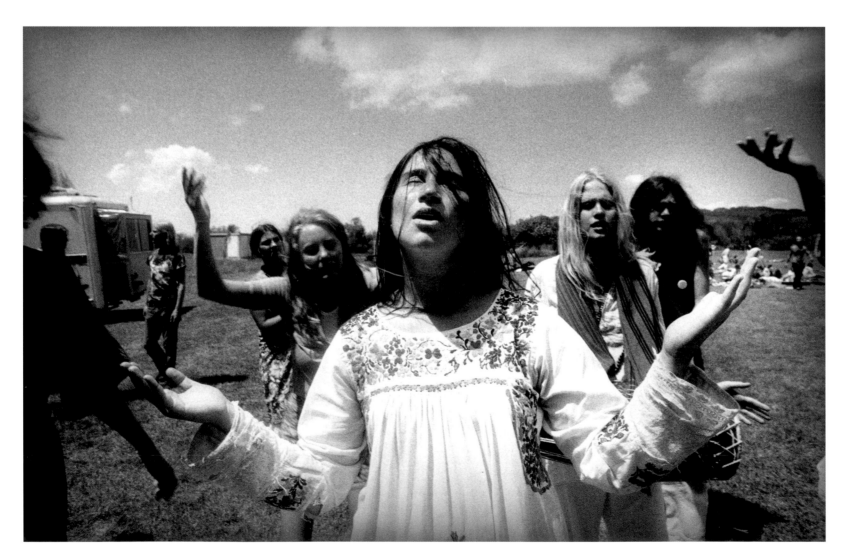

WE ARE ONE IN THE SPIRIT, SONOMA, CALIFORNIA, 1974.

Following that sad walk, Grace, Ronni, and I meditated together. Despite the tension that had been building, we were able to share the same space and see the place where we were one together. Our hearts had been opened up wide during the past few years of spiritual work, and I was overcome with love for both of them. Through tears and laughter we tried to achieve peace and a clear understanding of the unfolding events.

My relationship with Ronni became a focal point, and my desire to commit so much time and energy to "the path" began to lapse. David Silver, who gave a Joya-blessed class at his apartment on West Seventy-ninth Street in New York, told me he certainly wasn't about to give up sex with his wife and that he more or less lived his life as he saw fit. I adopted his laissez-faire philosophy; I took what I needed and left the rest.

Meanwhile, Ram Dass, Rameshwar Dass, and I had finally put together a book proposal that would combine Ramesh's and my photographs with Ram Dass's text. We called the book *Innerview* and got a deal with Dutton. We received a twenty-thousand-dollar advance and split it three ways. Ramesh and I spent many hours in the darkroom printing negatives, and Ram Dass started working on his text.

But after about four months of work, a shock wave of gossip circulated around the *satsang*. Ram Dass and Joya were said to be having an affair. The fact that she was married, he was gay, and that they preached celibacy to all their followers made us wonder whether we had been misled and betrayed. The justification was that she was only doing it to help him "get over his sexual hang-ups." Finally, Ram Dass admitted the truth, much to his embarrassment. He even wrote an article for the *Yoga Journal* called "Egg on My Beard."

In the spring of 1977, when Joya and Ram

Dass split up, followers were forced to take sides. I had no problem — Ram Dass was my man, even though I had lost a bit of respect for him. Ramesh, on the other hand, stayed with Joya for some reason. This made our collaboration impossible. Ram Dass wrote us each a letter saying he was tearing up the contract and returning the advance. He was willing to pay us each $3,500 from his own pocket, as we had already worked hard and he felt ashamed. It was a very sad resolution to what could have been a wonderful book.

Ronni and I decided to get married; our

RONNI AND RAM DASS SHARE A DANCE AT OUR WEDDING.

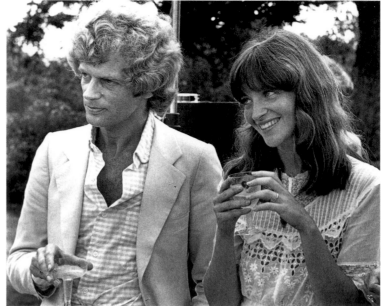

wedding day was July 9, 1977. We asked Ram Dass to officiate the ceremony; he graciously accepted. We planned it down to the smallest detail. It was an eclectic ceremony that used elements of Judaism, Buddhism, and American Indian rituals. At one point, Ram Dass had us each stare at ourselves, using a two-sided mirror. Then we meditated while looking into each other's eyes. Then he took a blue string and intertwined it among the fifty or so loved ones present. We all held the string at once and prayed for the happiness of our union, and for the unity of mankind. My sister Joanna sang "The Lord Bless You and Keep You," a song my three sisters used to sing as we grew up. At the end of the ceremony I crushed the wine glass with a rock, because we were all barefoot. And then the party was on!

Ram Dass had always chided me about using the spiritual path as a vehicle to find a woman. He turned out to be, once again, right. It had all come full circle. It was God's way of allowing me to search for and find Ronni, and our way of living with his blessing — a pact we have held as sacred ever since.

The summer of 1977 was probably the most joyous of my life. I had arranged a Chilmark home for Ram Dass overlooking the north shore, a home my parents once rented in the fifties. His coterie shared the rambling house, and we revisited the Berkeley experience, this time in a vacation/celebratory mode. We would have many spontaneous dances and meditations by night, and spent hours praying and chanting as we watched one glorious sunset after another over Vineyard Sound.

The post-Joya Ram Dass was ever more humble and more deeply loving and compassionate, less judgmental, more accepting. The lessons I had learned from searching for the spirit were never more apparent: The answers lie within, the teachings are just a tool to take along, a vehicle for deeper understanding — a means to an end. No one master/guru/teacher has all the answers — we are all just humans in different stages of evolution. Ram Dass had served as an invaluable channel for all the ancient Eastern teachings I never would have understood without his overlay. He was the medium for a profound message that is now woven deeply into my soul for this lifetime, and hopefully beyond.

PHOTOS FROM OUR WEDDING
CELEBRATION, JULY 9, 1977:

<

KATE TAYLOR, ELLEN EPSTEIN, CARLY,
AND JOHN HALL WERE THE WEDDING
BAND, SEEN HERE SINGING "CHAPEL OF
LOVE"; BEST MAN DAVID SILVER AND
RONNI LOOK ON AS I DELIVER A TOAST.

>

RAM DASS "OFFICIATES" OUR WEDDING
CEREMONY; WE CUT THE CAKE.

RAM DASS ON THE VINEYARD, 1977.

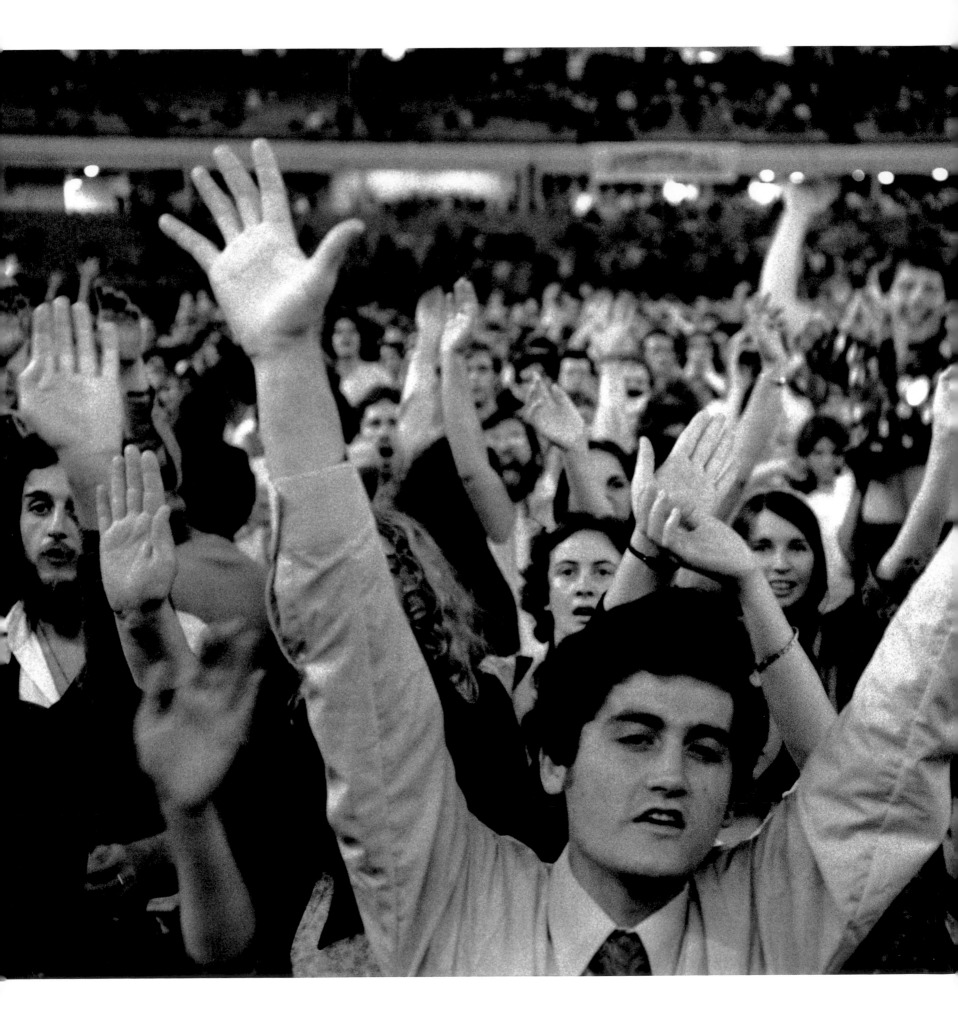

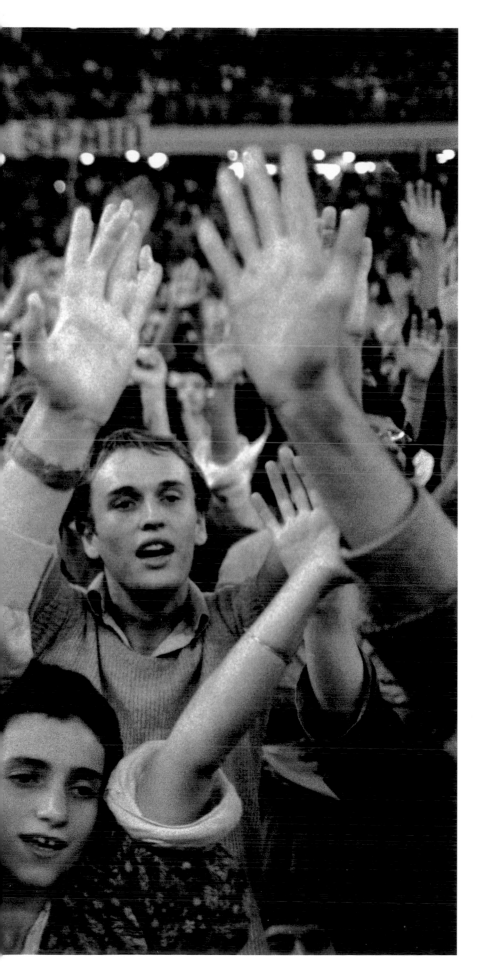

BLISSED-OUT GURU MAHARAJI DEVOTEES OUTSIDE THE
HOUSTON ASTRODOME, NOVEMBER 1973.

GURU MAHARAJI GIVES HIS AUDIENCE A CONTACT HIGH.

ARICA'S
GURU,
OSCAR
ICHAZIO.

YOGI SATCHENENDANDAH ("CAPTURE
YOUR DOLLAR") AT A RETREAT IN NEW
YORK CITY, 1974.

YOGI BAJAN AFTER THE "CONSCIOUSNESS FESTIVAL" IN SAN FRANCISCO, 1974.

SWAMI MUKTENANDA GIVES A SPEECH IN NEW YORK CITY, 1977.

DELIVERING THE ARICAN MESSAGE
AT THE LEARNING CENTER IN NEW
YORK CITY, 1976.

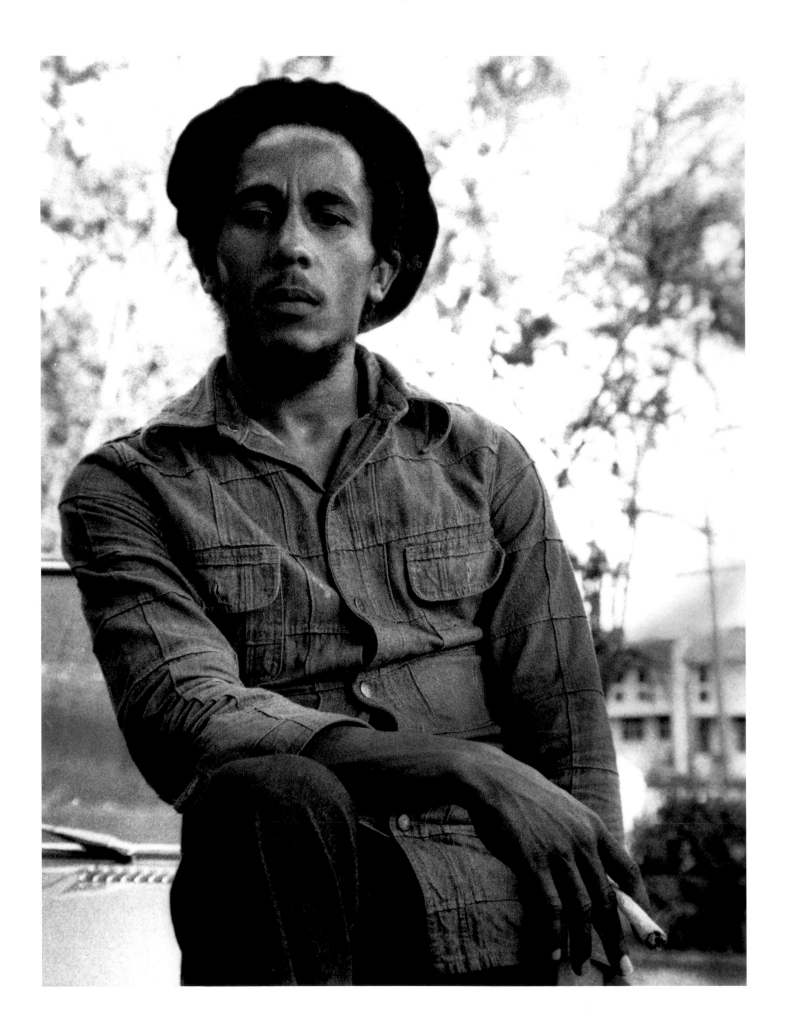

Reggae Bloodlines

1973–1976

It all started in 1973 — that is, my fascination with Jamaica and reggae culture. The movie *The Harder They Come,* starring reggae great Jimmy Cliff, riveted me. There was love in those Jamaican eyes. I loved the patois. And I adored the music, off-beat syncopation, and lyrical content, which was a strong presence in Jamaican reggae. The oppression that the Rastafarians felt reminded me of what we hippies had gone through in the late sixties. The sense of oneness that I had experienced through drugs and spiritual teachings permeated most of the movie's songs, such as the biblical "Rivers of Babylon" and "You Can Get It If You Really Want." I must have seen that film twenty times in two years, many of the showings being at the Orson Welles Theater in Cambridge at midnight.

For the next two years, I collected as many reggae albums as I could, but few were available in the U.S.A. I began hosting a late-night radio program on the Vineyard's low-key 5,000-watt station, WVOI (later renamed WMVY). It was a "free-form" show, i.e., anything I wanted to play. When I programmed reggae, the phones lit up. "Where can I get more of this?" the listeners asked. Thus, I played more and more Bob Marley, Jimmy Cliff, Toots and the Maytals, and Burning Spear, the leading reggae exponents at the time. This was at the expense of the Rolling Stones, the Beatles,

JIMMY CLIFF, THE STAR OF "THE HARDER THEY COME," REVISITS THE GHETTO OF HIS YOUTH.

Dylan, and Joni Mitchell. The show took off. I was suddenly on some kind of mission to expose America to this infectious third world music.

By 1975, the rudimentary nature of my reggae education was beginning to bother me. I wanted to know more, to scratch beneath the surface. Then one inspired day at a beach on the Vineyard, I had a revelation with my longtime friend and

< PERHAPS MY BEST-KNOWN PHOTO OF BOB MARLEY, SITTING ATOP HIS BMW

IN THE LATE AFTERNOON IN FRONT OF HIS HOUSE ON HOPE ROAD IN KINGSTON.

TOOTS HIBBERT OF TOOTS AND THE MAYTALS, AT A SUBURBAN BOSTON MOTEL, 1976. THIS PHOTO, ALONG WITH ONE OF JIMMY CLIFF AND BOB MARLEY, WAS USED ON THE FRONT PAGE OF THE "NEW YORK TIMES" ARTS AND LEISURE SECTION ON A SUNDAY IN NOVEMBER 1975, WHICH LED TO MY BOOK ABOUT REGGAE MUSIC, WITH STEPHEN DAVIS.

collaborator Stephen Davis. Why not go to Jamaica so that we could publish an entire book about this emerging musical form? Stephen was clearly intrigued, but as the waves crashed in the background, he rather objectively said, "I don't think there is a broad enough market for a book about this rather cultish, poverty-driven music." We started to cogitate. Perhaps an article in the Sunday

New York Times could set off a wave of interest. Stephen proposed such an article, and in the fall of 1975 the *Times* featured our reggae article on page one of the Arts and Leisure section. Sure enough, when we then peddled our proposal to the publishing world, Doubleday went for it, thanks to our foresightful editor, Marie Brown.

Thus, in February 1976, just as my newfound relationship with my future wife, Ronni, was blossoming, I was whisked away to the tropics. I suddenly found myself immersed in a culture about which I had no real knowledge. On the plane ride to Kingston, Stephen showed me a series of articles he had collected about reggae. He said, "Read all this stuff. Let's try not to look uncool." The articles contained names of people and performers I had never heard of and photographs of faces I didn't recognize.

Once in Jamaica, we had to acculturate gradually. We were not there to report on the tourist attractions but to record our adventures while seeking out the music and culture of the country. As a somewhat skewed introduction, we listened to the radio and read the daily papers. I dutifully monitored the radio shows, which alternately reported on local violence and governmental taxes and played middle-of-the-road R&B and disco music from the States. Where were the Rastas? How could we find the "real" Jamaica? The one behind the tourist posters and advertisements for Red Stripe beer and Blue Mountain coffee? What about the struggle to topple the "shitstem" and create a new order — one in which the Rastafarians (ganja-smoking folk with matted hair who believed that the late emperor of Ethiopia, Haile Selassie, was the messiah of the African people) could gain respect and dignity, and not be treated like third-class citizens in a third world country? Stephen and I had

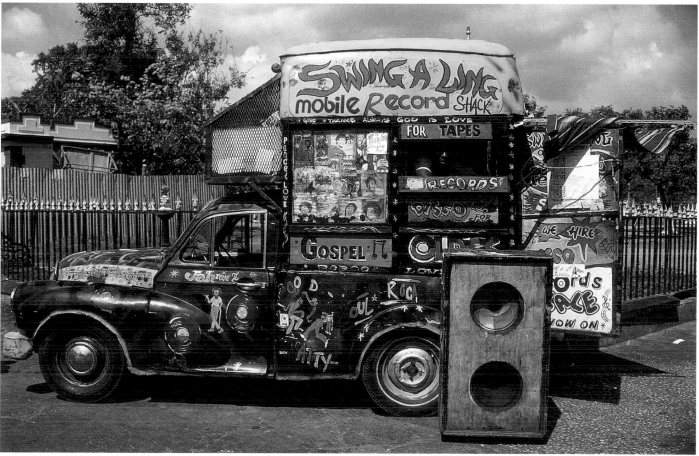

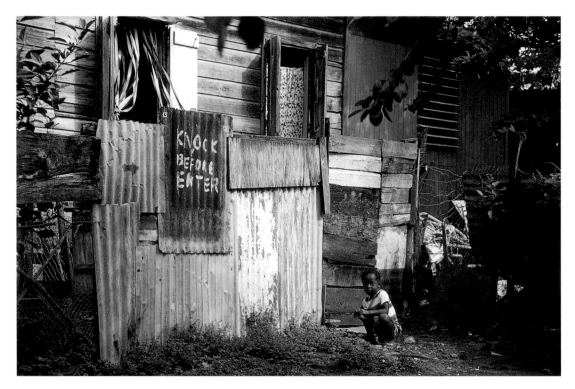

JAMAICAN ETIQUETTE.

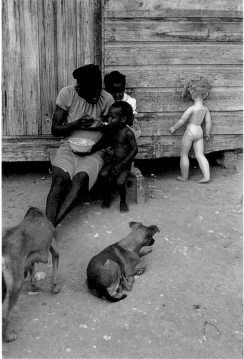

HARDLY ENOUGH FOOD TO GO AROUND.

to get past the postcard image of Jamaica to uncover the true roots of reggae culture.

What I heard was enlightening, but what I saw was frightening. Being the sheltered, upper-middle-class suburban college grad turned hippie that I was, I could hardly fathom some of the living conditions in Jamaica. There were ghettos where people had little food and lived in crowded shacks made of corrugated tin and scrap wood. Houseflies and mangy dogs fed on piles of garbage and filth that accumulated along the curbs. Kids with torn shirts watched me blearily as I self-consciously took out my gleaming camera and pointed my telephoto lens at them. Compassion I had, but the need to record overwhelmed me. I could finally understand what reggae was all about . . . a cry of suffering, bitterness, and despair at social injustice, and a plea for salvation. Songs like "Trenchtown Rock" by Bob Marley and "Mama Say" by the Heptones took on a reality that I could have only imagined before

this trip. At times the tears in my eyes made it impossible to focus my lens.

Stephen and I didn't have much of an advance for the book project, maybe ten grand between us. Out of this sum we paid for our plane tickets, car rental, housing, ganja, food, and the occasional reggae single (45s were the norm, as few people could afford a whole album) that we just had to have. But we hadn't anticipated this: Every time I pointed my lens at someone, I would hear, "Me pitcha ten dollah, yah know!" Sometimes they'd ask for fifty dollars, or whatever they thought they could get. A lot of hard bargaining would ensue. I had to make instant decisions about whether a given photo seemed worth it. Since the U.S. dollar was worth triple the Jamaican dollar at the time, foreign journalists and photographers were often forced to help relieve the poverty in this way. At times I wished I could give the entire advance to the ghetto youth. I even thought of getting in a heli-

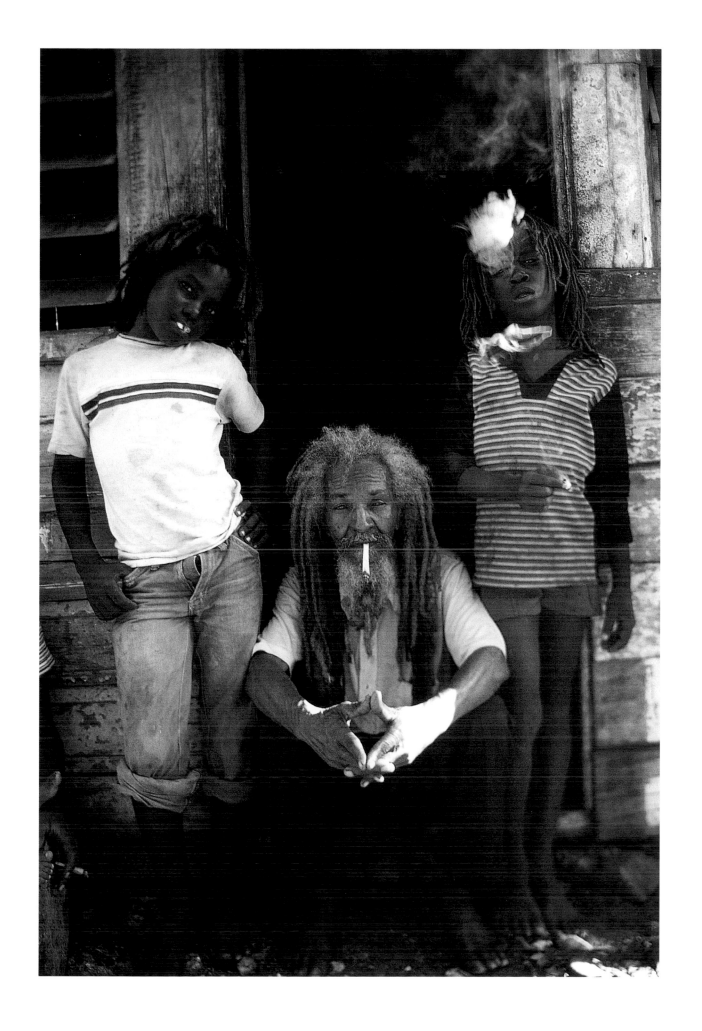

THE POOR MON FEEL IT.

THE KINGSTON REAL ESTATE MARKET.

BEACH LIFE ON THE

OUTSKIRTS OF KINGSTON.

copter, throwing money out the window, and showering the people with wealth. But Stephen and I were not in a position to do more than help by increments. What money I did dole out to various Rastas and bystanders I felt good about. It was a win-win situation, if nothing else. Establishing a sense of trust came first; the photos evolved later, as I soon learned.

During our two-month stay in Jamaica, we were able to avoid most of the violence that had ravaged the island for decades. But at one point, the car we were being driven around Kingston in was held up at one of the notorious police "road-blocks." I angered the police by taking photos of them brandishing their scary M-16 rifles. They stopped us, searched the car for drugs, insulted and humiliated the Rastas accompanying us, and were frustrated by the fact that they could smell the herb but could not find it. At one point we thought they would plant some and had nasty visions of being thrown in jail with little recourse. We even made up a ghastly headline for the daily paper, the *Gleaner:* "American Journalists Caught with Pot, Now on Death Row." But fortunately (or unfortunately), the Rastas were all too accustomed to this and knew how to stash it when necessary. On the way back home, one of our passengers pulled out a big "spleef" and said to us, "Now white mon know what it like. Can see how police violence is the cause of so much hate. Can see why Rasta must go home soon." (By "home" he meant Africa.)

In another incident, after Ronni came down to join our adventure for a few days, she and I were told of a nice, isolated beach outside of Kingston called Bull Bay, where we could relax for the day. When the wind picked up we decided to split. As I started the car, a ragged youth emerged from the bush and came over to the window, pointing a

knife at my throat. "Give me all your blood-clot money," he demanded. Instinct took over. I shoved the car into reverse and backed down the long dirt road that led to the main road. The guy hung on to the bumper and while being dragged along, he tried to slash the tires. Eventually he let go. There was a locked gate at the end of the road. I hustled out of the car and as I fumbled around for the key, Ronni shrieked, "Calm down, he can't catch us." The scene unfolded like a grade B thriller. My hands shook as I pathetically tried to insert the key in the lock and our pursuer sped closer. We managed to escape with about ten seconds to spare and made it back to our Kingston hotel with our tails between our legs, but with quite a tale to tell.

But these instances were rare. Jamaica, once I got used to it, was fascinating. I loved its quirkiness. The Rasta philosophy was particularly intriguing. Much of it seemed a natural extension of the spiritual teachings I had learned from Ram Dass and other masters. I did, however, have trouble swallowing some of their dogma, particularly the notion that the late emperor of Ethiopia was a messiah. After all, he was also known as a dictator. But I chalked that up to cultural differences. I enjoyed getting to know a new dialect replete with colorful words and phrases like "seen" (understand),

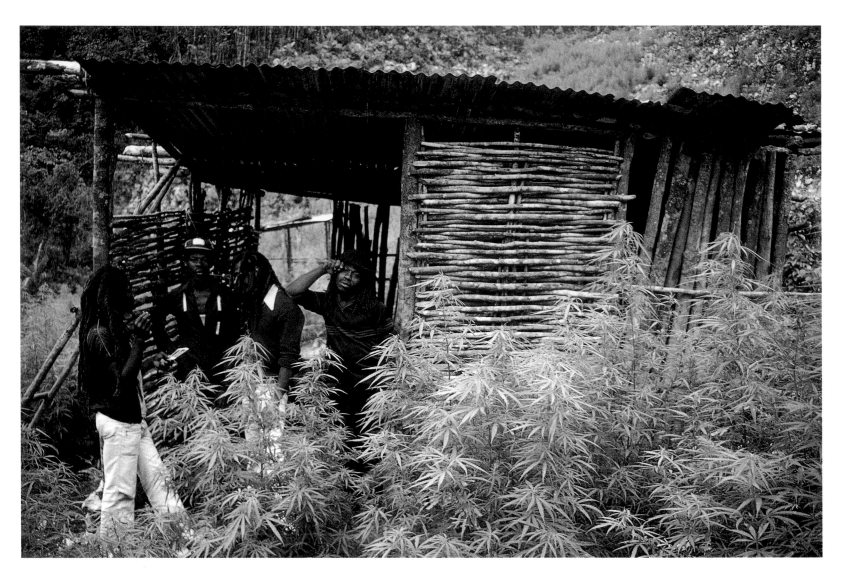

RASTAS HANG AT THEIR GANJA PLANTATION IN THE HILLS OF THE NORTH COAST.

"I and I" (I, me, you, we, they), "soon come" (don't hold your breath waiting for something to happen on time), "livicate" (dedicate), "bumba clot" (a swear word), "lickle" (a little), and "ya mon" (for sure), just to mention a few. After word of what Stephen and I were attempting to accomplish spread around Kingston, we were met with cooperation and respect. The Jamaicans could sense our appreciation of their music, that we were not out to trash it or exploit it. Even Bob Marley, a few years later while looking our book *Reggae Bloodlines* over, offered, "It does more good than harm."

The highlight of the trip had to be the day that Stephen and I were escorted to Bob Marley's home/hangout on Hope Road in Kingston. We had been anticipating photographing and interviewing him for some time, but as was typical in Jamaica, there had been a lot of false starts and glitches along the way. Finally we were there, to witness the master at the height of his powers. My journal entry dated March 14, 1976, says it all:

Ah, today we finally got to meet Bob Marley. He stayed with us for two hours, sitting on top of his BMW Bavaria while we

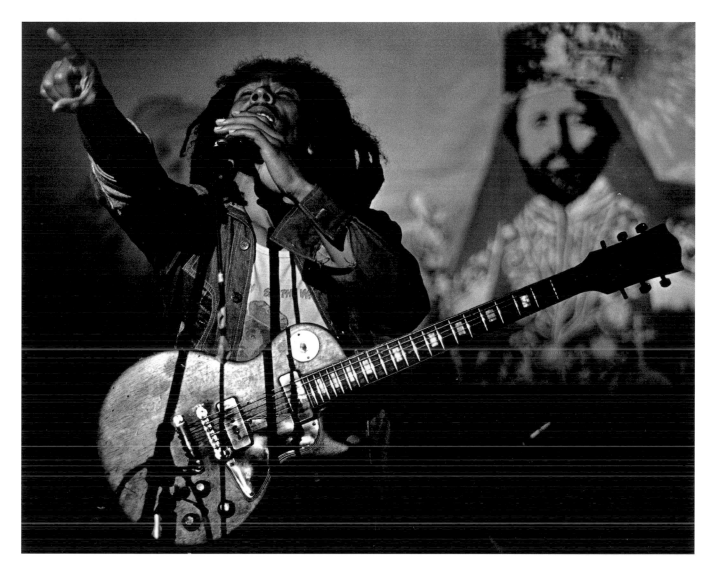

BOB MARLEY SINGS TO HIS IMPERIAL MAJESTY, HAILE SELASSIE.

gathered around him, asking mostly NYC-type media questions. He was patient and not overly condescending despite our obvious naïveté. Gradually more Rastas and hangers-on gathered by, and the scene evolved into a rather bizarre conglomeration, most of which occurred in the dark, hence — no photos of the event except for a few at the start. It was highly photogenic, but I hate using flash, and I could cry but I haven't.

Bob was his usual stoned, articulately nonunderstandable self, refusing to answer or else sidestepping certain queries, and babbling about others. Sometimes his prophetic lyrics seem much more advanced than his casual conversations. But it's my adoration of his music that attracts me, not his dreadlocks or svelte body,

although there is a certain bigger-than-life quality that comes forth at times. But for the most part, other than knowing he was Bob Marley, I may not have distinguished him from other Rastas that we've encountered. But now, at least, I can say I've met the true master, the Black Prince of reggae. JAH LIVE!

As the trip began winding down, having met most of the key musicians, stars, and radio people, and having visited the various recording studios and their in-house producers, we took off to the countryside to witness the island more in a vacation mode, with many stops along the way. The north

BANANAS FOR SALE ALONG THE NORTH SHORE OF JAMAICA.

coast, dotted with tourist towns such as Port Antonio, Ocho Rios, and Montego Bay, was scenic but predictably plastic, especially within the confines of huge hotels where guards kept the beggars and Rastas out. The contrast between the well-maintained high-end resorts and everyday Jamaican living was stark. While the country seemed somewhat functional from the tourist perspective (despite the undercurrent of violence and paranoia and the constant hucksters promoting their latest fare), the real story was the culture and roots music, not sipping martinis at Rick's Café in Negril. Indeed, much of what Stephen and I found in Jamaica was clearly not what the tourist board had in mind.

When we ventured into the back woods, particularly to a marijuana plantation, the sights were unforgettable. On the plantation we were guided through a field of budding plants, saw the harvest, and observed how the herb was hung to dry, then cut up and bagged. The Rastas worshiped ganja as a

holy sacrament. It became increasingly clear why so many people seemed willing to put up with such "substandard" living conditions. They were so stoned so constantly that they just didn't care all that much. Jah would provide.

At one point, we stayed overnight in a hut in a tiny inland village called Blue Hole. There was no electricity or running water. The people bathed regularly in a medium-sized pond whose water was strangely turquoise. A few people there looked at us and remarked curiously, "Whitey white!" It wasn't meant as an insult. Many of them had never seen a Caucasian before. Yet in the background I could hear the occasional roar of a 747 flying overhead.

We came back to America tanned and joyous. Stephen had nearly a manuscript's worth of notes. I had more than 150 undeveloped rolls of film, about 50 assorted reggae singles and albums, and many hours of taped interviews. We went to work, and *Reggae Bloodlines* hit the stores about a year later. It is still in print. Some have credited us with bringing reggae music and its message to America for the first time. I know there were many others, but I was proud to be one of the earliest importers. The last paragraph to my chapter in *Reggae Bloodlines* (also entitled "I and Eye") sums up my visual experience:

In America, you walk down a busy street, notice people buying food at the supermarket, glance at the lines waiting for a bus, others hanging out on a front porch, and you don't really make much of it. But in Jamaica, each scenario seems so carefully crafted and balanced, as though it were a live Rousseau painting; a perfect tableau, down to the smallest detail. What accounts for this phenomenon I cannot say for sure, but I certainly hadn't encountered it before.

Or since.

THREE GENERATIONS IN THE GHETTO.

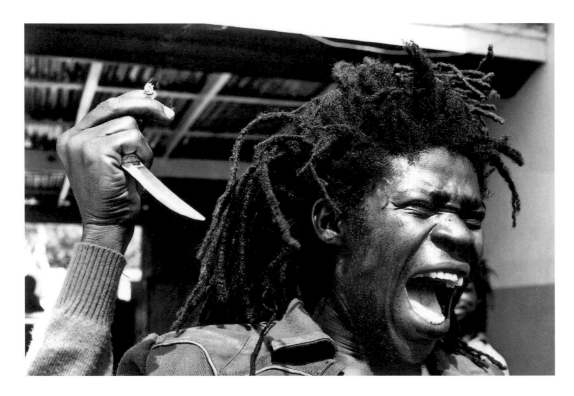

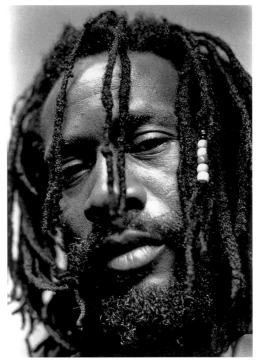

REGGAE DUB ARTIST DILLINGER, RE-CREATING HIS HIT "MURDERER."

WINSTON RODNEY, ALSO KNOWN AS BURNING SPEAR.

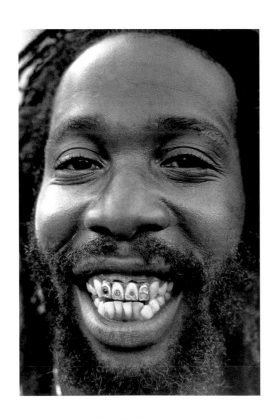

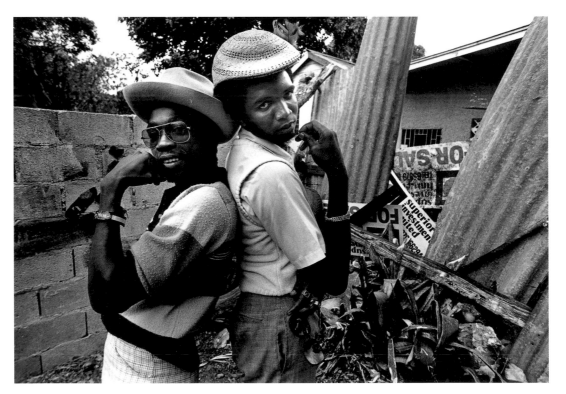

DUB ARTIST BIG YOUTH, TEETH AND ALL, IN KINGSTON, 1976.

MICHIGAN AND SMILEY, DUB DUET ARTISTS GALORE, 1978.

MAX ROMEO, WHO HAD A HIT WITH A SONG
CALLED "WAR INA BABYLON."

PETER TOSH, AN ORIGINAL MEMBER OF THE
WAILERS (WITH BOB MARLEY AND BUNNY
WAILER), TAKES A TOKE. TOSH, WHO WAS
MURDERED IN 1987, PROVED TO BE THE MOST
CHARISMATIC OF THE THREE ORIGINAL WAILERS.

MR. GREGORY ISAACS, A REGGAE CROONER WHO IS EXTRA CLASSIC.

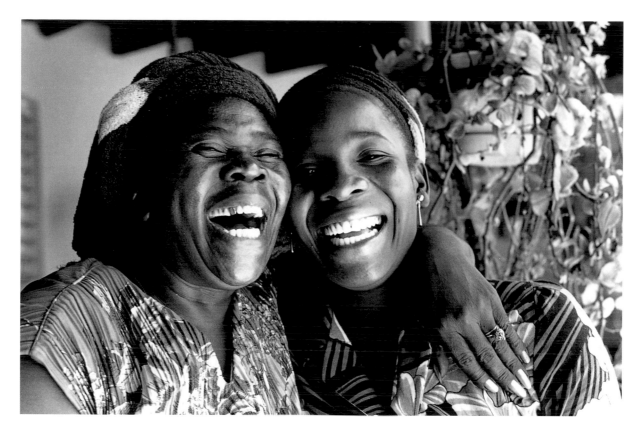

CEDELLA BOOKER (BOB MARLEY'S MOTHER) AND RITA MARLEY (BOB'S WIFE) IN FLORIDA, 1980.

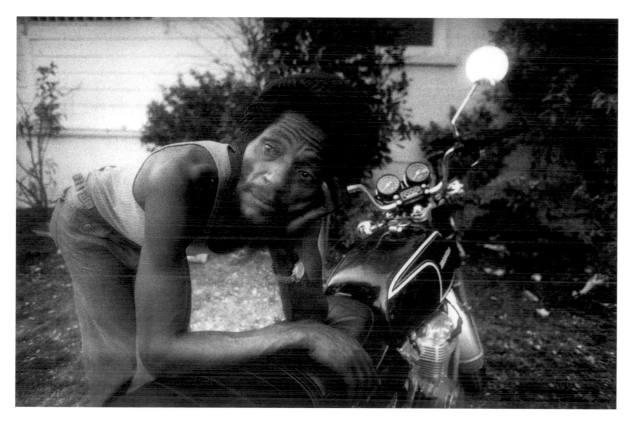

SEECO PATTERSON, A MEMBER OF BOB MARLEY'S BACKING BAND, 1976.

< JUDY MOWATT, A MEMBER OF BOB MARLEY'S BACKUP TRIO, THE I-THREES, IN KINGSTON, 1980.

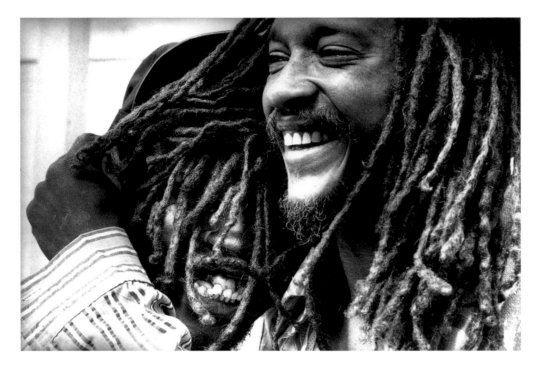

JAH LOVE.

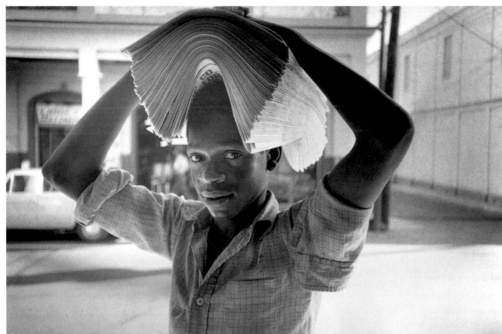

HAWKING THE "STAR,"
THE JAMAICAN TABLOID.

KEITH RICHARDS, MICK JAGGER, AND PETER TOSH ENJOY A BACKSTAGE SMOKE WHILE GETTING READY
FOR A HISTORIC APPEARANCE ON "SATURDAY NIGHT LIVE," DECEMBER 1978.

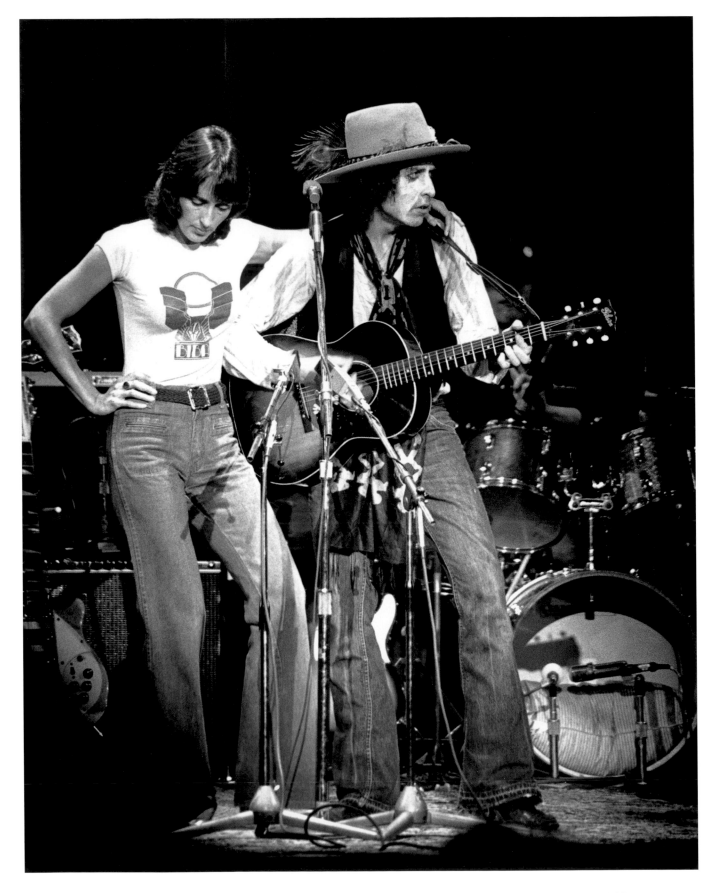

JOAN BAEZ AND BOB DYLAN PUT ON QUITE THE PERFORMANCE DURING THE ROLLING THUNDER REVUE

AT THE HARVARD SQUARE THEATER IN CAMBRIDGE, 1975.

Playing with the Bands

1966–1985

My obsession with music started early. It was the common language of the Simon family — one in which we could all participate and rejoice. My father, a gifted pianist, would sit at his Steinway grand in our Riverdale living room and play his heart out day and night. I particularly adored his rendition of Beethoven's "Moonlight Sonata." Dad would occasionally accompany my mom as she sang Gershwin's "Summertime" and Broadway tunes of the forties and fifties.

We had a beautifully crafted wooden Victrola upon which we played the great classical LPs. I became hooked on Tchaikovsky in particular. On my fifth birthday I received a turntable and speaker of my own. I noticed that the music I played on it seemed higher and faster — not as lush and resonant as it sounded on the Victrola. One day I got my nerve up to complain to my father about this. He said, "You must be imagining this." I persisted, so Dad got scientific. He placed a small piece of paper on the Victrola. He took out his watch and counted exactly how many times the paper revolved in a minute — thirty-two times. Then he did the same with my record player upstairs. This time the paper went around thirty-four and a half times. "So you see, I am right, Dad!" I was so proud of myself. He replied, "God, son, you have a really good ear."

My sisters took over the piano in the mid-fifties and would sing three-part harmony. Their distinctly different yet perfectly blended voices sounded angelic echoing through the house. During the holidays we would have family sing-alongs around the piano while various aunts and uncles (many of whom were involved in the music business, from artist rep to radio disc jockey) played and sang. My outrageously zany uncles, Peter Dean and Frederick "Dutch" Heinemann, usually stole the show, adept at entertaining the crowd with every

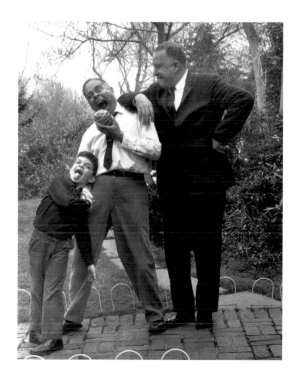

MY "ZANY" UNCLES IN ACTION: PETER DEAN (WITH HIS SON PETER JR.) AND FREDERICK "DUTCH" HEINEMANN, 1962.

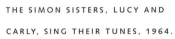

MY SISTER JOANNA IN THE
DRESSING ROOM BEFORE A
PERFORMANCE OF "COSÌ FAN
TUTTE" WITH THE SEATTLE
OPERA, 1972.

>

THE SIMON SISTERS, LUCY AND
CARLY, SING THEIR TUNES, 1964.

manner of song, from "Baby Won't You Please Come Home" to "Mississippi Mud," accompanied by a ukulele and unrepeatable banter.

My sisters all went on to enjoy careers in music. Joanna, the oldest, had a thirty-year career in opera. She starred at the opera festivals of Spoleto and Salzburg, and appeared at the Teatro Colón in Buenos Aires. She was also a soloist with many of the major orchestras and opera companies of America. Her starring roles in *Carmen* and *Bomarzo* brought acclaim and appreciation. Joey was one of the more sexy divas of her day; she had a distinctly glamorous image, with movie-star looks and a quick wit as well. Joanna, always the queen, looked over us with care.

Lucy and Carly formed the Simon Sisters during the early folk era of the mid-sixties. They had a cult hit, "Wynken, Blynken, and Nod," which Lucy adapted from a poem by Eugene Field into a sea-chanteyesque folk tune. The Simon Sisters released two albums with Kapp records and performed at coffee houses up and down the East

Coast. They decided to part after two years, although in 1969 they reunited to record "The Lobster Quadrille," featuring existing children's poems set to Lucy's original music.

After raising a family, Lucy pursued what would ultimately be a highly successful career as a songwriter in musical theater. She spent years working on worthy projects, but it wasn't until 1991 that she had huge success and recognition with the musical *The Secret Garden.* I've always thought of Lucy as highly compassionate; I could go to her with my problems and her solutions were right on. Her purity of spirit and magnificently glowing features are a rare combination. I love Lucy! Everybody is happy just to be around her.

Carly and I are closest in age and thus shared many of the same musical and cultural references. When the Beatles hit American shores for the first time, we watched their arrival at the airport, the subsequent press conferences, and their historic appearance on *The Ed Sullivan Show* with rapt attention. We stayed in constant touch during the late

TIMELESS FOLKSINGER ODETTA, 1982. CARLY WAS GREATLY
INFLUENCED BY ODETTA'S PASSIONATE FOLK/BLUES SONGS.

sixties and shared absolutely everything. Even our various significant others had to pass the test of each other's judgment. Fortunately, most did. We spent hours in my room with a crude Wollensack tape recorder and a cheap mono microphone, capturing her unique voice and evolving guitar licks. She did a great version of a song Odetta once sang, "Oh Freedom," a few Peter, Paul and Mary covers, and some originals, just to name a few. We must have recorded more than fifty songs all told. We imagined her becoming the female counterpart to Dylan some day, particularly when Columbia records gave her a deal in 1967 to record Dylan's "Baby, Let Me Follow You Down." Dylan's manager at the time, Albert Grossman, had plans to add Richie Havens on background vocals and call the group Carly and the Deacon. But those tapes, along with the masters of many of her well-known subsequent hits, have for some reason disappeared. Those early sessions, featuring Dylan's backing band circa 1966 (which included Robbie Robertson, Rick Danko, Al Cooper, and Mike Bloomfield), were superb. Carly's basement tapes are still sitting somewhere in a vault. How unfortunate.

While I was in college and tripping on Martha's Vineyard and listening maniacally to the Stones and the Beatles, Carly was honing her musical skills. With her enormous talent, big lips, and sexy countenance, Carly landed a contract with Elektra. Her first hit, "That's the Way I've Always Heard It Should Be," struck a chord with the feminist movement. Almost overnight Carly was a rising star. After the multitudes of photographs I had taken of her through the years, one finally gained national exposure as the cover of her first album: Carly sitting on a fairly uncomfortable couch at Tree Frog farm, looking gorgeous yet somehow vulnerable. Maybe her facial expression had to do with the fact that one of our communal cats had just scratched her and drawn blood.

The next summer, Carly flew me to England to photograph the cover of her second album, *Anticipation*. The pose we constructed, arms and legs framed within an elegant Regent's Park gate, was not unlike many others from the past. But the see-through dress and soft backlighting brought the photo to life. While in London photographing candids for the album's inner sleeve, I observed a recording studio for the first time. Carly was working with expert producer Paul Samwell-Smith. He added little touches and flourishes to the tracks the way a brilliant chef adds an obscure spice to his signature dish. Paul had produced most of Cat Stevens's music, so Cat was hanging around the studio quite a bit. Already a huge fan (*Tea for the Tillerman* remains one of my all-time-favorite albums), I felt honored to be in his casual presence and to shoot photos of him for *Rolling Stone*.

Carly married James Taylor in the fall of 1972; simultaneously, she had the biggest hit of her life, "You're So Vain," featuring Mick Jagger on backup vocals. Suddenly it was all Carly all the time. I

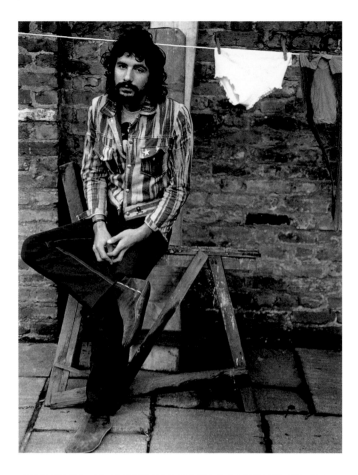

CAT STEVENS, AN INFLUENTIAL SINGER/SONGWRITER IN THE EARLY SEVENTIES, HANGS OUT IN A LONDON BACKYARD.

couldn't believe how many times I was asked, "Who is that song about?" I couldn't answer because Carly had sworn me to secrecy. I had always sensed that Carly was going to make it "big" one day. She had the talent, boundless creative skills, charisma, and ambition to form quite the combination platter. But when she was vaulted into the superstar category, our family was not prepared. Now everyone wanted a piece of her, and she was tugged in an untenable number of directions. Our relationship changed drastically. She was no longer as available, and our day-to-day contact became more week-to-week, and eventually month-to-month. I missed our closeness terribly, but I was proud of her and hoped all the acclaim was what she wanted. Certainly it was well deserved.

Being "Carly Simon's brother" evolved into an issue for me. No doubt I used her name to open doors (obtaining music photo gigs, procuring a good table at a restaurant) and to provide an occasional perk. In fact, I signed a book deal with Knopf to combine many of the photographs I had taken of Carly through the years with a Q&A interview I conducted, plus all of her sheet music to date (1975). We called it *Carly Simon Complete*. The book was handsome and did well. But there was a thin line between collaboration and exploitation. I tried to be careful, but I wasn't always successful.

On the other side of the equation, to many people I was no longer just Peter Simon, the freelance photographer, but the brother of a famous rock star. These types played up to me in order to get to Carly. While my instinct for self-preservation protected both of us, at times this treatment was demeaning. Fortunately, I had a moderately successful career in place by the time "You're So Vain" ripped through the charts. I also adored Carly, so how could I justify feeling jealous or resentful of her success? But I did occasionally ask myself, "Why can't you be as famous and wealthy as Carly? Wouldn't that be just great? Or would it?"

After a string of hits, magazine covers, television appearances, and public breakups and makeups, Carly achieved possibly her greatest recognition in 1989, when she received an Oscar for the song "Let the River Run," which was the theme for the Mike Nichols movie *Working Girl*. My mixed emotions were expressed in my journal entry of March 29:

Here I am, sitting in my living room watching my sister receive an Oscar. Wow! My own flesh and blood! And what a powerful, triumphant song for which to be honored. But my excitement and pride are slightly muted because I can't help but

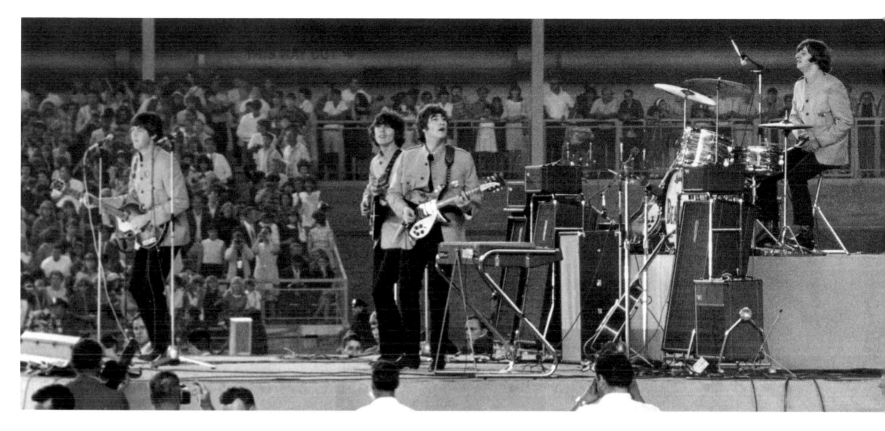

THE BEATLES ROCK SHEA STADIUM DURING THE SUMMER OF 1965.

compare her success with my relatively obscure life here on the Vineyard. Is it by choice or design? Could I achieve such heights in my field were I as motivated or talented? Is it pot-induced laziness that is my main demon, or am I simply more comfortable living a simpler, less challenging existence?

Carly recently confessed that her guilt over being the star of the Simon offspring was probably more difficult to deal with than our envy. Being that famous came at such a price. I've seen her wounded and hurt by the press and so-called friends as much as she has been glorified. Having to be in the spotlight — constantly scrutinized and reviewed, with all the demands and expectations — must be very difficult.

. . .

My obsession with music started early, but soon my main goal was somehow to merge the media of music and my other obsession, photography. My first opportunity to do that was during the summer of 1965, when I went to Shea Stadium to see the Beatles. I smuggled my camera in, stuck on a telephoto lens, and managed to take a halfway decent shot of John, Paul, George, and Ringo onstage near second base. I was only seventeen at the time and still an amateur. Coming back home with a photo of *the Beatles* that I could call my own was a thrill. But my ears were still ringing from all those shrieking girls.

While I was at Boston University the folk rock movement gained momentum. Both the melodies and the lyrical content enthralled me. I was establishing myself as a photographer in the Boston area and used those skills to get free passes to clubs around town such as the Crosstown Bus in Somerville, where I saw Jim Morrison and the Doors in 1967; Club 47, where I saw and met people like

MICK JAGGER THROWS SOME PETALS TO THE CROWD AT
THE BOSTON GARDEN, 1969.

OPPOSITE:

JIM MORRISON AT A BOSTON ROCK CLUB, 1967.

THE FIRST TIME I EVER SAW THE GRATEFUL DEAD PLAY WAS IN
BOSTON, 1969. HERE THEY PLAY TO AN INTIMATE GATHERING
AT A SMALL CLUB NEAR KENMORE SQUARE.

PAUL SIMON SERENADES AN ENTRANCED AUDIENCE AT HIS
HOME IN RURAL PENNSYLVANIA, 1972.

Tom Rush and Bonnie Raitt; the Psychedelic
Supermarket, where I attended a Grateful Dead
concert for the first time in 1969; and the Boston
Tea Party, to hear the Byrds, Rod Stewart, and the
Lovin' Spoonful. With rock music still in its infancy
at this point, getting access and permission to pho-
tograph these emerging talents was easy. I sold the
pictures to places like *Crawdaddy,* the folk magazine
Broadside, the *Village Voice,* and eventually *Rolling Stone.*
In the fall of 1969, a new weekly paper began
entitled the *Cambridge Phoenix.* I got press tickets to
the Boston Garden to see the Rolling Stones and
other big-name groups as they rolled through town.
I had a chance to see Jimi Hendrix, but stupidly
dropped a little acid beforehand, mistook Storrow
Drive for F.D.R. Drive, and never made it to the
Boston Garden. What a fool I was!

I formed a good working relationship with
Rolling Stone during the early and mid-seventies. I
considered it the most relevant and imaginative
magazine I had ever seen. Just being associated with
it was a boon, but the access I got to the stars was
incredible. In 1965 "The Sounds of Silence" had
gotten me through my freshman year at BU, and
here I was in 1972 driving out to Paul Simon's
Pennsylvania summer home to do a cover shot. I
met his wife (now ex), played with their dogs, shot
some hoops, and talked about poems as song lyrics.
Just Peter and Paul, hangin' out.

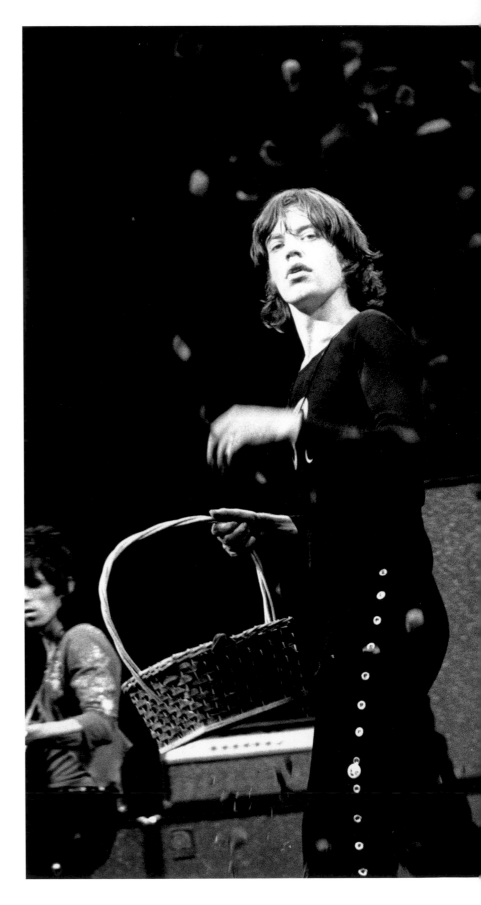

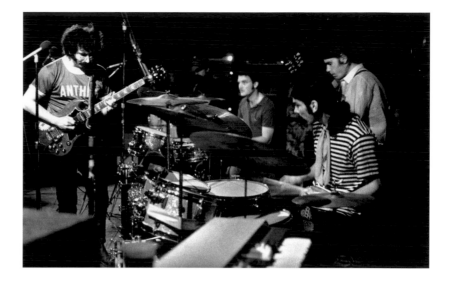

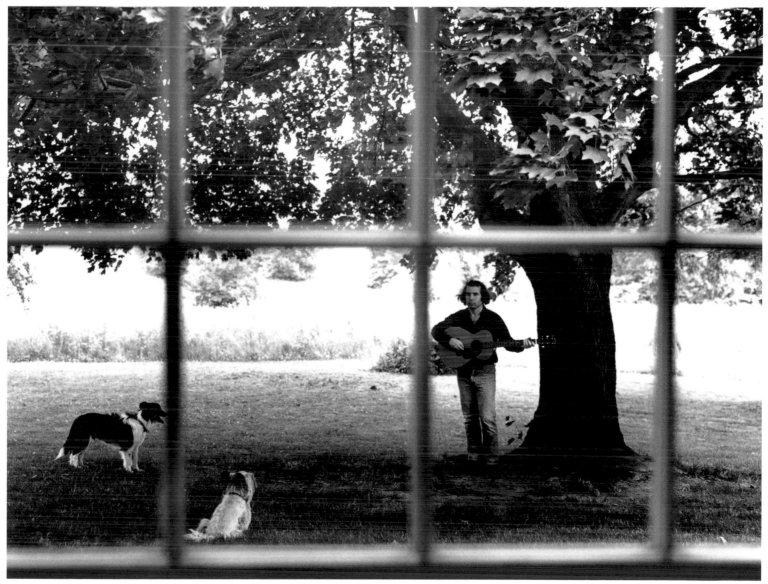

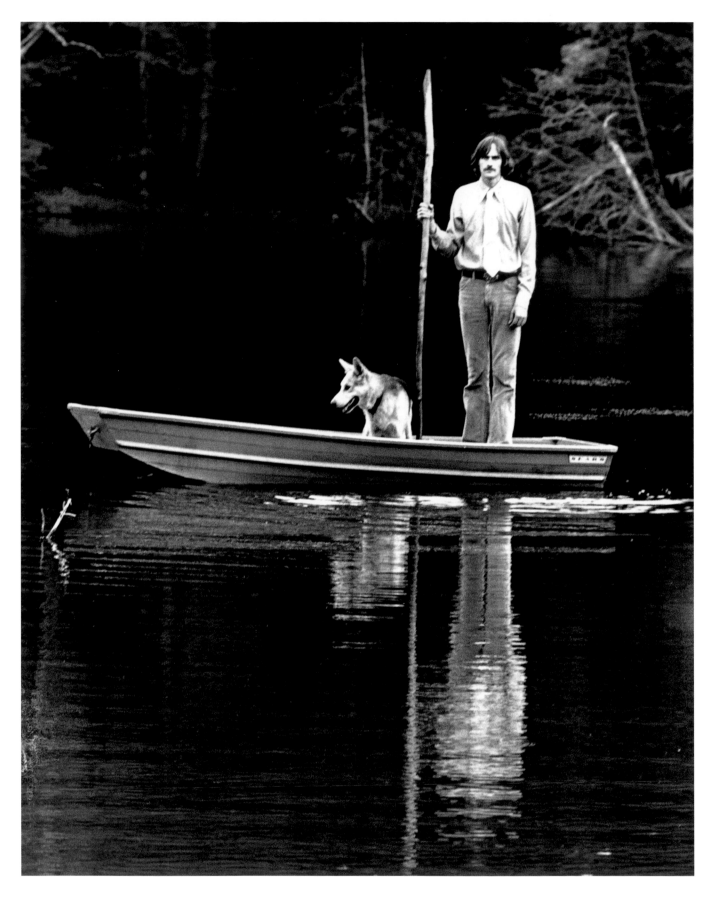

JAMES TAYLOR POSING FOR THE "ONE MAN DOG" ALBUM COVER AT TREE FROG FARM IN VERMONT, FALL 1972.

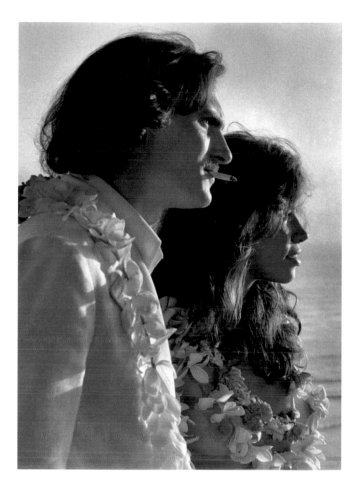

That fall, James Taylor and Carly arrived at Tree Frog in a colossal Winnebago. I never figured out how that vehicle made it down our long narrow dirt road. I was asked to do a photo session for the cover of his *One Man Dog* album, a version of which also made *Rolling Stone*. In my typically laid-back way, I suggested that we (James, his dog, and I) head toward the beaver pond. Without much in mind, I spotted a funky old rowboat. I was mildly curious to see if they could get in and stay afloat. James was game and rowed out to the middle of the pond. The photo magically manifested itself.

A few months later, James and Carly went to Hawaii for their honeymoon. I arranged a cover shot for *Rolling Stone* to accompany an interview conducted in New York a month earlier. Without prior warning, I flew to Hawaii and nonchalantly appeared on the beach at Waikiki, totally surprising

Carly. We hugged madly in the tropical waves, reveling in the spontaneity of it all.

The next afternoon, I visited Carly and James in their honeymoon suite on the top floor of a high-rise hotel. The photo session that followed was one of my most memorable. I'd always been fairly passive when it came to photographing celebrities. I liked to ride the tide and go with the flow — no props, no unusual outfits, no special lighting, no makeup people, no outlandish poses, no studio effects: no artificial anything. I just started shooting without restraint — Carly and James on the bed, on the floor, out on the lanai, at the table eating sumptuous pineapple and papaya, occasionally wearing leis without anything else. One of those shots appeared in the 1999 *Rolling Stone* special photo issue "Behind the Scenes." My accompanying quote read. "What you're looking at there are two people who were young and madly in love. Their relationship was fresh, and they were very open to sharing that flush with me. That was indeed a time when we felt everything was new and the world was our oyster. As a generation we felt that way, and perhaps this attitude comes across in the photograph."

In 1975, while trekking around the West Coast, I frequently hung out at the *Rolling Stone* offices, then located in downtown San Francisco. I got to know many journalist icons of the day, including Jann Wenner, David Dalton, Hunter Thompson, and Annie Liebovitz. Annie advised me about photographing celebrities: "Don't be an outright fan. Be with them on equal terms, let your creativity flow, and let your work speak for itself." Annie was observant. I often let my fandom inhibit my vision. Who was Peter Simon to tell Jerry Garcia how he should look and smile?

A few months later *Rolling Stone* gave me the exclusive assignment to photograph a huge rock festival at Golden Gate Park. It was a charity event organized by concert promoter Bill Graham to raise money for children's education. The idea that rock music could be a fulcrum for social awareness and a means of financing just causes was a true inspiration. Finally, "we" had the (monetary) power to influence change. I gained full access, including "onstage plastic" (a laminated card that enabled me to do just about anything). The concert included the Dead, Jefferson Airplane, Carlos Santana, and Dylan. As Dylan roamed around backstage beforehand, I noticed a certain hush set in among media and musicians alike. We were in the presence of a god who had rearranged so many ways of thinking. We all kept a respectful distance, despite my urge to move close to him for a full-frame head shot. I settled for a behind-the-stage grab shot of Dylan playing the piano, solo, with thousands of fans staring at him single-mindedly. When he sang "Forever Young," it felt as if the whole world were standing still, forever.

Then in 1977 came my dream assignment: following the Grateful Dead on tour. I'd been a Deadhead from the early seventies. They played an impromptu "concert" at MIT during the student strike of May 1970, protesting the killings at Kent State. Hippies swirled around the half-empty gym, Jerry Garcia's soaring "Dark Star" guitar solos echoed and reverberated across the high ceiling and into my solar plexis. I had never witnessed such a scene — straight out of some trippy acid New Age movie yet to be made. I must have gone to at least fifty concerts between 1970 and 1977, from the Fillmore East to the Fillmore West and points in between. Each one sent me to that indescribable place of bliss where everyone seemed as one, enjoy-

ing every note. In 1973, I took a girlfriend to the Boston Music Hall for a Dead show, and she casually took off her shirt and bra, and squished topless among the throngs. No one seemed to be particularly concerned — it was just part of the scene.

In 1974, while living in Berkeley, I met Jerry Garcia for the first time. He was editing *The Grateful Dead Movie*. I was on assignment for a newly formed magazine, the *New Age Journal*. I admired Jerry for his music, but also for his intelligence, warmth, humility, and enthusiasm for life. To his adoring followers, he was "Captain Trips," providing a great forum for tripping and loving, expanding and connecting. He never liked to take responsibility for all that stuff, but he was clearly the man. This was my chance: I asked him everything I wanted to know, particularly about the spiritual aspects of his more ethereally spacey jams.

 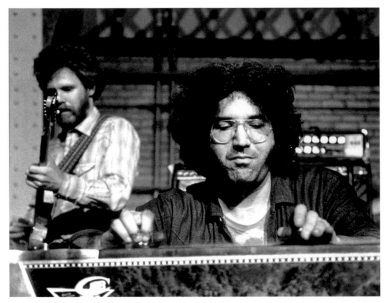 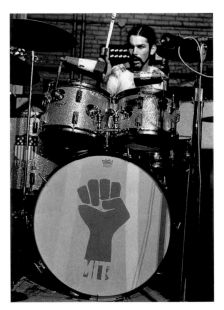

"One thing that I get from your playing," I told him, "is the sense that what you play is coming to you from a higher source. Can you relate to that?"

"Oh, sure," he replied. "When I'm talking about playing, I'm ready for that. It's just like when I'm talking about miracles and stuff. I'm talking about being ready for that and for me. It has to do with being technically ready. If there isn't a flow, either I'm hanging it up or it's just not happening. I prefer to be able to play at the moment, whatever it may be. I can't say that there is a certain sense when I'm totally transformed. I can't totally tell when God is speaking through my strings. It's more like, if you're really lucky, and you practice a lot, and play a lot, then there is a chance that it will happen. Even when I'm not playing that great, mediocre at best, I can still get off because the audience loves it. Music is my yoga; if there is a yoga, this is it. Life is my yoga as well, but I've been a spiritual dilettante off and on through the years, trying various things at various times. But I firmly believe that every avenue leads to a higher consciousness. If you think it does, it does. I believe

GRATEFUL DEAD GUITARIST BOB WEIR AND DRUMMER MICKEY HART (LEFT AND RIGHT) GIVE A FREE CONCERT AT MIT DURING THE STUDENT STRIKE OF MAY 1970 IN PROTEST OF THE KENT STATE KILLINGS. JERRY GARCIA (CENTER) PLAYS PEDAL STEEL GUITAR WHILE OPENING FOR THE BAND NEW RIDERS OF THE PURPLE SAGE, WITH DAVID NELSON IN THE BACKGROUND, AT THE SAME EVENT.

that it's within the power of the mind and body to do that."

So in 1977, when I had the once-in-a-lifetime opportunity to travel with the Dead thanks to *Rolling Stone,* I took it. I photographed the good, the bad, and the questionable. Garcia told me in a pre-assignment get-together that he was comfortable with me in that I was the "left wing of all media photographers," meaning I didn't try to orchestrate. He appreciated my nonintrusive approach, and I in turn was able to be part of their coterie without interfering; I was a fan and a Deadhead to boot. I adored my privileges as a photographer, adored the lifestyle, adored the Deadheads.

The Deadheads, as an entity, seemed to me

BACKUP SINGER DONNA GODCHAUX
GETS COZY WITH MEMBERS OF THE
GRATEFUL DEAD, CIRCA 1977.
IT WAS A RARE EVENT TO GET THE
GROUP TO POSE TOGETHER UNDER ANY
CIRCUMSTANCES.

BELOW:
PHIL LESH EXTOLS THE VIRTUE OF
DUTCH BEER.

BOB WEIR SHOWS OFF HIS "AX" IN THE
ALLEYWAY BACKSTAGE AT THE BOSTON
GARDEN, 1977.

GRATEFUL DEAD KEYBOARD PLAYER
BRENT MYDLAND, SEEN HERE IN
CONCERT SHORTLY BEFORE SUCCUMBING
TO A HEROIN OVERDOSE, 1990.

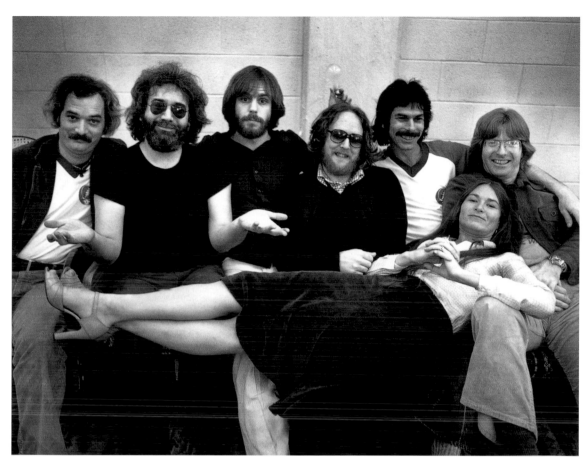

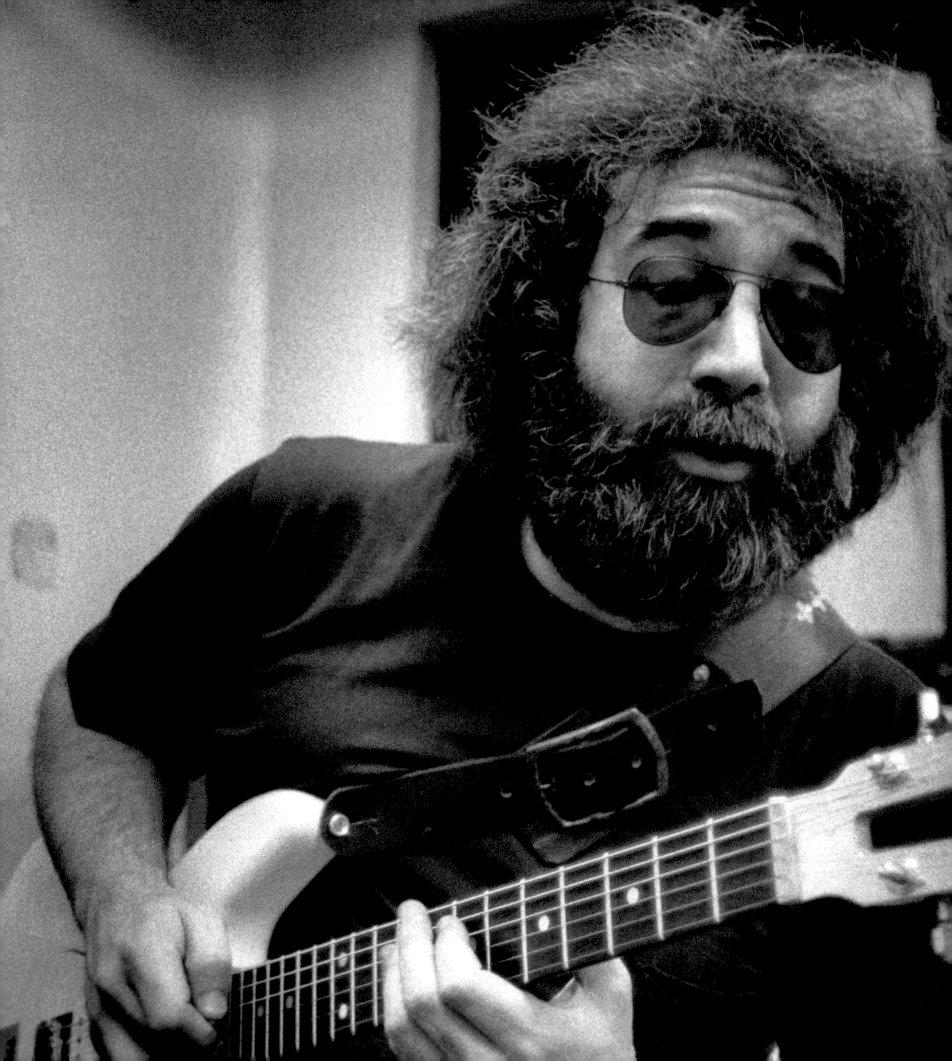

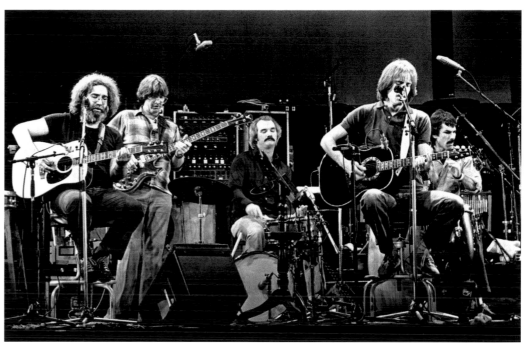

THE DEAD PERFORM THEIR ACOUSTIC SET AT RADIO CITY
MUSIC HALL, 1980.

like a large, moveable feast of pioneering spirits
caught somewhere between Woodstock Nation and
late-seventies anti-disco imperialism. I loved their
passion and willingness to give up their lives, what-
ever they were, to travel en masse to the next Dead
occasion. It was a lifestyle, a focus, a reason to exist,
an identity, a tribe of fellow warriors — connec-
tions made and gobs of drugs consumed. I enjoyed
comparing notes with other Deadheads like, "Did
you think the eighty-five Greek Theater version of
'The Wheel' was better than the seventy-six one at
the Capital Theater?" Or, "Do you think they
should go from 'Scarlet Begonias' into 'Fire on the
Mountain' so much, or try a new segue?" I felt
slightly older (thirty) and a bit set apart from the
grungier aspect (many Deadheads lived like gypsies,
tenting or sleeping on the ground between con-
certs), but their devotion was highly contagious.

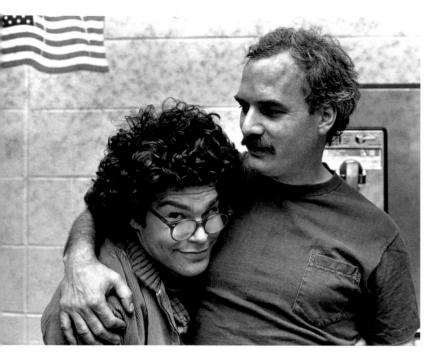

AL FRANKEN WITH A BUDDY,
GRATEFUL DEAD DRUMMER BILL
KREUTZMANN, BACKSTAGE AT
RADIO CITY MUSIC HALL, 1980.

SPEAKERS IN THE LOBBY,
HALLWAYS, AND BAR ALLOW
DEADHEADS TO FREAK FREELY
ALL OVER THE PLACE AT THEIR
ANNUAL NEW YEAR'S EVE BASH
AT THE OAKLAND AUDITORIUM,
1982.

>

BOB WEIR AND CARLY SIMON
EXCHANGE A FEW LAUGHS IN
HER NEW YORK CITY
APARTMENT, WINTER 1985.

THE DUELING "RHYTHM DEVILS" OF BILL KREUTZMANN AND
MICKEY HART DURING A BOSTON GARDEN SOUND CHECK, 1976.

The Dead's philosophy of letting "tapers" (fans with recording equipment) collect their stuff was great, and flew in the face of record company greed. I collected over three hundred hours' worth of live Dead during my time following the band, some material right off the board during my *Rolling Stone* gig (thanks to sound man Dan Healy).

The only bad vibe came from the stagehands. Sure, I knew I wasn't part of the highly select "in crowd," but I did have work to do. Yet I was still treated somewhat as an interloper backstage. By the late seventies, the need for heightened security and outright materialism, particularly on the part of

the record companies, had started to create boundaries between the fans and the artists that were nonexistent in the sixties. The Dead and their fans were growing increasingly disconnected, and I was stuck in the middle somewhere.

. . .

Whereas rock was a catalyst for political and social change in the sixties, it became an important focus for environmental awareness in the mid- and late seventies. The No Nukes movement started gathering steam in 1974, when a member of the Montague Commune in western Massachusetts, Sam Lovejoy, noticed a huge weather tower being erected two miles away. He discovered that the tower was measuring prevailing wind speed and direction in preparation for the construction of a nuclear power plant. Sam and fellow communard Harvey Wasserman began to research the dangers of nuclear power, and on one fateful day, Sam cut the guidelines and toppled the tower.

Word spread through the counterculture that a new movement was being born — No Nukes. I was immediately motivated to contribute what I could. Activists and rock stars became involved, rallies and teach-ins held, and finally antinuke concerts were staged. Our suspicions were verified on the morning of March 29, 1979, when a nuclear plant at Three Mile Island in Pennsylvania almost melted down. It was called an accident, but it was a near disaster. The threat of nuclear power was real, and most of the world was hiding its collective head in the sand.

Galvanized by TMI, plans were finalized for a series of concerts at Madison Square Garden. Resources were summoned, and a new organization was formed: Musicians United for Safe Energy (MUSE). Writers, photographers, organizers, and

FOLK LEGEND PETE SEEGER AT THE BATTERY PARK NO NUKES
RALLY, NEW YORK CITY, 1979.

THE BOSS, BRUCE SPRINGSTEEN, SIGNS AUTOGRAPHS BACKSTAGE.

musicians gladly donated our various skills to stop
the proliferation of nuclear power. John Hall (a
founding member of the group Orleans), Bonnie
Raitt, Jackson Browne, and Graham Nash helped
organize the rock community for this biggest anti-
nuke concert ever. Music mogul Danny Goldberg,
then president of Modern Records, helped to pro-
duce the event. David Silver, who was working on
The Compleat Beatles, a definitive video documentary,
was asked to direct the home video, and David Fen-
ton, a high-powered public-relations man, put out
the message to the media. Ronni donated her serv-
ices as a press relations coordinator, and I, along
with a few other music photographers, documented
the concert from all angles. Ronni and I saw the
Madison Square Garden festival as a great coming
together of spirit and a great adventure — all expenses
paid but no salary: the work ethic of the decade.

The five-day extravaganza did not disappoint.
We had access to everything: rehearsals, press con-
ferences, dressing-room conversations, onstage
camera positions, late-night backstage get-
togethers and postconcert parties. Ronni and I had
the time of our lives, mingling with the icons of

popular culture. The "greater cause" aspect relaxed
many of the rules. Ego power trips of various kinds
were simply not appropriate.

Ronni was reunited with Roy Bittan, her close
childhood friend and pianist extraordinaire for
Bruce Springsteen's E Street Band, and we were
welcomed as family. I "reunited" with reggae great
Peter Tosh (whom I had gotten to know well during
the *Reggae Bloodlines* project). James Taylor, his sister
Kate, Carly, and Graham Nash figured out chords
on the piano for Dylan's "The Times They Are A-
Changin'," as I listened in and photographed. The
four-part harmony they worked out sent shivers
through me. Jackson Browne and Bonnie Raitt
schmoozed in the background, telling stories about
the early days. That was fascinating stuff to over-
hear. It was a perfect blend of movement con-
sciousness and music royalty hobnobbing.

The performances were uniformly great.
Tosh, wearing a severe black-and-white-striped
"Mystic Man" outfit, stunned the crowd. Carly,
wearing a green-and-blue plaid stretch suit, joined
James for an energetically choreographed version
of "Mockingbird." Bruce Springsteen did two

A GROUP SHOT FEATURING MANY OF THE KEY ACTS THAT PARTICIPATED IN THE NO NUKES FESTIVAL. >

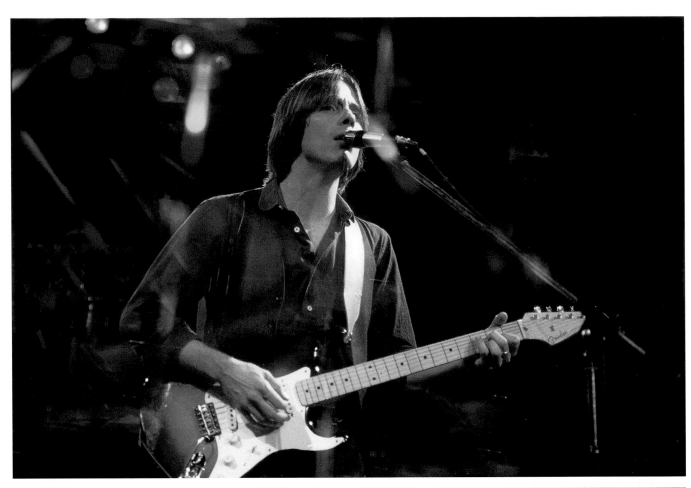

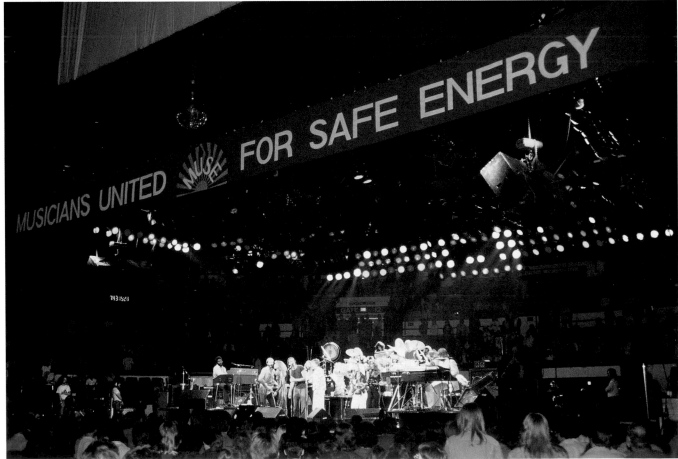

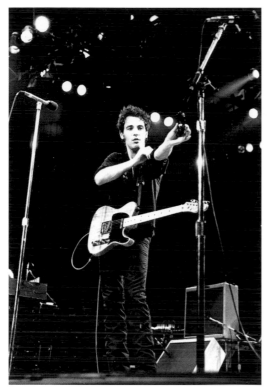

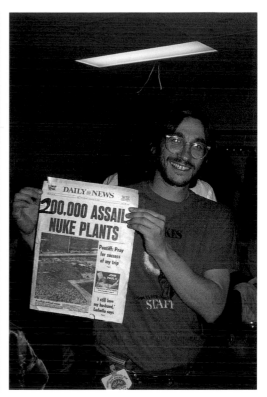

BRUCE SPRINGSTEEN PERFORMS AT THE NO NUKES FESTIVAL,
AS DOES PETER TOSH, SPORTING A MOST BIZARRE OUTFIT.
HARVEY WASSERMAN, ENVIRONMENTAL ACTIVIST AND DEAR
FRIEND, HELPED TO ORGANIZE AND EXECUTE THE EVENT.

spectacular, over-the-top performances, dancing on Roy's piano and grabbing unsuspecting cuties out of the audience to sing along to "Badlands." The girls practically passed out. The grand finale exceeded all expectations. John Hall invited all the entertainers (more than forty) up for his antinuke anthem "Power."

The five nights at MSG, coupled with a free rally at Battery Park, raised a nice amount for the cause and greatly increased public awareness. About three hundred thousand people attended the festivities, and to our great credit no one was arrested.

The battle is still being waged against nuclear power, but the proliferation was slowed and more attention and money started pouring into alternative energy sources.

The overwhelming presence of music in my life took a gradual downturn after the peak of the No Nukes festival. Two of my heroes, John Lennon and Bob Marley, died. I attended a hastily arranged memorial service for Lennon on Boston Common. One college kid said to me while I shot pictures of the makeshift shrine, "Now I won't know what to think about anything anymore." I knew what he meant. Lennon had seemed to have the answers.

When Marley was diagnosed with melanoma on his "soccer" toe in 1978, I prayed for his recovery. But being a Rasta, he had no interest in conventional therapy. The cancer spread extensively over the next three years. Some of his most spirited music, such as his seminal album *Survival,* was made during that time. I had one last chance to interview him in 1980 for my weekly radio show "Reggae Bloodlines," over WBRU in Providence. He was gaunt and pale and sweating profusely. Bob answered my questions politely but with a raspy

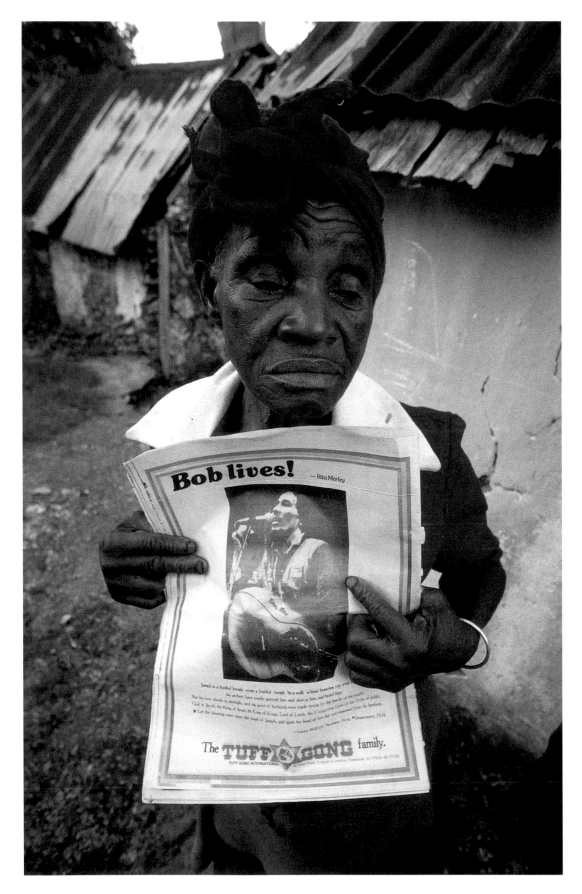

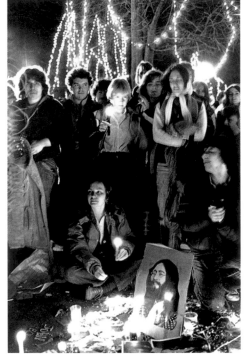

MOURNERS TOUCH BOB MARLEY'S COFFIN AT HIS FUNERAL, WHICH OCCURRED AT HIS BIRTHPLACE, NINE MILES, IN THE PARISH OF ST. ANN, MAY 1981.

NEIGHBORS AND DEVOTEES BELIEVE THAT BOB MARLEY'S SPIRIT WILL LIVE FOREVER.

voice. I asked him "What is your legacy?" His reply: "To bring reggae music up from the ghetto to the world. To spread the message of unity and equality. To end the needless suffering of mankind. You know, things like that. Simple things, really."

When I attended his funeral in May 1981 in Kingston, I caught a final glimpse of him, perfectly embalmed, with his dreadlocks, re-attached, flowing down to his waist and his left hand holding his electric guitar. He had completed his work and now was at rest. A nation mourned, but his life would be forever celebrated.

In 1984 I traveled again with the Grateful Dead for a month or so in preparation for the book *Playing in the Band: An Oral and Visual Portrait of the Grateful Dead,* with writer David Gans. Garcia was no longer hanging backstage with his band members or jovially engaging in conversation with roadies, managers, media folk, and the occasional lucky Deadhead who somehow managed to talk his way through the layers of security. He was secluded in his hotel suite. One night I went up to visit him and was shocked by what I saw — an almost obese, wasted-looking man with scraggly whitish hair all matted up and dandruff covering his black T-shirt. His beard was stained with the brownish tinge of nicotine. He was chain-smoking as we talked, and wheezing. He kept scratching his thighs and legs. He recognized me and we exchanged pleasantries, but it wasn't long before his attention drifted off into space. I never saw him again, except onstage.

There, despite some moments of magic, the Dead's playing had become sloppier. Garcia would forget the words of some of their best-known material. Their sets were shorter, and their signature jams, those long improvisational riffs that tied the songs together, seemed disjointed. While the crowds, now at mass-market level, loved every note, whether out of tune or not, I was more critical. That night I wrote a journal entry, dated March 19, 1984:

Today is the day the music died, Buddy Holly, Richie Valens, and the Big Bopper notwithstanding. First there was John, then Bob, and now Jerry, at least it seems like the beginning of the end. But it's not just those three. Rock no longer seems vital, it's just entertainment now. The passion is gone. Artists are in it for the money and the glory. Record companies prepackage the groups and sounds to suck up the wealth. It's all promotion and hype. Rock is now big business. Musicians play with synthesizers and drum machines. Where is the humanity? Where is the voice of conviction? Where is the truth to all this sound? Who will take over and be the new prophet, a true original? Has it all been said and played out? Is this all there is?

Thankfully, Jerry got his act together following a near-fatal overdose and diabetic coma in 1986. He came back re-energized in 1988, and the band played some of their best music. I continued to follow them, but with less intensity. Finally, in the summer of 1995, Garcia died of a massive heart attack. We all knew it was coming, the only question was when. The world of sex, drugs, and rock and roll had finally swallowed him up. What a long, strangely wonderful trip it had been for all of us.

As John Lennon sang after the Beatles broke up, "The dream is over." And so it was for me. But I can relive the past through the tapes, albums, and interviews I've collected over the years. I now have a weekly radio show on my local station, WMVY, called "Private Collection," on which I share many of my archives and special moments. One moment I can't share but will always remember was my dad playing the "Moonlight Sonata" on his grand piano with tears in his eyes. And the beat goes on. . . .

NOTED SINGER/SONGWRITER JESSE
WINCHESTER AND SON, WHILE EXILED IN
CANADA IN ORDER TO AVOID THE DRAFT,
WINTER 1970.

MASTER BLUES MUSICIAN MUDDY WATERS AT THE FELT FORUM IN NEW YORK CITY IN THE EARLY EIGHTIES.

THE POLICE: STING, STEWART COPELAND,
AND ANDY SUMMERS, IN BOSTON, 1981.

LEGENDARY CANADIAN FOLKSINGER GORDON LIGHTFOOT, WHO
WROTE AND SANG THE HIT "IF YOU COULD READ MY MIND,"
REHEARSES BACKSTAGE BEFORE A CONCERT IN HAWAII, 1972.

IAN ANDERSON OF JETHRO TULL SENDS OUT SOME ETHEREAL NOTES
AT THE NEWPORT FOLK FESTIVAL, JULY 1969.

ALICE OF ALICE'S RESTAURANT FAME SHARES A MOMENT WITH ARLO GUTHRIE,
WHO MADE HER FAMOUS. THIS WAS TAKEN DURING AN ASSIGNMENT FOR
"ROLLING STONE," 1976.

PHOEBE SNOW DISPLAYS HER COVER, JANUARY 1976.

ROBERT PLANT OF LED ZEPPELIN LOOKS AT SUNSET STRIP FROM A BALCONY AT THE RIOT HOUSE IN LOS ANGELES, MARCH 1975. AS I TOOK THIS PHOTO, ON ASSIGNMENT WITH STEPHEN DAVIS FOR "ATLANTIC MONTHLY," PLANT SHOUTED OUT, "I'M A GOLDEN GOD."

SONGSTRESS JONI MITCHELL TAKES A PUFF, 1979.

FRIEND AND COLLEAGUE RICHARD SKIDMORE NEEDS A MUSIC FIX.

THE METS "MURDERERS' ROW" AT THE START OF THE MAGICAL 1986 SEASON:
GEORGE FOSTER, KEITH HERNANDEZ, DARRYL STRAWBERRY, AND GARY CARTER.

Let's Go Mets

1985–1988

Baseball has always been in my blood. I grew up loving the game more than anything in the world. My parents, their friends, my uncles, and even my sister Carly bled Dodger Blue through and through. There were numerous excursions to Ebbets Field. I adored that right field wall with all the ads and that high screen. Duke Snider fouled back a ball that I caught with my tiny glove. After the game he autographed it for me. I have it to this day. I even enjoyed watching Happy Felton's Knot-Hole Gang, the pregame show, each time the Dodgers game was televised, and those insipid Lucky Strike and Schaefer beer commercials that rotated every half inning. Oy! In those old days of black-and-white television with only two camera angles I was still glued to the screen.

The main focus of my early devotion to baseball was Jackie Robinson. Having broken baseball's color barrier in 1947 (the year I was born) and courageously endured hideous abuse and racial slurs, Jackie was a Simon family hero. In fact, each time Number 42 came up to the plate and assumed that distinctive batting stance, hands high above his head,

my mother would jump up from her chair and actually kiss the TV screen. We became close family friends with the Robinsons in the early fifties, and I developed a close bond with Jackie Jr. Even though he was clearly more talented than I at every sport imaginable, he was a gracious and loyal childhood buddy.

At my mother's urging, the Robinson family decided to move to Stamford, Connecticut, where my family had a summer house, in 1952. In the beginning, they were blackballed from this upper-middle-class community, as no real estate broker would show them any appropriate property. Mom took matters into her own hands, writing letters to the local paper, the *Stamford Advocate*, church groups, and civic leaders. We received many hate calls. I remember one: "Hello?" "Who is this?" "I'm Peter Simon," I said in my high-pitched seven-year-old voice. "Oh, yeah?" said a gruff-sounding man. "Your parents are nigger lovers!" *Click.* I was frightened. I didn't even know what "nigger" meant, but I knew it wasn't nice.

Eventually, through my mother's tireless efforts, the

JACKIE ROBINSON DURING A JAZZ CONCERT HE HOSTED IN STAMFORD
TO RAISE MONEY FOR AFRICAN AMERICAN CONCERNS, 1970.

<

SISTER CARLY GETS IN SOME EARLY BATTING
PRACTICE, STAMFORD, CONNECTICUT, 1950,
IN A PHOTO TAKEN BY MY FATHER.

>

MICKEY MANTLE GIVES A PREGAME
INTERVIEW AT YANKEE STADIUM IN 1962.
EVEN THOUGH I GREW UP HATING THE
YANKEES, I HAD TO LOVE "THE MICK."

Robinsons bought land and built a home in North Stamford, an all-white neighborhood. The year the house was under construction, the family moved into one of our guest cottages. I got firsthand reports from Jackie after every Dodgers game. And on off-days he'd organize informal ball games on our front lawn. One time he even brought Lucy Monroe, the Dodgers' official national anthem singer, home with him. She sang live and in color before one of our games.

Nineteen fifty-five was the most exciting year yet, as the Dodgers finally beat the hated Yankees and became World Champions. We were in ecstasy. But the lights soon dimmed when Jackie was traded, foolishly, to the Giants the next year. Rather than play for the opposition, he retired and eventually entered the corporate world. The following year, the Giants and the Dodgers both left New York for "greener" pastures on the West Coast. We were bereft.

Five agonizing years passed until the National League finally adopted a new team, the New York Metropolitans. I became as much a Mets addict as I had been a Dodgers fanatic and eventually even published a book about the Mets. The tradition continued. . . .

Those early Met teams were laughably charming, with the likes of marvelous Marv Throneberry, the overweight Don Zimmer at third, pinch hitter Smoky Burgess chugging down the baselines, and good old Gil Hodges, a faint version of his former self, at first. There was the infectious non sequitur humor of Casey Stengel, probably the most quotable baseball personality this side of Yogi Berra. The more the Mets failed to win, the more laughs Stengel provided. At one point that first year, they lost seventeen games in a row. But I didn't care. National League baseball was back! The Mets were eliminated from the pennant race on August 7 and ended the season with a pathetic 40 to 120 record. But I still loved them and had no interest in who went on to the World Series.

As the years went by, the Mets slowly but agonizingly improved. The team remained my constant companion. Bob Murphy, Ralph Kiner, and Lindsay Nelson, the three Mets announcers, delighted me no matter what the score. Even Jim Bunning's perfect game against the Mets on Father's Day 1964 was riveting. Once I watched an entire twenty-three-inning game against the Giants — six hours on our library couch without moving. The Giants eventually won 6 to 4. I felt foolish having expended

so much valuable time on a losing effort. I kept a scrapbook of that entire season, pasting in every article, box score, and player's stats each day.

By 1968 a transformation had begun. Gil Hodges became the manager, and a trio of extraordinary young pitchers emerged. In 1969, the year the nation was on its knees with political and cultural revolution, the "Miracle Mets" won not only the pennant but the World Series as well. In my adolescent years I would have been in a Met-induced euphoric stupor, but I was so involved at Boston University with our changing social landscape that I could give the Mets only divided interest.

I took on an important assignment for the *Atlantic Monthly* in early October 1969, while I was a senior at BU. The concept of the story was to re-create the weeklong canoe journey that Henry David Thoreau had taken a century earlier up the Concord and Merrimack Rivers. Accompanied by my girlfriend, Lacey Mason, and Packer Corners communards Ray Mungo, Verandah Porche, and Marty Jezer, I aimed to demonstrate how the graceless hand of man had polluted and disgraced the bucolic grandeur of these rivers. It wasn't much of a task to photograph the floating tires and soggy mattresses near the industrial towns. The greater challenge was to incorporate my Mets mania with the *Atlantic Monthly* obligation. Ray Mungo put the whole issue in perfect perspective in his book *Total Loss Farm:*

I wanted Pierre to join us at that point, abandon his car and get on the boat. Fancying myself Kesey and all of us Merry Pranksters, I said, "Peter, you must be On The Boat or Off The Boat." But Tuesday was a Mets day, Peter said, and though he would follow us upstream and generally watch out, he must stay close to the car radio to keep tabs on Tom Seaver and so-and-so's stealing third. It meant nothing to me, but since Peter thought it

was important, who was I to belittle it? Some people get their energy off Kesey and Kerouac and Thoreau, others off Seaver and Swoboda. . . . So Peter was hooked on the Mets and there seemed no solution but to plan the rest of the trip around this handicap. Peter had to break camp early, drive to towns for newspaper reports of the previous day's game, leave the canoe to its own progress while he sought out television stores where the American Series would be coming across display color sets. He would then return to us radiant with news of the latest victories.

The riveting pitching exploits of Tom Seaver, Jerry Koosman, and Nolan Ryan; the acrobatic outfield plays of Ron Swoboda and Tommie Agee; the shoe polish found on Cleon Jones's shoe, awarding him first base during a crucial point in game five; and the final out of the historic series meant more to me than being in the canoe. My comrades ridiculed me incessantly as they paddled their way up the Merrimack.

When I moved to Vermont the next fall, the (mostly) good-natured ribbing continued. There was a contradiction in leaving the "real world" behind only to be connected to the World Champion Mets. I bought a huge antenna and installed it on the roof of our barn, pointed toward New York with the hope of catching an occasional Mets broadcast. My experiment failed save for the rare, snowy reception of some games.

By the time my beloved Mets reached the World Series again in 1973 (only to lose to the Oakland Athletics) I was in my own domain on Martha's Vineyard. Since cable television had yet to be invented, I once again relied on a rooftop antenna to receive WOR-TV on the occasional calm, humid night. I attended a few games, notably the playoff with the hated Cincinnati Reds, including the historic brawl with Pete Rose as he barreled into mild-mannered shortstop Bud Harrelson.

THE METS PLAY THE CARDINALS DURING THE PENNANT DRIVE OF 1986 AT SHEA STADIUM.

The Mets declined into mindless mediocrity during the late seventies and early eighties, and my interest waned considerably, but by 1985, with the advent of Dwight Gooden and the colorful Roger McDowell, my passion resurfaced. By then I was living in New York City during the Vineyard's off-season. The Amazin' Mets once again consumed my soul. In 1986, I could sense a championship team in the making. All the ingredients of 1969 were there: great pitching (Dwight Gooden, Ron Darling, Bob Ojeda), a charismatic lineup (imports Gary Carter, Keith Hernandez, Ray Knight), and pedigree (Darryl Strawberry). And there were scrappy support players like Mookie Wilson, Wally Backman, and the monosyllabic center fielder, Lenny Dykstra.

This cast of characters was hard to resist. I approached publisher Henry Holt with veteran Mets beat reporter Jack Lang about producing a comprehensive book on the history of the Mets to coincide with their twenty-fifth anniversary. Holt gave us the thumbs up, much to my delight. I could chronicle the Amazin's 1986 season from start to finish!

My many years of covering rallies and demonstrations, rock festivals and spiritual conventions hadn't adequately prepared me for the baseball arena. Everything was much more regulated. I couldn't go between the white lines during batting practice, could only go into the locker room after a victorious game, and was relegated to a first or third base "photo box" position during the actual game — crammed in with veteran sports photographers.

Of all sports, baseball, as it turned out, is the most difficult to photograph. Aside from the

NEW YORK CITY MAYOR ED KOCH, WITH
AN ASSIST FROM NEW YORK METS CO-
OWNER FRED WILPON, THROWS OUT THE
FIRST BALL OF THE 1986 SEASON.

STRAWBERRY GREETED AT PLATE AFTER
BLASTING A GAME-WINNING HOME RUN.

DWIGHT GOODEN, AN OVERPOWERING
PITCHER IN 1985 AND 1986, BEARS DOWN
TO GET OUT PETE ROSE.

KEITH HERNANDEZ HAS TROUBLE
HANDLING A DIFFICULT LOSS DURING A
POSTGAME INTERVIEW.

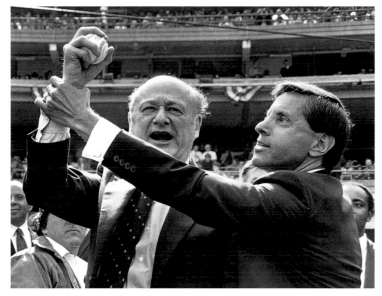

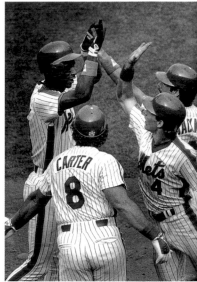

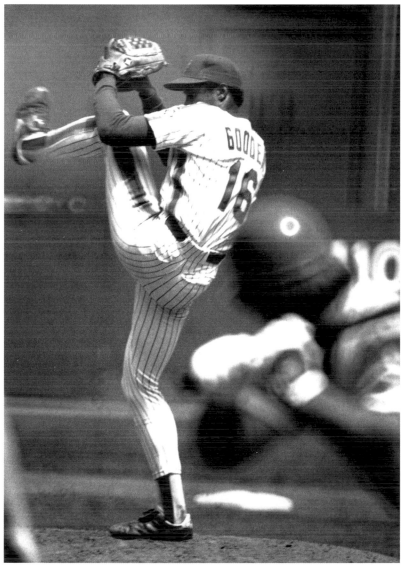

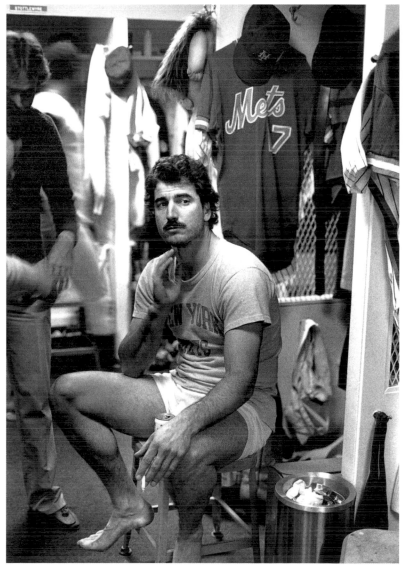

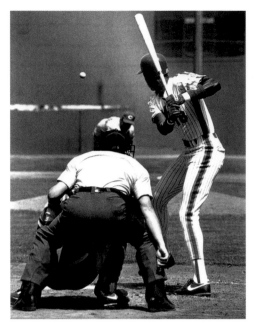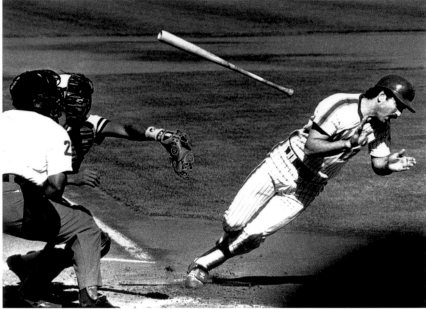

DARRYL STRAWBERRY LOOKS LIKE A THOROUGHBRED WITH HIS GRACEFUL STANCE. WATCH OUT, KEITH!

standard shots of a pitcher delivering the ball and a batter stationed in the batter's box ready to hit, the rest of the action is totally unpredictable. Luckily, I would occasionally be able to prefocus my lens on second base to grab a double play, or on the right fielder following a pop fly.

Over the course of the highly memorable and dramatic 1986 season I slowly learned the ropes. I developed personal relationships with Gary Carter and Keith Hernandez, and gradually felt I had become a distant relative of a diverse, extended Mets family. I followed their year much as one would follow an engrossing television series; I got to know each character's likes and dislikes, idiosyncrasies and history. To be intimately involved during the unfolding of a baseball dream was a thrill.

During the playoffs I was on the Vineyard, feeling terribly apart from the historic drama. I experienced the memorable sixteen-inning sixth game against the Houston Astros vicariously, riveted to the TV. I even followed each pitch with Carly, who was in New York City, over the phone.

Unfortunately, I was unable to obtain my usual "on-field" credentials for the World Series with the rival Red Sox, since I was considered an occasional media member. However, I was able to station myself in the press box area, high above the field. Carly, her son Ben, and her boyfriend Russ Kunkel joined Ronni and me to witness the improbable sixth game when Mookie Wilson's bouncer went through Bill Buckner's legs. We were in the same location for the indelible come-from-behind seventh-game victory, and I could only photograph the historic moment with a 400-millimeter lens. At least I was there to witness the ultimate victory of my baseball life. Being able to share those memories with my family only made it sweeter, a circle of baseball mania finally completed. We hugged and cried as the Mets celebrated their victory on the pitcher's mound.

Since 1986 my passion for major league baseball has taken a bit of a hit. First and foremost, the Mets hadn't "gone anywhere" except for a cameo appearance during the playoffs of eighty-eight and

> MOOKIE WILSON BLAZES A TRAIL TO FIRST BASE, RUNNING OUT HIS FAMOUS DRIBBLER THAT WENT THROUGH BILL BUCKER'S LEGS, WINNING THE SIXTH GAME OF THE WORLD SERIES.

BELOW:
ONE OF THOSE DECISIVE MOMENTS: JESSE OROSCO GETS THE FINAL OUT AND THE METS ARE WORLD CHAMPIONS, OCTOBER 1986.

AND THE CELEBRATION IS ON.

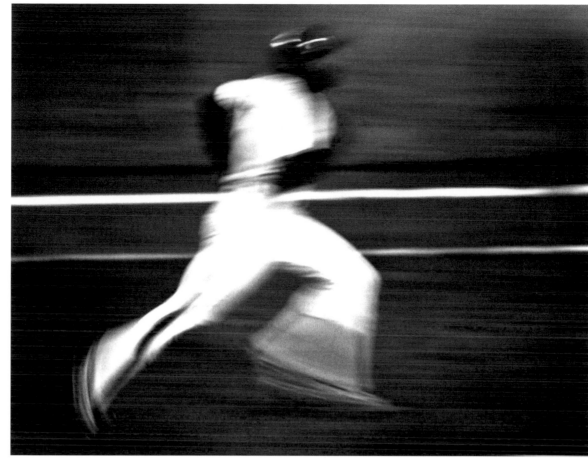

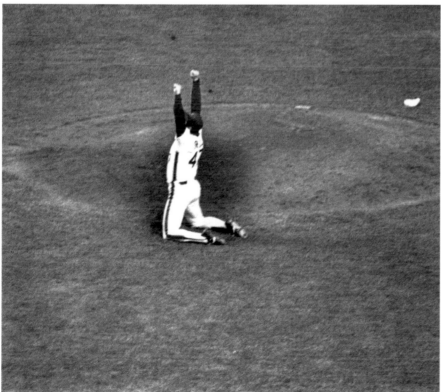

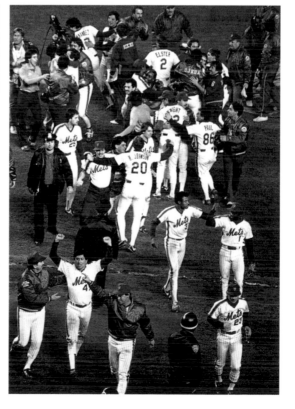

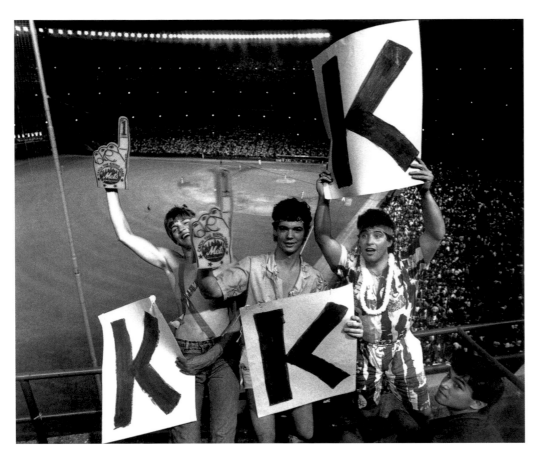

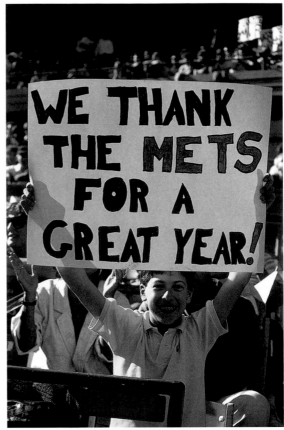

METS FANS KEEP TRACK OF DWIGHT
GOODEN'S STRIKEOUT TOTAL IN THE "K
KORNER" OUT IN LEFT FIELD.

JACK LANG, RUSTY STAUB, CARLY SIMON,
AND KEITH HERNANDEZ CELEBRATE THE
PUBLICATION OF JACK'S AND MY BOOK,
"THE NEW YORK METS: TWENTY-FIVE YEARS
OF BASEBALL MAGIC." THE PARTY WAS
GIVEN AT RUSTY'S RESTAURANT ON THE
UPPER EAST SIDE OF MANHATTAN, 1987.

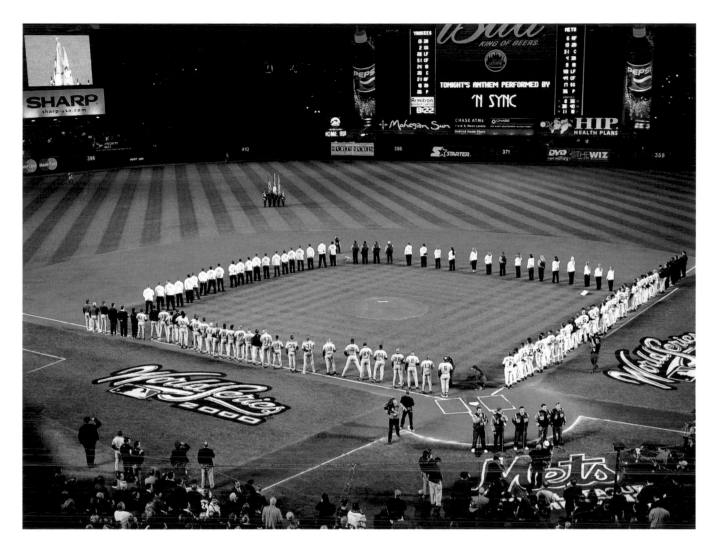

PLAYERS LINE UP AS 'N SYNC SINGS THE NATIONAL ANTHEM AT SHEA STADIUM DURING THE SUBWAY SERIES, 2000.

ninety-nine. Second, Darryl and Doc tragically sabotaged their careers with substance abuse. Third, greed, selfishness, strikes, and expansion have diluted the game as a whole. The owners can't see the big picture about revenue sharing. The parasitic agents bid up the players' salaries beyond comprehension. The stars are concerned with their stats over team spirit and loyalty. "My" Mets seem to change their roster at least 40 percent a year. How can I feel I know the team as an extended family anymore? Players I rooted for passionately have suddenly become the opposition. And the players' union, a fine concept in theory, has so much power that it ignores "the best interests of baseball."

In the year 2000, the Mets did manage to get to the big time and played the Yankees in the subway series. Although they lost to their archrivals 4–1, New York was abuzz with excitement. Strangely, I felt a bit detached from the hysteria. The 2000 Mets were less magnetic and dramatic than that 1986 team had been.

For me, I suppose there will always be a special quality between those diagonal white lines — the smells, the sights, the sounds — no matter what external forces may be at play. But the magic has disappeared.

Where have you gone, Jackie Robinson?

SUNRISE AT WINDY GATES, THE MOST STUNNING STRETCH OF SHORELINE I'VE EVER SEEN.

A Haven on the Vineyard

1980—2000

My first experience of Martha's Vineyard was in August 1955. My family rented a cottage near a beach in Chilmark for the month. My parents had vacationed there in the thirties and forties, having wild, carefree times with friends and associates from the Simon & Schuster world. Now, they had returned at last to savor all that the island had to offer. Sadly, it was one of the few vacations we ever experienced as a whole family.

The ocean has always had a magnetic pull for me: the thunderous crashing waves, the hissing white foam, the unlimited horizon, the glistening sand. But until 1955 I had witnessed these wonders only at the crowded and commercialized Jones Beach on Long Island, a two-hour trek from our summer home in Stamford.

On the Vineyard, the beach was a different story, even from my eight-year-old perspective. My father took me down the, count 'em, one hundred and three steps from the top of the breathtaking, multicolored clay cliffs to the deserted panorama

of endless sand and sea below. It was a private beach called Windy Gates, one of the most spectacular shorelines I'd ever seen. Dad and I splashed in the booming surf as the sun settled behind the high cliffs. The water was mid-August delightful. I figured I was somewhere I belonged.

But on the trek back up those wooden, weather-beaten stairs, my father grabbed his gut and said, "Ouch! There's something wrong with my stomach." I got scared. He hobbled back to the cottage in great pain and we rushed to the hospital. He had a hernia. A damp hand had been draped over our family vacation.

Nonetheless, the Vineyard made a major impression; I fell in love with the craggy stone walls, the road signs that said things like "Beetlebung Corner," the damp, low-ceilinged cottages, the pungent smell of over-ripe berries and uncut brush, the gulls and the beach grass, and even the way the playing cards we used for games like war and spit got all clammy. I started drawing road maps of the island, never

MY MOTHER DURING HER HEYDAY ON THE ISLAND IN THE FORTIES,

IN A PHOTO TAKEN BY MY FATHER.

forgetting to add the solid or dotted lines dividing the curvy, two-laned country roads.

I cherished every moment; I had never felt so close and connected to my family, poison-ivy rashes and sunburns notwithstanding. Carly observed the "laugh in the hands" effect, which referred to the combination of sand and salt water, with a spice of sunburn, that made tickling others quite satisfying.

From that summer onward, not a year went by without at least a week's escape to the Vineyard. Many of my parents' closest friends — publishing associate Albert Leventhal, authors Max Eastman and Lillian Hellman, *New Yorker* staff writer Daniel Lang, sports columnist Red Smith, puppeteer Bill Baird, actress Katharine Cornell, ecologist Anne Simon (no relation), and media mogul Kay Graham — were part of the circuit. I was embraced by this group as some sort of sacred son, always welcomed at various cocktail and dinner parties.

After my father's death in 1960, we kept up the tradition. Once our summer home in Stamford was sold, the weeklong escape to Martha's

Vineyard became a month at least. By the summer of 1965 I had rented my own little hovel, and in 1973 I took the money from my Tree Frog property and bought a pasted-together group of lobster shacks. So what if there was no electricity or plumbing. At least I owned a part of "the rock."

I began living there year round that fall. The first few years up in the tiny town of Gay Head (smallest one in all of the Commonwealth of Massachusetts) were funky but fun. There were futons on the floor, collectively sautéed dinners of tofu and brown rice, incense, meditation, and music around campfires by moonlight. The "free love" philosophy was in full effect, and I searched the shorelines and groovy dance parties for "the one." There were many ones, but not exactly the right one.

My little shack was finally upgraded with electricity and a modicum of plumbing, thanks in large part to a bunch of hangers-on who hung in and helped out. The scene evolved into a smaller version of the commune at Tree Frog. The Vineyard lifestyle — laid back and barefoot; anything went and usually did — fit my desires perfectly. John Updike

extolled the pleasures of going barefoot in the first of my three books about the island, *On the Vineyard,* using it as a metaphor for the endearing images of summer:

> *When I think of the Vineyard, my ankles feel good — bare, airy, lean. Full of bones. I go barefoot there in recollection, and the Island as remembered becomes a medley of pedal sensations: the sandy rough planks of Dutcher's Dock; the hot sidewalks of Oak Bluffs, followed by the wall-to-wall carpeting of the liquor store; the poky feel of an accelerator on a naked sole; the hurtful little pebbles of Menemsha Beach and the also hurtful half-buried rocks at Squibnocket; the prickly weeds, virtual cacti, that grew on a certain lawn near Chilmark Pond; the soft path leading down from this lawn across giving, oozing boards to a bouncy little dock and rowboats that offered yet another friendly texture to the feet; the startling dew on the grass when one stepped outside with the first cup of coffee to gauge the day's weather. A friend of mine, who took all these photographs, played golf barefooted . . . he managed to get away with it.*

Going barefoot was one pull; going totally naked was another. And smoking homegrown weed, unmolested, was a distinct third. The cine-matic vision of various island police folk of that era fearlessly driving down my dirt road in their Chevy Blazers and taking off their badges and guns to share joints with me was beyond my previous experiences. I figured the counterculture revolutionary war was finally over and that we had somehow won.

My garden grew and we consumed: beets, carrots, strawberries, snow peas, basil for pesto, the sweetest but worm-marred corn, pole beans, succulent peaches, cucumbers that grew beyond normal proportion, asparagus galore, and finally, but not minimally, the evil weed.

But as the seasons and years ticked by, I found life on the Vineyard, at least on a year-round basis, far too limiting. My hippie lifestyle was starting to wear thin. I needed to be more productive. My horizons needed expanding. One oft-said phrase kept echoing in my mind: "The Vineyard is a secure place for insecure people." Was that me? Maybe.

So while I kept my Gay Head abode, I would leave the island to drum up magazine or book projects during the off-season. I packed my crucial

belongings into my trusty Volvo and took to the road. My stops included places like Cambridge, my mom's in Riverdale, Vermont, California, Hawaii, and Jamaica — had camera, would travel.

By the mid-seventies, money started becoming an issue. Although my father had been wealthy, he had invested unwisely. Aside from a monthly two-hundred-fifty-dollar stipend from a trust fund, I never received much of an inheritance until my mother's death in 1994. My philosophy always had been to live with a passion for creativity, quality of life, and playfulness — the money would sift in as necessary. I never wanted to be driven by the desire for money alone. While I deliberately chose a simple subsistence lifestyle, I did indulge in the occasional gourmet-style dinner, new camera, enlarger for the darkroom, lava lamp, and new set of speakers for the living room. But I hardly ever bought new clothes, and my habit of going barefoot half the year saved money on shoes. I crashed on friends' floors rather than paying for impersonal hotel rooms when I traveled.

During the late seventies, I began observing many of my sixties compatriots changing their priorities. The desire to accumulate set in. Many blood-brother souls seemed somehow compromised by that desire — radicals turned dentists, dropouts turned real estate developers, New Agers turned lawyers. I didn't want to "cop out" if I could help it. My father had often said to me, "Never do anything for money alone." But then my mother would chime in, "Peter, you are so talented. Be smart. Get paid for what you're worth. Don't underestimate yourself." Although I knew that was good advice, I felt strange asking to be paid for something I loved to do anyway. I clearly had not (and sometimes think I still haven't) come to terms with money and its proper meaning. Meanwhile, I

merely wanted to make various loose ends meet, whatever my standard of living might have been at the time.

By 1977 my bachelor years were over, and the pressures of a more "grown-up" lifestyle and set of responsibilities eventually started changing my carefree ways. But the ladder to "suckcess" still remained unsteady. When I married Ronni we renovated and expanded the shack. The futons were replaced with an actual sofa, and an oil furnace supplemented our wood-burning stove. Slowly, the artifacts and philosophies of my youth gave way. How could I keep up with our upwardly mobile lifestyle without sacrificing my ideals? That was a daunting challenge indeed — the challenge of my generation, in fact.

From 1982 through 1986, I gave it my best shot to become an ambitious, highly sought after freelance photojournalist out of New York, at least during the colder months. We sublet a nice apartment on the Upper West Side. During that time I did manage to complete *Playing in the Band, Reggae International,* and *The New York Mets: 25 Years of Baseball Magic,* three of my best-selling books. But as the publishing world embraced me, the magazine industry rebuffed me. There were always at least twenty-five photojournalists competing for any given assignment at any given magazine. I would dutifully drop off my portfolio at places like *Life* magazine, *New York* magazine, or Contact, a major photo agency at the time. The company line would always be "Great work. We'll call you if we need you." In order to succeed, I would have had to hit aggressively on everyone I knew or even half knew to get that coveted "exclusive" celebrity picture, or wine and dine assignment editors whom I may not have even liked. It was all about connections. Either I lacked confidence in my abilities, or else my heart just wasn't there, or both.

REFLECTIONS OF ANOTHER ERA, AQUINNAH.

THE KEITH FARM.

The well-paying gigs in the photo world at the time were shooting annual reports for major corporations; taking highly produced, in-studio shots of women wearing, for example, expensive lingerie for print advertising; or becoming a bottom-feeding paparazzi type, hanging out at discos and movie premieres awaiting the stars. Not much of a life for me.

At one juncture, I even considered following in my dad's large footprints, getting some sort of gig at Simon & Schuster, or possibly another publishing house, taking charge of a photo imprint, perhaps. But the nine-to-five aspect was unappealing. The hippie years had spoiled me in that regard.

Ronni, on the other hand, was thriving. She had pursued a career as a screenwriter and met with success. She was represented by the William Morris Agency and was usually either working on a script or meeting with producers to line up a new one. For me, it was a lesson in humility.

Ronni became pregnant during the fall of 1985 and gave birth to our son, Willie, on June 2, 1986. During the following fall it became clear: We should move to the Vineyard year round. That was that. Although we both could happily leave behind the daily hassles and threats of city life, the decision meant a sacrifice for Ronni's career. But being a new mom soon became the overriding, all-important focus in her life, ambitions aside. Giving our son a good shot at safety and quality of life in a small, supportive community became our mutual goal. When we compared real estate values between Westchester or Rockland County and the Vineyard, the island proved more affordable. The handwriting was scribbled on my brain like the graffiti sprayed over the subway walls — my love/hate relationship with the Big Apple was over.

Indeed, by that time we weren't partaking of a lot that the city had to offer — the theater, museums, and the like. So the hardest aspects of New York to give up for me were the daily contact with my immediate family and my growing professional association with the Mets. While I tended to be swallowed up by the morass of competition in New York, I was slowly cultivating a good reputation and client base, and starting to make a respectable living, on the island. I sold landscapes to Vineyard lovers at various galleries, photographed summer families down by the beach during "the golden hour" (just before sunset), and took on wedding photography. I also created posters, wall calendars, notecards, and Vineyard books. Peter Simon Photography sprouted organically and developed into a small cottage industry. This helped pay for our expanding pile of bills.

We sold the Gay Head shack (too funky for child rearing) and traded up for a new homestead in Chilmark, where we have lived ever since. It's a relatively modest cottage-style house (particularly when compared to the "trophy homes" that have sprouted up over the past decade) but offers such amenities as a tennis court, a swimming pool, a duck pond, lush plantings, and a large lawn. Subconsciously (or perhaps not) we've given Willie and ourselves a smaller, more user-friendly version of my childhood summer estate in Stamford.

So far, I can't say I would have preferred it any other way. Not that the Vineyard is perfect. We work very hard for three months to make enough money to last twelve. The midwinter can be isolating in a Bergmanesque sort of way. Expanding cultural experiences are rare. The Vineyard is slow to accept change and seems backward at times. Issues of growth and affordable housing are diligently argued. Occasionally the plover's rights outweigh those of humans.

>

MALCOLM FORBES VISITS THE ISLAND WITH HIS REGALIA, 1987.

JUDY BELUSHI GIVES HER HUSBAND, JOHN, A GOOD-BYE HUG AT THE MARTHA'S VINEYARD AIRPORT, EARLY EIGHTIES.

BELOW: CHRISTOPHER REEVE AND SON AT A VINEYARD FUND-RAISER, 1995.

ALAN DERSHOWITZ SKIPPING STONES, 1998.

Somehow, though, for me, it all seems to fit. I even like the dichotomies. I enjoy working for the newspapers here, though the pay is a small percentage of New York rates. At least I'm a contributor to our "grapevine." I cherish the sense of trust between souls, even those who hardly know each other. I love the misty mornings, the foggy nights, the salty air, the stunning sunsets, and the rural simplicity overlaid with the urban complexities that the celebrated summer people import. We have a good crop who arrive here each summer (Alan Dershowitz, Diane Sawyer, Ted Danson and Mary Steenburgen, William Styron, Walter Cronkite, Mike Wallace, Spike Lee, Carolyn Kennedy, Michael J. Fox, Keith Richards, Dan Aykroyd, etc.) and contribute to the community in their own ways. Their privacy, if wanted, is respected. There isn't much gawking. In fact, everyone seems to exist

MY SON, WILLIE, SWINGS INTO WINTER WITH AN ELEMENTARY SCHOOL PAL, 1994.

on an equal playing field: The music superstars and multimillion-dollar CEOs generally mingle comfortably with the lobstermen and caretakers. We can think globally while acting locally. What a concept!

During the summer of 1994, long before he had disillusioned us with his many imbroglios, President Clinton made his first visit to the Vineyard with his family. One late afternoon they visited Carly. Ronni, Willie, and I were invited. After the formal introductions were concluded, I spotted Bill and Hillary hanging out in the foyer alone for a moment. I seized that moment and approached them. I blurted out, "I feel really honored and proud that you guys are able to represent our generation in office. We all have stood up for many things through the years — equality, peace, justice, and a warmer and more compassionate way of relating to one another. Thank you for bringing it all to the mainstream." I had tears in my eyes as they both spontaneously reached out to hug me. I felt a connection through them, a bridge between past and future, and a new destination for our nation. It was only fitting for this to have happened on the Vineyard — the place to which I have always returned in order to make sense of it all.

PRESIDENT CLINTON, RONNI, AND WILLIE AT CARLY'S, 1994.

MARIO CUOMO, WHILE VISITING HIS DAUGHTER MARIA AND SON-IN-LAW
KENNETH COLE, REFLECTS UPON A BEAUTIFUL VINEYARD SUNSET, 1999.

<

WILLIAM STYRON RELAXES WITH HIS FAMILY, SUSANNA, POLLY, TOM,
AND ROSE, ON THE BACK PORCH OF THEIR VINEYARD HAVEN
WATERFRONT HOME, 1974.

WALTER CRONKITE GETS READY FOR A SAIL ABOARD HIS BELOVED BOAT,
WYNTJE, 1989.

< AN OAK BLUFFS
PORCH-SIDE
DISPLAY.

< SPIKE LEE ON
THE PORCH OF
A COLORFUL
GINGERBREAD
HOUSE IN
OAK BLUFFS.

> GINGERBREAD
HOME
SPECTACLE.

SALT MARSHES IN ISOLATION NEAR CAPE POGUE, CHAPPAQUIDDICK.

THE MAJESTIC GAY HEAD CLIFFS, THE VINEYARD'S MOST PRECIOUS NATURAL RESOURCE.

SEASIDE TAPESTRY.

MENEMSHA SOLITUDE.

ISLAND COMMUNICATION.

THE MULTIHUED
CLAY SHADES
OF AQUINNAH.

WISTERIA ROAD.

MOTHER NATURE PUTS ON
AN OFF-SEASON SHOW
AT THE ISLAND THEATER.

194

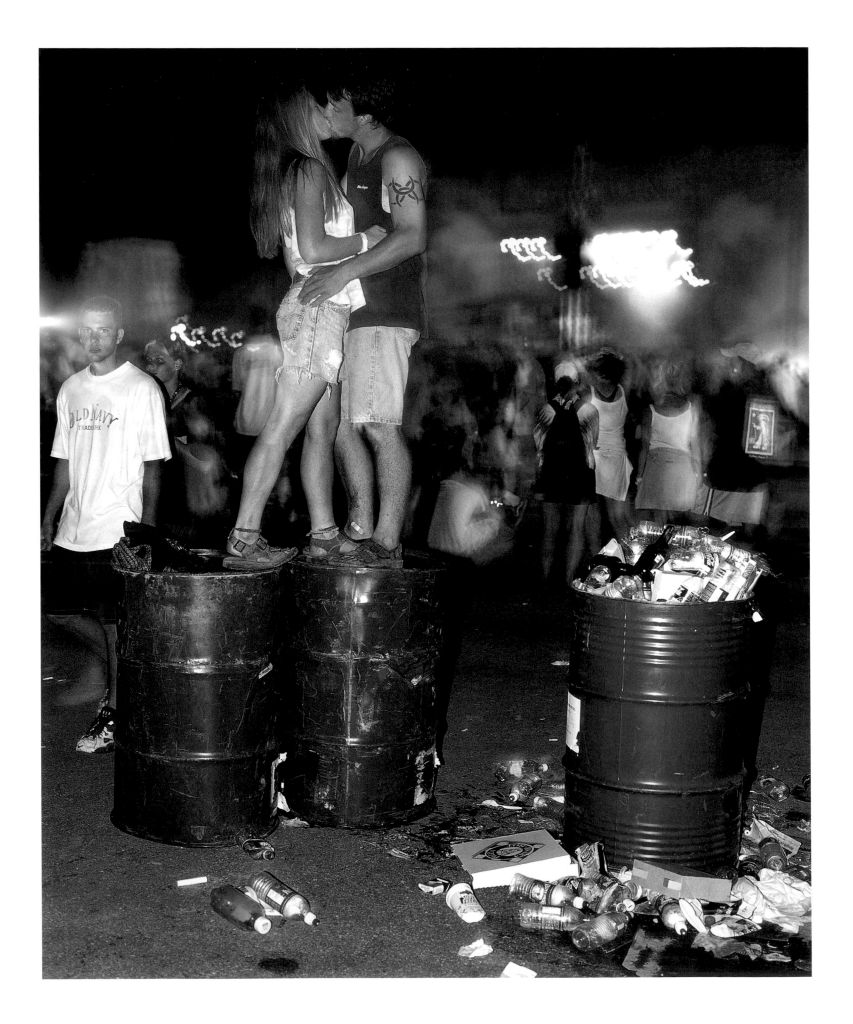

Woodstock'99.com

1999

During the summer of 1969, Tim Rossner and I decided it would be a blast to run an experimental art film festival on Martha's Vineyard. We figured it wouldn't make much money but could probably cover the rent for a Chilmark shack and minimal living expenses.

Publicity about Woodstock began filtering to the island in July of 1969. It was on the night Neil Armstrong said, "One small step for man, one giant leap for mankind," that I decided I *had* to go to the concert, despite my film festival responsibilities.

I worked it out with *Rolling Stone* magazine to get press credentials and tickets, and made a ferry reservation to leave the island with a few friends for the three days of peace, love, and music. But it was not meant to be, as my Saturday, August 15 journal entry explains:

Woodstock: hippies have taken over the planet. 13-mile traffic nightmares have ensued, Bethel is a complete haywire place, and there's no food, shitting places to hide, hippies and media are being helicoptered in emergency measures, and meanwhile I couldn't get off the Vineyard due to a ferry breakdown. And so here I am holding a press pass and a regular 3-day ($18) ticket at my shack, not being particularly bothered except maybe a bit disappointed 'cause now I can't take all the pretty leetle peectures and meet all the beautiful hippie chickies.

While I was able to rationalize away the frus-tration of not going, the images I saw in *Rolling Stone,* and later in the Woodstock movie, have haunted me for years. If only I had tried a little harder, I could have come back with great photo reportage and firsthand experiences I could tell my grandkids about. I probably could have avoided the bad acid, if not the rain and mud.

Not to be denied the Woodstock Nation spirit altogether, Tim and I spontaneously decided that weekend to open the doors to our fledgling theater and invite any and all to come in free to share a night of my collection of rare, live Grateful Dead tapes. Word spread quickly, and on Sunday night we had more than 250 loving, mesmerized young tie-dyes at our venue, mushroomed out on blankets and mattresses hastily placed on the floor. Joints and jugs of LSD-laced grapefruit juice were passed freely among the crowd. A fine time was had by all. Dawn broke to passed-out love freaks, grateful to have avoided the traffic and mud of Bethel. As we said our good-byes, kisses and hugs and hits of patchouli were exchanged.

Thus it was with a mixture of wistful melancholy and mild curiosity that I heard thirteen-year-old Willie ask, "Dad, please take me to Woodstock Ninety-nine." While my first instinct was to say, "No, you're too young and it might be overwhelming," I pondered the idea of taking an older friend

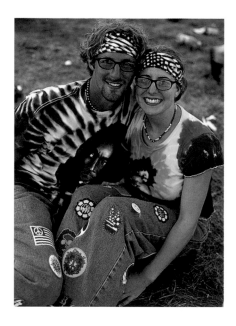

of his along as a chaperone so that I could be free to photograph the event as a closing segment for this book, as in my counterculture heyday. The notion began growing as Willie's pleas persisted and my desire to share a bonding experience with him at a pop-culture extravaganza became increasingly "important." I wondered if there was still an "alternative culture," and if so, how would we react to it?

So, exactly thirty years later, I went through the same routines: getting ferry tickets, lining up a place to stay, and, most important, obtaining press credentials. David Silver, writing for the Woodstock.com web site, came through with those in the clutch. I ordered Willie and his older friend Willy regular tickets over the Internet. How far we had come since those ancient days of waiting for the U.S. Mail to bring me my tickets for Woodstock 1969.

By the time we got to Woodstock '99 (which actually took place at an ugly former military base near Rome, New York) the audience was a quarter of a million strong, and everywhere there was song and desecration. As we wended our way from the main entrance through the throngs to get to the press area, I shouted to Willie and Willy to meet me

stage left at sunset. But they were clearly too excited about getting a glimpse of DMX live to really care about logistics. We separated.

Left on my own, I got out my Pentax and began shooting with a passion that I hadn't felt for years. I found the manifestations of youth culture riveting — but it was a morbid fascination. I no longer felt a part of the scene. Even though there were smatterings of middle-aged post-hippie holdouts around, for the most part they seemed burned out and slightly degenerate. The mostly white twenty-somethings were either mesmerized by the relentless barrage of head-banging groups onstage (Kid Rock, Limp Bizkit, Rage Against the

WILLIE SIMON, PHONE HOME!

Machine) or parading around the outskirts mimicking the tie-dye and nudity of yesteryear, with a leaning toward exhibitionism. Most seemed affluent, using their parents' ATM and credit cards. I didn't see a sense of purpose, such as the consciousness raising or fighting for peace, freedom, and liberation of my day. These event-goers were rebels without much of a cause, only out for a good time.

And then there was the trash. For some reason, security and maintenance were either understaffed or undermotivated. Garbage heaps grew like tumors out of the grass and concrete, and mud caused by Porta-Shower and Porta-Potti runoff took on a stench as festival-goers tried to re-create the mud baths of sixty-nine. I saw people excreting bodily fluids almost everywhere, without inhibition.

In spite of all this, a festive and larger-than-life atmosphere abounded. When Sheryl Crow took the stage, I was momentarily transported. But as I tried to get near the stage to photograph her, I was rebuffed by security insisting that I sign various approval contracts before proceeding. I soon gave up and chalked it up to professional indifference on my part. Besides, the next act to go on put Sheryl down as hopelessly boring, saying that

Berkenstocks had gone out of style years ago. So much for that!

Backstage there was a media feeding frenzy, as each outlet (MTV, VH1, *Rolling Stone*, Woodstock.com, etc.) whisked the various performing artists to its own tent for interviews. Gaggles of microphones and cameras were pointed at the stars continuously. I battled for position a bit and then receded. It all seemed so militaristic and greedy. David Silver did conduct some interesting dialogues, but these could be seen only online, if anyone cared.

By nightfall, there was a miniwar going on among the throngs. Anyone pushing close to the stage who got claustrophobic (an understandable sensation) was body-surfed to the "pit" at the very front of the stage and then dropped to the ground. Bruised and bloodied, they were then carted off to waiting ambulances and EMTs. All around me there were groaning spectators, dazed and confused by the crush of humanity. I kept fearing that the two Willies would be the next ones flying by.

Fortunately, we did reunite as planned and headed back to our seedy hotel room, zigzagging through the highways and byways of semirural upstate New York.

The next day dawned hot and muggy. We made it to the festival by noon and saw a repeat of the day before, only more so. We wandered as a threesome around the extremities of the campus for a while, seeing people snoozing under garbage bins, paying six dollars for a bottle of Evian, declining offers for Ecstasy for fifty dollars a dose, and noting how the heaps of trash had expanded. We saw lesbians feeling each other's breasts and men comparing the size of their organs. And the bands played on, oblivious to the chaos surrounding them. The three of us took refuge in the roped-off backstage area, recharging and hanging with Mr. Silver, and then headed out for more abuse.

By day's end, we had just about had it. But I had one last desire — to photograph the "mosh pit" from the sound platform high above. That was a photo op not to be missed. I was escorted out there by walkie-talkie-toting ushers. I got perched just as Korn took the stage. The stampede was on. I sensed another Who concert catastrophe in the making. Whoever Korn was, people were clearly risking their lives to get close to them. It was a highly photogenic adventure for me, but the seeds for a full-scale riot were being sown.

Backstage that night, a joint was passed around by some of the media types. An instant camaraderie took place as we were finally able to relax and reflect. Since the aroma of marijuana and the vibe of getting high had prevailed extensively over the past two days, Willie was more than curious. After a bit of thought, I decided he was too young to share the joint. His whole future was at stake. I wanted him to feel directed and keep up his grades at school. He would have his time a few years down the road.

The next morning, the three of us agreed that we had had enough of the crowds, chaos, and confusion. As we made our six-hour trek back home to the Vineyard, we exchanged thoughts and feelings about what we had seen. What about peace, love, and music? Were these things as important to the late-nineties pubescent generation as these were to mine? Probably not. Had the MTV culture hopelessly commercialized and numbed the excitement that I had gone through in the late sixties? Probably so. Did the latest single by Korn have the impact on their audience that "Like a Rolling Stone" by Bob Dylan had on me? Clearly not. Did these kids care about improving the state of the universe, were they willing to risk their lives in order to help others survive? No way. Had any of the lessons I had learned or cultural changes our generation had engendered made any difference to this new breed? Maybe.

We agreed that America was in good shape. Crime was down, the stock market was up (for the moment). The Internet was a good tool if not abused. Most people had enough money to live comfortably. Racial and religious differences were better tolerated. The Clinton boomer years had handled these issues well. But I had to admit to myself that my generation was going through some sort of midlife depression. Is this all there was?

Will life ever seem as enticing again? Will these kids ever get the pioneering spirit we had in our youth? Not sure. Had the pursuit of financial reward co-opted any desire to break on through to the other side? Most likely, yes. What universal goals would the youth of today have? Too soon to tell. Had Woodstock '99 left any permanent impressions? Yes: good music, yucky surroundings, and stupid people. Were we stardust? Were we golden? No. Did we have to get back to the garden? Yes. The Vineyard had never seemed so inviting.

That night, safely ensconced in my home on the island, I switched on MTV to catch the latest updates on the festival. Willie and I watched in horror as fires and anarchy consumed the stage, equipment, media, and hangers-on. We thanked our lucky stars for having sensed that things were going to run amok and getting out when we did.

I felt more of a kinship with Willie than ever before. We had gone through a multigenerational leap together that we would never forget. Maybe his generation wasn't destined for the same ground-breaking, mind-blowing changes that ours had wrought. But at least we could experience episodes like this one together. Indeed, in doing so I was living up to my promise not to let my son's early years go by without my input and sharing.

Certainly I absorbed, probably by osmosis, the teachings my own father had to offer. But with Willie, I am eternally grateful for the "hands-on" approach that modern-day dads can offer. We are able to share with and guide each other much more deeply than my ancestors could ever have imagined doing. Willie dislikes the Grateful Dead, has no interest in the Mets, doesn't take photographs to any major extent, and makes fun of my "New Age" mentality. But his classmates can't get over the notion that I once met and smoked pot with Bob Marley and

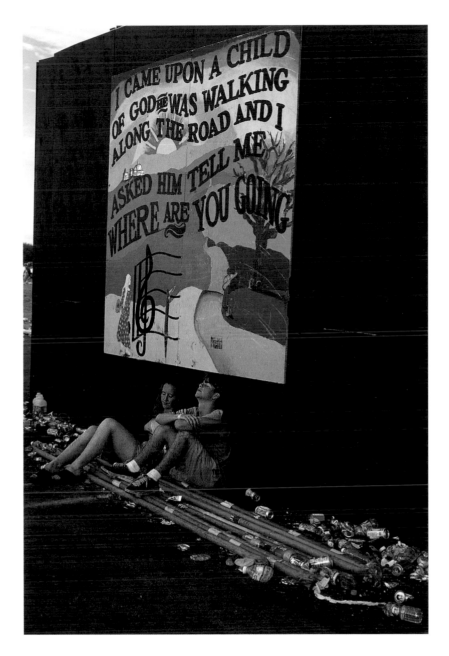

lived on a naked-hippie commune. "My friends think you're cool," he often says. And he confides in me about his dreams and fears. What he will eventually do with all of this is an intriguing mystery. And, despite the ugly manifestations and ramifications of Woodstock '99, I sincerely feel that my generation is leaving the world in a better place due to our "not-me" and "we are all together" attitudes of the late sixties. Only time will tell the real story. I hope I am still around to share the next chapter.

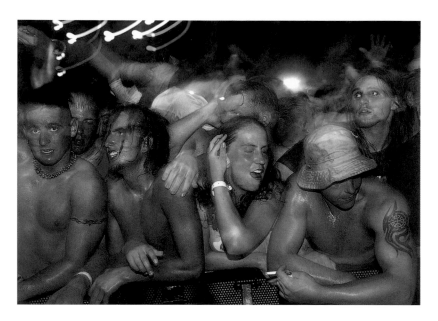

A CRAZED CRUSH TO THE
FRONT.

>

THE "MOSH PIT."

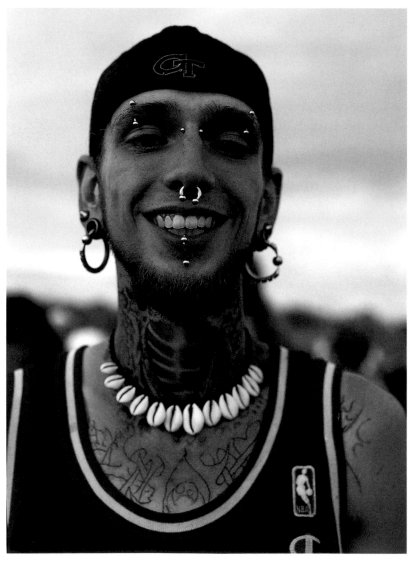

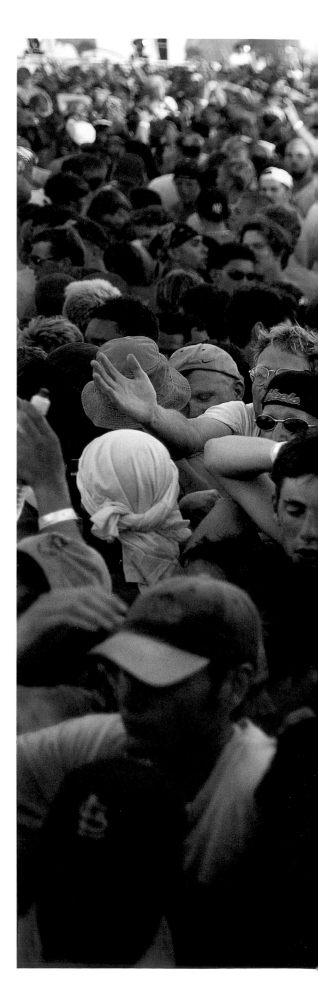

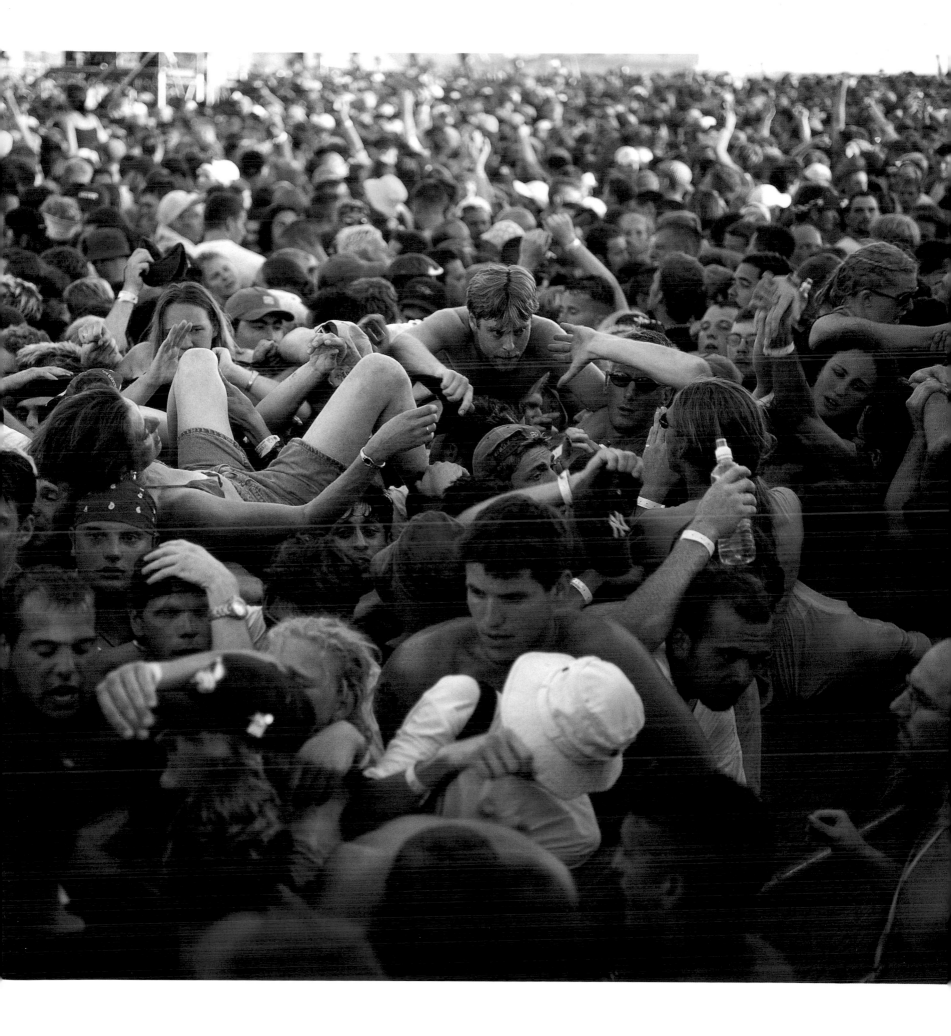

I would like to give thanks and praise to the following folks for helping me make *I and EYE* as fine a book as possible:

My introductory essayists: sister Carly Simon, longtime collaborator Stephen Davis, media mentor David Silver, and new Vineyard pal novelist Richard North Patterson. These people put in the time to express their ideas, anecdotes, and personal feelings — and some well-deserved needling — lovingly and eloquently.

The Bulfinch Press staff: editor Janet Bush, her assistant, Helen Watt, production manager Melissa Langen, and copyeditor Betsy Uhrig, for putting up with the myriad "author's alterations" I requested throughout, and for giving highly professional guidance, space, and support throughout the creative process.

Expert designer Susan Marsh, for her keen eye and sense of proportion. Editing down more than 800 photographs to a more manageable 320 or so is a task I wouldn't have wished upon anyone. She merged everything together with grace and charm.

My agent, Sarah Lazin, who believed in and encouraged this project from the outset, and who steered me to Bulfinch Press, for which I am grateful.

My wife, Ronni, and son, Willie, who helped to create a loving and nurturing environment in which to complete my work.

And finally, to everyone who appears in the images in this book. Without you, none of this would have been possible.

One love, one heart.

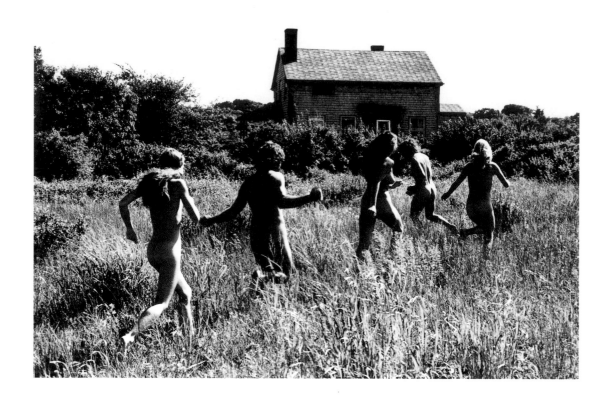

DESIGNED BY SUSAN MARSH

TYPE COMPOSED IN MRS. EAVES AND SYNTAX BY MATT MAYERCHAK

PRINTED AND BOUND IN SINGAPORE BY IMAGO